ICONS OF THE LEFT

ICONS

OF THE

LEFT

Benjamin and Eisenstein,
Picasso and Kafka after
the Fall of Communism

OTTO KARL
WERCKMEISTER

THE UNIVERSITY OF CHICAGO PRESS

CHICAGO AND LONDON

OTTO KARL WERCKMEISTER is the Mary Jane Crowe Distinguished Professor in Art History at Northwestern University. Recognized worldwide as a specialist in both medieval and modern art, he has written a number of books in German and English, including *The Making of Paul Klee's Career, 1914–1920* (1989) and *Citadel Culture* (1991), both published by the University of Chicago Press.

The University of Chicago Press, Chicago 60637
© 1999 by The University of Chicago
All rights reserved. Published 1999

07 06 05 04 03 02 01 00 99 1 2 3 4 5

ISBN: 0-226-89355-3 (cloth)
 0-226-89356-1 (paper)

First published in Germany in 1997 by
Carl Hanser Verlag, Munich and Vienna, as *Linke Ikonen*
© 1997 Carl Hanser Verlag, Munich and Vienna

Library of Congress Cataloging-in-Publication Data

Werckmeister, O. K. (Otto Karl), 1934–
 [Linke Ikonen. English]
 Icons of the left : Benjamin and Eisenstein, Picasso and Kafka
after the fall of communism / Otto Karl Werckmeister.
 p. cm.
 Includes bibliographical references and index.
 ISBN 0-226-89355-3 (cloth : alk. paper). — ISBN 0-226-89356-1
(pbk. : alk. paper)
 1. Communism and art. 2. Socialism and art. I. Title.
HX521.W45513 1999
700'.458—dc21 98-41461
 CIP

Editorial Assistance: Elizabeth Seaton

∞ The paper used in this publication meets the minimum requirements of the American National Standard for Information Sciences—Permanence of Paper for Printed Library Materials, ANSI Z39.48-1992.

Contents

v

List of Illustrations

INTRODUCTION

A Time for Revision

Who are you? To whom
Are you speaking? Who benefits from what you are saying there?
And, by the way:
Does it leave the reader sober-minded? Can it be read in the
morning?
Is it tied to what is there already? Have the sentences
That were said before your time been used, or at least been
refuted?
Is everything verifiable?
By experience? What experience?

BERTOLT BRECHT, *The Doubter*[1]

Icons of the Left

Since the period in 1989–91 when Communist governments in Eastern
Europe, and finally in the Soviet Union, suddenly ceased to function, the
long-standing Marxist tradition within the critical culture of capitalist so-
cieties has become subject to more trenchant revisions than ever before.
What is at stake is no longer the adequacy or inadequacy of a Marxist cri-
tique of the relationship between society and culture, but whether the
manifest dysfunctionality of Communist politics has stopped such a cri-
tique from drawing any political conclusions. This question is now ever
more urgent in capitalist democracies, where a political view of culture is
becoming commonplace just as the political institutions of democracy
prove to be less apt to handle the problems of society and hence are losing
their social support, their undisputed political legitimacy notwithstanding.

In the Marxist culture of capitalist society, some works of modern art or literature have attained a high degree of canonical validity. Marxist writers, artists, and intellectuals have invoked them as time-transcending absolutes embodying the negative indictments or the positive goals of a coherent Marxist world view. They seem to carry a perpetual challenge to, if not subversion of, capitalist political or social ideologies, capable of being targeted on ever new historical situations. From the very beginning, their dissident significance has been bound up to various degrees with Communist politics or ideologies and hence been subject to controversial assessments. This is what distinguishes them from the proclaimed doctrinal clarity of orthodox Communist art and literature and has facilitated their recurrent, variable appropriation for the Marxist culture of capitalist society. Their critical potential of political dissent could be maintained even if their Communist presuppositions were jettisoned, ignored, or forgotten. They became the focus of ideological projections that turned out to be more abstract the less likely their political enactment would appear.

Three of these works—Sergei Eisenstein's *Battleship Potemkin*, Pablo Picasso's *Guernica*, Walter Benjamin's literary description of Paul Klee's *Angelus Novus* as an Angel of History—are the subject of this book. I call them "Icons of the Left," because in the Marxist culture of capitalism they have been detached from their historical and political origins and made into visual or literary rallying points for a dissident leftist mentality with no political constituency or political allegiances. They shine as lodestars on the firmament of a reactive Marxist cultural critique whose political pronouncements have never come to pass because this critique lacks a political perspective of its own. I will attempt to show that the ideals that have come to be invested in them are not just politically untenable but historically misperceived. Their historical revision is part of an overdue political critique of the distorted dissident culture of the Left in capitalist society today. Whoever wishes to advance the Marxist challenge to capitalism with a greater stringency than before ought to shed such liabilities.

Ideology Critique of Marxism

The Marxist tradition of dealing with art has been beset by more reckless ideological projections than competing world views because its pronouncements were already advanced as an ideology critique of those world views in full awareness of the difference between prejudice and ob-

jectivity. In that tradition, historical diagnoses and political objectives were habitually identified in the synthetic concept of a "tendency," simultaneously to be discerned as a reality and pursued as a goal. Within the institutional realm of Communist governments, Marxist art theory had a license to be formulated in the expectation that political power will ensure the convergence of both. That privilege dispensed it from the need to carry any inherent historical or aesthetic persuasiveness. Critical Marxist art theory in capitalist society could neither draw on this kind of orthodoxy nor match it with any political assurance of its own. Proceeding with a greater sense of historical critique, it was unable to found its propositions on a plausible political alternative to communism. So it fell back on categorical negations or utopian projections. It never had a chance to make good on the assumption that Marxist intellectual work is aimed at animating, if not leading, political practice, and expects its vision to be borne out by historical experience. As a result, Marxist cultural critics compensated their nagging sense of political disenfranchisement by a nostalgic fascination with images, films, and texts from an earlier period, when the arts were part not only of political culture, but also of cultural politics. In capitalist society there is at present no coherent policy, and hence no persuasive political culture, of the Left. The transfiguration of art on the Left from history to ideology, from testimony to icon, fills that void.

Marxist cultural critique has not been compromised from without by the recent political collapse of Communist governments, but from within by its failure to come to terms with the political democracy it has taken for granted as its field of operation despite its hostility to democracy's economic base in capitalism. Its schematic critique of capitalism will remain nonpolitical as long as it cannot proceed toward a critique of democracy. Whoever speaks of capitalism today must not pass over democracy in silence. Marxist cultural critique, however, still unabashedly deploys itself within the political culture of democracy. It avails itself of this culture's literary, artistic, and academic spheres, using them as surrogate fields for ideological debates that have no political repercussions. Here the Left finds a resonance that it is denied within the political institutions of democracy. Taking recourse to its prewar tradition, when its cultural critique was not yet predicated on political disenfranchisement, the Left searches for a retrospective validation. Images and texts from a time when art and literature unfolded in a public political culture transcending their aesthetic limits are made into its emblems.

In art history, where I work as an academic teacher, the Marxist tradition was accepted as an operating premise only belatedly, during the years

1968–74. By then, it had ceased to be anchored in the cultural policy of any political movement and had been transposed into a theoretical observance, largely founded in the writings of the Frankfurt school. The resulting conceptual coherence of neo-Marxist art history, including my own, was explicitly or implicitly founded on substantive ideas about a hypothetical decline of "Late Capitalism" and an equally hypothetical rise of "progressive" forces. It presupposed the long-term dialectics of a rightful course of history that is no longer grounded in the experience of politics, including Marxist politics. The illusory consistency of such a mindset was fundamentally different from the contradiction-laden, argumentative reflections about the relationship between art and Marxist politics from the time between the two world wars, most urgently during the Great Depression. Leon Trotsky, Bertolt Brecht, Antonio Gramsci, György Lukács, or André Breton were political writers of this period whose active engagements prompted them to plot ever new courses between the two poles of Marxism's political legitimacy, that is, the commitment to workers' movements on the one hand and the allegiance to Communist governments on the other. Their reflections about an artistic culture of the Left were sensitive to the contradictions imposed on them by the political conflict between democracy and communism over the issue of artistic freedom. Marxist writers dealing with art in the capitalist culture reconstructed after the Second World War have operated under no such pressures. Their preferred model has been Walter Benjamin, an intellectual with no political range of action, who remained unsuccessful, during the first three years of his exile, in his ambition to link his work with a cultural policy of the Left, and was hence thrown back into the ideological idiosyncrasies and enforced continuities of his own thought (see pp. 22–24). The displacement of Marxist thought into critical theory has invested Benjamin's writings on art with a posthumous authority detached from his and shielded from our own historical experience.

To be true to itself, a Marxist critique of artistic culture ought to subject the ideological equivocations under which it has been operating for some time to the ideology critique that it has taken to be germane to its own methodology. It ought not to emulate Communist orthodoxy, which has reserved ideology critique for the political adversary while revalidating ideology as a function of its own politics. After all, historical scholarship as an instrument of ideology critique already figures in the original thought of Marx, before he politically systematized world history according to Hegel's paradigm. It should be possible to reach behind this systematization of history, politically refuted as it has turned

out to be, and recover the Marxist tradition as the fundamental questioning mode of a radicalized historical investigation of artistic culture. Its ideological function of providing utopian surrogates for political practice and its existential function of transfiguring aesthetic experiences into political self-awareness may get lost in the process. But political practice and political self-awareness will only become more deliberate and less illusory without the false backing of a theory to suit conviction, of an aesthetics blinded by dissent.

The Seventies and the Eighties

The predicament of leftist intellectuals working in capitalist society, like myself, has been that their principled critique of capitalism has nearly always been advanced in a hypothetical mode. Long before the collapse of state socialism as a form of government in the East, capitalist society in the West had never shown any lasting signs of moving in the direction projected by Marxism. There have been times when such a movement has seemed more likely—the four revolutionary years after the First World War, the decade of the Great Depression, the "Cultural Revolution" of 1968–74—but such expectations have been have turned out wrong.

It was in the last of those three periods that the current tradition of Marxist cultural critique was founded. At that time, a self-confident capitalist culture, at the apparent high point of its postwar success, experienced its first political crisis. In the United States, domestic affluence coincided with unsuccessful neocolonial warfare in Southeast Asia; in the Federal Republic, postwar reconstruction was exposed as having relied on the leadership of social elites compromised by their political support of the National Socialist government. It was to dispel the continuing self-gratification of that culture by a "modern" art transfigured into a near-absolute aesthetics beyond historical experience that Marxist art historians launched their revisionist accounts of art as ideology, as a tool of propaganda, and as a product of social strife. Our historical propositions were meant to contribute to the ongoing political critique of culture by the Left.

In the period of 1978–89, however, Marxist intellectuals had to face a conservative turn in politics that was legitimized by electoral majorities in the major capitalist states. These politics supported rearmament, including nuclear rearmament, as a means of economic expansion, ostensibly in order to right a perceived imbalance of mutual nuclear deterrence. The ensuing Second Cold War ended with the Soviet Union's defeat and disintegration. But the resurgent capitalist economy, financed by a lasting state indebtedness, led to such glaring social

imbalances that a diffuse yet all-pervasive crisis consciousness, magnified by near-apocalyptic fears of nuclear war, became a cultural common-place. Security and risk, affluence and poverty, confrontation and coex-istence were being perceived in an inextricable simultaneity belying any manifest politics of governments and opposition parties. Now cultural critique could be advanced in even more radical terms, since it no longer felt obligated to offer political solutions and could be expressed in an openly inconclusive hyperbole. Tending toward the aesthetic, the moralistic, and the agnostic, it became part of a prevailing, officially sanctioned culture that claimed to be critical in and of itself. I have called it Citadel Culture, a performative culture in which moralistic self-in-crimination and aesthetic posturing made for a display of glaring tragedy. At this point the Marxist tradition of cultural critique lost any residual political perspective it may have harbored during the preceding decade. Its systemic critique of capitalism was unable to promise any re-dress through democratic politics, which had on the contrary given cap-italism a solid political mandate. Left-wing parties, politically on the retreat, had no credible cultural policy to offer. The economic and social decline of Communist governments in Eastern Europe and the failure of the state and party reform in the Soviet Union made it impossible to justify communism's systemic lack of democracy. By contrast to the time of the Great Depression, communism offered Marxist intellectuals no orientation, not even as a reference point for critical debates. The re-sulting self-contradictions prompted most of them to forego the strin-gency of the Marxist tradition and to join the prevailing diffuse skepticism toward any normative values of culture. Marxism blended into a cultural critique of politically inconsequential dissent, where it was kaleidoscopically configured with poststructuralism, feminism, psychoanalysis, and deconstruction. The attendant relativization of val-ues deprived Marxist ideology critique of its traditional function as a unified premise of political practice and historical inquiry. It was re-duced to sharing in the coexistence of discrepant values beyond politi-cal dispute, the pluralistic social ideal of "postmodern" culture.

Finally, when the collapse of socialist government irrefutably ex-posed its long-standing historic failure, the realization could no longer be obviated that Marxist politics in action had been bound up with, not merely compromised by, oppressive regimes. Now the lingering politi-cal disorientation of Marxist intellectuals was complete. The critical culture that had perpetuated the assurance about a Marxist course of history over and against all appearances had arrived at a terminal point.

Its shaky course between the Scylla of intellectual sacrifices to Communist Party doctrine and the Charybdis of vacuous speculations on revolution and utopia had ended in a wreck.

This Point in Time

And yet recent historic events have not mooted any political challenge to the economic and social order of capitalism mounted by the Left. For the failure of socialism was instantly followed by a global structural crisis of capitalism that is still in progress. The capability of democratic governments to redress the systemic social crisis entailed by economic expansion is weakening, and with it their political support. The expectation that the simultaneous installation of political democracies and capitalist economies in the formerly socialist states of Eastern Europe would lead to their speedy social recovery has not been confirmed. In several of these states, socialist parties, successors to the Communists, have won democratic elections. For the first time, socialist governments can claim a democratic backing. In Russia, a Communist Party has at present a majority in parliament and in 1996 ran a strong second in the presidential election. Whether we like it or not, we cannot speak of the end of socialism as a political force.

How this process will eventually unfold is hard to tell. What has been disproved, however, is the world-historical scheme of the conflict between capitalism and socialism as envisioned by the critical culture of Marxist observance. According to this scheme, a worldwide class struggle between capital and labor was to be decided on the basis of a calculable convergence of capitalist decline and socialist progress. Yet today, in Western Europe and the United States, a Marxist critique of culture is no longer confronted, as it was at the beginning of the seventies, with celebrations of artistic achievement as part of the culture of capitalism in expansion. Rather, the dominant culture projects a deceptive dissidence from the ideology of the capitalist society that sustains it. Marxist critique has become an accepted cultural sideshow of the state theater of capitalism, where the spectacle of capitalism's self-correction toward social justice by means of political democracy is being played on the main stage. Its political disorientation is made up for by theoretical abstraction or moralistic outrage. Largely disconnected from the political process of democratic government, it has internalized the sense of its own impracticality into an utopian mode of thought. Icons of the Left are guiding images of such a mindset. My critical revision of these images pertains to a sobered mentality, a precondition for reconnecting cultural critique to a cultural policy of the Left.

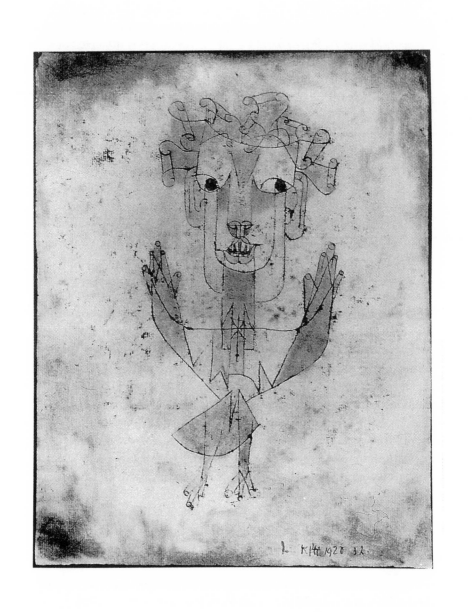

ONE

Walter Benjamin's Angel of History, or the Transfiguration of the Revolutionary into the Historian

A Thesis for an Institute

In the spring of 1989, six months before the Berlin Wall was breached, a West German professor of history at Essen, Lutz Niethammer, was writing yet another commentary on Walter Benjamin's ninth "Thesis" about the Concept of History, that well-known aphorism evoking the image of an Angel of History blown away by a storm over an inexorably growing pile of rubble on the ground. He was also organizing a new government institute for cultural studies at Essen, to be opened the following year. In the preface to the book of which his commentary on Benjamin's thesis forms a chapter, Niethammer recalls writing in the dead of night, after the administrative duties of the day, on the empty premises of the future institute.[1] In the official publication documenting and commemorating the foundation, he likewise remembers his daytime and nighttime activities as mutually complementary.[2] As soon as the institute opened, Niethammer put his planned interdisciplinary working program up for discussion by a study group called Memory, whose first order of business was a reading of Benjamin's late writings.[3]

The founding director's ambitious goals for a convergence of cultural history and cultural policy, set forth at length in the institute's program, were hence to some extent founded on the world-historical claims advanced in Benjamin's thesis. Like Benjamin half a century ear-

lier, Niethammer sought to challenge the notion of culture as surrogate for historical experience. What he saw prevailing in the economically saturated Federal Republic of West Germany the year before the unification of the country was the notion of culture as a spiritual complement to, and aesthetic fulfillment of, material well-being. He diagnosed an "orientation crisis," or even a "cultural crisis,"[4] which required redefining the political legitimacy of cultural history as a scholarly discipline. The new institute was to operate on such a redefinition.

This intended political revalidation of cultural history for the democratic industrial society of West Germany largely guided Niethammer's interpretation of Benjamin's thesis. For the first time in the exegetical history of the text, he gave weight to the distinctions separating the Angel of History from author and readers,[5] *"him"* from *"us,"* words that Benjamin underlined in his typescript and that his editors typeset in italics. These distinctions, Niethammer argues, allow us to stop regarding the Angel of History as an agonizingly problematical paradigm for our work as historians or critics of culture, as had been taken for granted in the preceding literature. On the contrary, we can maintain a distance from the conceptual allegory and avoid the fate of being reduced to helplessly driven witnesses of history. We can retain the angel's wish to undo the destructions of the past as a utopian perspective, even without committing ourselves to its religious premise. It is in our hands to blend the study of the past "into political action in the present."[6] Accordingly, in the inaugural publication about his institute, Niethammer called for "cultural research with a political intent,"[7] for a "culture of intervention."[8]

Thus, the program of the Essen Institute was to achieve what Walter Benjamin fifty years earlier had, for obvious historical reasons, envisaged in vain: an understanding of history that makes political sense. The secure, constitutional democracy of the Federal Republic, which by 1989 could look back on forty years of continuity, was more propitious for such a task than the irreconcilable three-way confrontation between democracy, fascism, and communism at the start of the Second World War. A self-assured revision of Benjamin's propositions, taking this historical distance into account, would entail a historical critique of their conceptual unease.[9] Niethammer advanced no critique, however, only another attempt at ascertaining the contemporary relevancy of Benjamin's text through more accurate, immediate rereading. He chides earlier commentators, who have often identified

the angel with the historian, for their "spontaneous projections . . . not worked through in the text."[10] Can Benjamin's fifty-year old text today be set up as a paradigm for an institutional research program with a political mission, merely through being properly understood? Niethammer did not speak of cultural policy, particularly that of the Social Democratic government of the federal state of Nordrhein-Westphalia, to which he was accountable on a daily basis. He simply took the political relevancy of intellectual culture for granted. In the Federal Republic of those years, this was a matter of course. Catchwords such as *Kulturgesellschaft* or *politische Kultur* were advanced habitually to exempt the political claims of intellectuals pursuing culture in the public sphere from any political accountability. Whereas Benjamin, the politically disenfranchised intellectual in exile, had been excluded from any potential impact on "political practice," Niethammer, the civil servant with a political appointment, was privileged to skirt the issue. If the institutional setting of intellectual work stays out of reach of a political critique, such work remains within political abstraction. It makes no difference whether the removal from politics is enforced by historical emergency, as in the case of Benjamin, or granted as a privilege by a state government, as in the case of Niethammer and his institute; the abstraction is the same.

An Icon of the Left

More than forty years of commentary on Benjamin's ninth thesis shape up as a continuous ideological debate among academics about the political validation of intellectual culture. A dozen lines of printed text, conveniently focused on one picture suitable for incessant reproduction, have become a venue for drawing out the fundamental contradictions between revolution and religion, activism and resignation, political partisanship and historical detachment. Paul Klee's unexplained watercolor *Angelus Novus* (1920) has become, on Benjamin's rather than Klee's terms, a composite pictorial and literary icon for left-wing intellectuals with uncertain political aspirations.[11] Benjamin's interpretation of a "modern" artwork as a mirror of autobiographical self-assurance and as a fantasy of political dissent has been turned into a foundational text for a theoretically abbreviated and metaphorically stylized historical mode of alternative thought intent on resolving its own inconclusiveness. It has seemed to hold out an elusive formula for making sense of the sense-

less, for reversing the irreversible, while being subject to a kind of ideological brooding all the more protracted the less promising the outlook for political practice appears to be. Through the stream of its exegesis, Benjamin's suggestive visual allegory has become a meditative image—an *Andachtsbild*—for a dissident mentality vacillating between historical abstraction and political projection, between despondency and defiance, between challenge and retreat. The image keeps the aggressive critical impulse of such a mentality in a decisionless abeyance, so that the tension stays put within the politically disenfranchised, and hence ideologically overcharged, realm of culture. For this perpetual holding pattern of thought, Benjamin's notion of a "Dialectics at a Standstill" offers its own tailor-made philosophical validation. The complications of the commentary literature, which is wont to claim a license for the paradox,[12] result from an effort to wrest positive meaning from the seemingly absolute verdict, pronounced in the thesis, about the catastrophic course of history and the powerlessness of its witnesses. The Angel of History has become a symbolic figure for the contradiction-laden alignment of life, art, and politics to which left-wing intellectuals have aspired, an alignment that in turn fascinates left-wing academics emulating such aspirations. It embodies the political and conceptual short-circuit between "modern" culture and revolutionary rhetoric encapsulated by the catchword *avant-garde.*

Commentators of the thesis, often academically secure but rarely engaged in cultural policy, have usually tackled its questions of historical objectivity, moral judgment, and political action from the viewpoint of the individual subject. They posit a seemingly absolute subject, detached from Benjamin's historical situation in 1940, and with no apparent reference to their own. On this assumption they have interpreted the angel's flight over the landscape of unfolding catastrophes as a straightforward allegory of subjective historical experience as such. Niethammer attempted to resolve the ensuing contradictions between perception and reality by dwelling on the institutional and pluralistic preconditions of historiography. Yet he himself was still prepared to install Benjamin during his final, socially most isolated and politically most hopeless phase of thought as a lead figure for the institute's program.

The first such installation had been inaugurated in 1942, two years after Benjamin's death, through the posthumous first publication of his *Theses on the Concept of History* in a mimeographed memorial volume for

a circle of members, collaborators, and friends of the New York Institute for Social Research. Soon thereafter, Max Horkheimer and Theodor W. Adorno promoted the dead Benjamin from a closely watched, critically managed contributor to their journal to a "guiding star" for their philosophy of history.[13] The incorporation of the *Theses on the Concept of History* as Benjamin's final pronouncements into the canon of critical theory has contributed to the steadily rising authority of Benjamin's writings. They formed a vital ingredient in a collective corpus of reference for debate to which a group of academics subscribed and which they succeeded in making into the premise of an institutional program with public visibility. After 1968, fierce debates about Benjamin's communism, and about the communist significance of the *Theses,* informed the confrontation between the Institute for Social Research, which had returned to the Federal Republic and adapted to academic politics and cultural policy there, and left-wing intellectuals with little institutional standing, who sought to challenge the constitutional order of the Federal Republic on the terms of cultural revolution. The contradictory reception of Benjamin's texts—on the one hand as expressions of an autobiographically reflected, subjective political critique, and on the other hand as paradigms of an institutionally consolidated theory—dates from the year 1935, when the New York institute put Benjamin under contract as a free-lance correspondent while he was in exile in Paris.

One difference of principle between the institutes at Essen and New York pertains to their claimed social engagement. The New York institute absorbed Benjamin's late philosophy of history at the moment when its director, Horkheimer, and then leading member, Adorno, abandoned their initial critical engagement with the cultural policies of their host country and moved to Los Angeles, where they shielded themselves from, and hence polemicized against, any functional enactment of culture in society. From this individualist, elitist posture Horkheimer and Adorno issued, in their jointly authored book *The Dialectic of Enlightenment* of 1947, gloomy world-historical judgments surpassing even Benjamin's *Theses* in their apodictic severity. Those judgments were all the more severe because they were aimed at the authors' immediate living environment with a maximum of vehemence making up for a minimum of observation. It was the private endowment of the institute, its funds secured in Switzerland, that afforded the authors their principled detachment not only from the intellectual culture but also

from the social life of their country of refuge. For a government-supported institute in the Federal Republic of 1989, such detachment was not feasible. But neither was it necessary. For in the peculiar, institutionalized balance of consensus and dissent the West German *Kulturgesellschaft* had reached by then, dissent confined to culture had turned into conventional conduct. Left-leaning intellectuals free to operate with few, if any, existential risks of the kind that Benjamin faced when he wrote his *Theses*—except if they were declared Communists—have come to practice dissent as an instinctual mode of thought. Should it slacken off for lack of an identifiable political target, it can be tightened with historic templates of political urgency furnished by past authors from times of deadly political confrontation. Benjamin's thesis about the Angel of History is such a template.

Angelus Novus

In two of his texts, Walter Benjamin has related Paul Klee's watercolor *Angelus Novus,* which he owned since 1921, to a Jewish tradition which has it that God continually creates innumerable angels in order to have them sing his praise for a short moment and then makes them perish.[14] The first text is an announcement of a journal he planned to edit under the title of Klee's picture in 1922; the second, an essay about Karl Kraus he published in 1931. In calling his projected journal *Angelus Novus* and in addressing the journalist Kraus as a winged "messenger" of the "newest news" calling for a radical protest, Benjamin transfigured the exalted literary ambitions of his own journalism, with its claims to topicality, into a religious metaphor. In neither text did he elaborate descriptively upon the watercolor or the legend.

Once in exile, Benjamin wrote two more texts about the *Angelus Novus* that differ from the earlier ones in their literary character and figurative detail. The first is the short autobiographical tale entitled "Agesilaus Santander," of which Benjamin wrote two successive versions on 12 and 13 August 1933 in Ibiza—his first residence after emigrating from Germany—and which he kept among personal papers.[15] The second is the thesis of February 1940 about the Angel of History, which Benjamin sent to the New York Institute for Social Research to clarify the philosophical premises on which he intended to proceed with the writing of "a sequel" to his recently published essay "On Some Motifs in Baudelaire."[16] Neither one of these texts about the *Angelus Novus* refers

to the profession of journalism, which Benjamin could no longer pursue in his exile, and neither one was intended for publication. The earlier text evokes a meditative viewing of Klee's picture, which is unnamed, in Benjamin's apartment in Berlin. The later text identifies the picture by artist and title and makes it into a world-historical parable. In both texts, Benjamin gives poignant descriptions of the angel, the space where he moves, and what he does, following the ancient literary genre of the *ekphrasis,* where an author blends the description of a picture into that of an imaginary reality. Between one text and the other, he has widened the scenery—from the "room . . . in Berlin" to the landscape of the world.

Some visual discrepancies remain between Benjamin's descriptive evocations and Klee's watercolor.[17] Klee's figure displays neither "claws" nor "wings . . . sharp as knives" like the angel's in both versions of the "Agesilaus Santander," and the pictorial field of the watercolor offers no suggestion of a "catastrophe which keeps piling wreckage upon wreckage and hurls it in front of his feet," as the thesis does. In both texts, Benjamin has invested Klee's image with aggressive and destructive traits that are absent in the original. Moreover, in the text of 1940 the relationship between the angel's movement and the process of destruction is reversed from that in the text of 1933, "from patience to tempest," as Gershom Scholem has aptly pointed out.[18] In "Agesilaus Santander" the angel is poised to move forward for an assault, yet out of his own volition does not advance; in the thesis he wishes to stay put in order to redress the destruction but is blown away against his will. In both texts, the relationship between the angel and the subject, "I" in the first, "we" in the second, suggests a difference in perspective.

"Agesilaus Santander"

The two passages in the second version of "Agesilaus Santander" that elaborate upon this difference in perspective read:

> In the room I inhabited in Berlin that [name], before it stepped forth into the light out of my [current] name in full armor, has attached its image to the wall: New Angel. [. . .] In short, nothing could weaken the man's patience. And the wings of that patience resembled the angel's wings in that very few strokes were sufficient [for it] to maintain itself immovably in the face of the one whom he had decided never to let go. [. . .] For even [the angel] himself, who has claws and wings

that are pointed, or even sharp as knives, does not reveal any intent to pounce upon the one whom he has sighted. He holds him firmly in his gaze—for a long time, and then recedes stroke after stroke, but inexorably. Why? In order to pull him along behind himself, on that path into the future on which he came and which he knows so well that he traverses it without turning back, and without turning his glance away from the one he has chosen.[19]

In both versions Benjamin pictures the viewer's encounter with the hovering angel as the equivalent of the incessant erotic fixation of a man—himself—on a woman. Her gender remains hidden behind the generic male pronoun, "him," partly because of the male-gendered language of that time and partly because Benjamin conceived of the woman as his twin identity, his double. Rather than seizing her by force, he lies in waiting until she voluntarily surrenders to his unyielding attraction. This apparently is how Benjamin fancied his long-term relationship with the women he loved:[20] Jula Cohn, Asja Lacis and, finally, Toet Blaupott ten Cate, whose acquaintance he made in 1933 on Ibiza and who inspired him to write "Agesilaus Santander."[21] Although all three were married or committed to other men, Benjamin felt his one-sided erotic bond to them as lasting, forever vacillating between expectancy and resignation. In the second version of "Agesilaus Santander" he transfers the interplay of confrontation and attraction between the angel and the human to his self-identification with the angel.[22] Now the angel turns from an allegory of the beloved into an embodiment of the lover's will or destiny, a fiercely self-assured projection for an uncertain future.

Scholem, who published both versions of "Agesilaus Santander" for the first time in 1972, has decoded its title as an anagram of *Der Angelus Satanas*. This enabled him to trace the angel figure to the image—in both Jewish and romantic traditions—of Luciferian angels, that is, apostates from God. One might add that the earliest Jewish text about fallen angels, the third book of Enoch, contains the two specific points of reference for Benjamin's identification: it is the guardian angels assigned to human individuals who apostatize, and they do so because of their sexual desire for the daughters of their wards (3 Enoch 6–11).[23] Benjamin writes in the second version of "Agesilaus Santander" that he had "made [the angel] shirk his hymnody unduly long," and in the first version, more pointedly, that the angel "was interrupted" in his chant. According to the third book of Enoch, God makes angels who fail to sing in an or-

derly fashion drop out of the ranks into an abyss by pointing at them with a fiery beam emanating from his finger (3 Enoch 40:3).[24] In a further reference to Judaism, Scholem has drawn attention to current Jewish belief in angels being assigned to individuals, as well as to the custom of giving boys, in addition to their first names, two unlisted Hebrew names only to be publicly revealed at their bar mitzvah. One might add again that in ancient Jewry a particular species of guardian angel was believed to be fashioned in the likeness of the human beings entrusted to them.[25] Scholem concedes that the secret naming evoked in the "Agesilaus Santander" amounts to a Satanic inversion, rather than an observance, of such religious traditions.

Werner Fuld, Scholem, and Jürgen Ebach subsequently have expanded the associative field of speculation underlying the telescoping, in "Agesilaus Santander," of image and name, man and woman, identity and ideal, biography and projection. In 1978, Fuld discovered in the Gestapo files pertaining to Benjamin's expatriation Benjamin's two middle names, until then unknown: Benedix Schönflies, the latter his mother's maiden name. But Fuld was unable to establish a meaningful relationship between the names—which, moreover, were not secret but on public record—and the religious references in Benjamin's text.[26] And when Scholem, in a rejoinder to Fuld, traced the first of the two middle names to Benjamin's paternal grandfather, Benedix Benjamin,[27] it became still less clear what the additional naming had to do with those speculations.

It was Ebach who in 1986 brought new evidence to bear on the elucidation of the text as biographical testimony and literary allegory.[28] He relates Benjamin's letters from Ibiza about a severe wound infection on his right leg, which he suffered from July to September 1933,[29] to the historical tale of King Agesilaus II of Sparta (444/3–360/59 B.C.), who since birth walked lame with a crippled leg.[30] If one follows this lead, it appears that Plutarch, in his biography of Agesilaus, has an additional story about the king's leg. He reports how the king, traveling through Megara, was struck by "a very violent inflammation" in his good leg, whose treatment by bloodletting brought him to the brink of death and kept him long on the sickbed.[31] Even more than the story about Agesilaus II's congenital lameness, this one resembles what Benjamin writes about the "very unpleasant wound infection on [his] right lower thigh." It was this wound infection, not malaria as is often assumed, that gave Benjamin so much trouble during late sum-

mer 1933.[32] A German physician on Ibiza even told him that it might be fatal and "that they [would] probably have to make an incision."[33] Ebach further recalls the biblical story of Jacob, who after his struggle with the angel walked lame with his right leg and was given the new name Israel (Gen. 32:23–33). Both of Ebach's observations clarify the literary references embedded in Benjamin's autobiographical speculations, but they also complicate the understanding of the "Agesilaus Santander." On the one hand, they tie it more straightforwardly to Benjamin's biographical situation at the time he wrote it; on the other, they obscure its meaning even further by enhancing the text's inherent self-mystification.

Cendrars

None of the religious references adduced by Scholem and Ebach clarify the peculiar self-projection of a man into "his" angel who becomes the absolute embodiment of his will, an inversion that deprives "Agesilaus Santander" of any protective certainty offered by a straightforward religious orientation in the tradition of Judaism. This particular motif recalls a quotation from Blaise Cendrars's fantastic novel *Moravagine* (1926)[34] included in the essay "About the Present Social Position of the French Writer," which Benjamin wrote in Ibiza in May and early June 1933, just before the onset of his infection and about two months before he wrote "Agesilaus Santander." The essay was Benjamin's first contribution to the *Zeitschrift für Sozialforschung*, where it appeared in the first issue of 1934.[35] The imaginary author of Cendrars's novel, a psychiatrist, makes common cause with his patient and hero, a sexual murderer, professional conspirator, and political terrorist. He recalls their joint participation in the Russian Revolution of February 1905:

> We were men of action, technicians, specialists, pioneers of a new generation who had made themselves over to death, harbingers of world revolution . . . [. . .] Angels or demons? No, to say it in one word: automatons [. . .] We did not dwell in the shadow of a guardian angel or in the folds of his robe, but rather as if at the feet of our own double, who was gradually detaching himself from us in order to take on a shape and a body. Strange projections of ourselves, these new beings incorporated us to such an extent that imperceptibly we slipped into their skins and became wholly identical with them; and our final preparations much resembled the concluding production of those terrible, those haughty automatons known in magic as Teraphim. Like them, we proceeded to destroying a city, to devastating a country.[36]

Like Agesilaus II of Sparta, Moravagine walks lame on one leg because of a childhood knee injury that his oppressive educators intentionally allowed to heal badly. His healthy leg is later injured, too.[37]

The apparent cross-references between "Agesilaus Santander" and "About the Present Social Position of the French Writer" transpire from yet another text Benjamin wrote in Ibiza in the summer of 1933, the essay "Experience and Poverty," which appeared on 7 December 1933, in the Prague journal *Die Welt im Wort*.[38] Like the other texts, it deals with the transition from anarchism to communism as a platform for artists' and intellectuals' social and political dissent. In "About the Present Social Position of the French Writer," Benjamin dates this historic transition, rather precisely, to the year 1926, when Cendrars's novel was published and when he himself traveled to Moscow in search of Asja Lacis, the woman he loved, pondering whether or not to join the Communist Party. For him, it was André Breton who personified the "overcoming of anarchism." In the "Second Manifesto of Surrealism" of 1930, Breton had located the impetus for an "absolute revolt" in the spontaneous urge to empty one's revolver into a crowd, to be disciplined into opting for communism and the example of the Soviet Union, for "the constructive, the dictatorial [features] of revolution," as Benjamin called it.[39] In "Experience and Poverty," Benjamin relates this constructive turn of violent dissent to his own radical speculations of cultural critique from the terminal years of the Weimar Republic. In his essay on Kraus of 1931 he had similarly vindicated his bend on "destruction":

> One must have followed [Adolf] Loos in his struggle with the monster "ornament," . . . or have sighted Klee's "New Angel," who would rather liberate men by taking from them than make them happy by giving them [anything], in order to comprehend a [notion of] humanity which proves itself by destruction.[40]

At that time Benjamin had imbued Kraus's pronouncement, "the origin is the goal," with an ideological dynamic, by rephrasing it as "but where origin and destruction come together," so as to relate it to the commonplace revolutionary dialectics of destruction and reconstruction. He compares the Austrian critic of culture first to the figure of a messenger in "old engravings," who comes running from far away and from long ago to report disasters, and then to the "new angel," who soars to God's throne from the world below, bewailing its corruption. Benjamin for his part makes the angel return to the corrupt world to destroy and restore it to its aboriginal status from which it can be re-created better. The artistic radicalism of Klee and Loos, who "first of all made a clean sweep" and

then started anew with their art, is charged up by him with revolutionary ideology. In one of the preparatory texts for the essay on Kraus, Benjamin represents these "most progressive German artists" as harbingers of Bolshevik industrialization during the First Five-Year Plan:

> What inspires this team is in the final analysis the consciousness that the organization of human existence—in the sense of increased production, better distribution of consumer goods, socialization of the means of production—demands something more and something else than a comfortable doctrine of how to make the world happy; that this rise of needs on the one side is matched by an ascetic attitude on the other.[41]

Two years later, in "Experience and Poverty," Benjamin again marshals the "team" of Loos and Klee on behalf of Soviet reconstruction. Here the two artists embody a "new, positive notion of barbarism."[42] The "hybrid of child and cannibal," which Klee's "new angel" had evoked for Benjamin in the essay of 1931,[43] turns into a model of Soviet "New Man": "The Russians, too, like to give their children 'dehumanized' names: they call them 'October,' after the month of the Revolution, or 'Pyatiletka,' after the Five-Year Plan, or 'Aviakhim,' after an aviation society."[44] Benjamin takes Cendrars's Moravagine, the *fauve humain,* the murderous "idiot," physically and psychically deformed since childhood, for such a "monster," whose aggressive drive can be channeled into Communist political determination.

In Cendrars's novel, Moravagine and his anarchist co-conspirators are leading the Russian Revolution of 1905 to a brief, fantastic triumph. "The [battleship] 'Potemkin' hoists the black flag" of anarchism[45] and assumes command of the Black Sea Fleet. In Sergei Eisenstein's film of 1925, by contrast, the fleet admiral merely allows the "Potemkin" to break free. Here the red flag of Bolshevism is hoisted in the final scene, hand-colored on the black-and-white projection print, a banner of the future. The concluding sequence of intertitles summarizes Lenin's historical assessment of the *Potemkin* mutiny as a preparatory move for the Bolshevik Revolution twelve years later. Benjamin, in *Die Literarische Welt* (1927), acclaimed *Battleship Potemkin* for just this "tendency"[46] and was hence in a position to discern the programmatic distinction between Cendrars's image about the short-term successes of anarchist revolts, perhaps already framed as a response to Eisenstein's film, and Eisenstein's visualization of a more realistic, long-term revolutionary strategy of Communism. In his essay "About the Present Social Position

of the French Writer," Benjamin now was taking sides on the issue, following the surrealist paradigm long after Breton had disavowed it: only the intellectual's "constructive" commitment to "the proletariat," that is, to the Communist Party, can lead him out of the politically self-deceptive posture of artistic revolt. Here Benjamin subscribes to Louis Aragon's call for writers to "betray" their bourgeois class origins and to cooperate with the workers' party. Such writers, he asserts, "turn into militant politicians."[47] This was Benjamin's attempt to draw political consequences from his class degradation as an impoverished emigrant at the hands of the National Socialist regime.

Benjamin may have understood Breton's "overcoming" of Cendrars's posture not only in political but also in erotic terms. In *Moravagine,* Cendrars, with extreme mysogynism, characterizes sexual relations as a deadly combat whereby woman strives to deflect man from his destiny.[48] By contrast, Breton—or so Benjamin writes in his 1929 essay on surrealism—in his relationship with Nadja had represented, and experienced, the convergence of revolutionary politics and love.[49] For Benjamin in 1934 the surrealist paradigm held the promise of fusing social degradation, politicization, and erotic determination into one compelling posture:

> The petty bourgeois who has resolved to act on his libertarian and erotic aspirations ceases to offer an idyllic sight. . . . The more undauntedly and deliberately he brings these aspirations to bear, the more assuredly he hits upon politics—on a path which is both the longest and the only one he can go on. At that moment he ceases to be the petty bourgeois he had been.[50]

This passage from the essay "About the Present Social Position of the French Writer" pinpoints the political and existential goal of two passages in the second version of "Agesilaus Santander" about the "longest, most fateful detour" and about the "path into the future on which he came and which he knows so well that he traverses it without turning back." In these passages, Benjamin retraces the long-term autobiographical coherence of his erotic as well as political radicalization, which he expressed first, in 1926, by dedicating his *One-Way Street* as "Asja-Lacis Street" to the woman he then loved.[51] It seems that in 1933, inspired by his love for Toet Blaupott ten Cate, he was ready to implement a similar reciprocal radicalization of love and politics.[52] In a passage of *Moravagine* preceding the passage about the guardian angel Benjamin translated in "About the Present Social Position of the French Writer," Cendrars characterizes man's anarchistic resolve with the

phrase: "Each one of us lived under the image of his own destiny."[53] Woman, by contrast, is a generic traitor to the revolution, incapable of "doubling herself," of "concretizing the image of her destiny," of "ever attaining the spiritual projection."[54] In "Agesilaus Santander," Benjamin envisages a communist resolution of this sexual conflict in the spirit of Breton's note from the Second Manifesto of Surrealism, which speaks about the "faith that unspoiled man must be capable of placing, not only in the Revolution, *but also in love.*"[55]

All three texts Benjamin wrote at Ibiza in the summer of 1933 are animated by similar autobiographical reflections, suggested in the recurrent motifs of angel, new names, barbarism, and destruction. In "Agesilaus Santander" Benjamin reassured himself about the erotic continuity of his leftward "path." In "Experience and Poverty" he ascertained the political pertinence of his pre-1933 cultural critique for his new Communist militancy. And in "About the Present Social Position of the French Writer," he set the social terms for a political engagement of his work in the antifascist struggle as an emigrant in France.

From Literary Politics to Cultural Critique

As soon as Benjamin left Ibiza in October 1933 to reside in Paris, he attempted to live up to the French surrealists' challenge to actively struggle against fascism. Would he be able to fulfill his implicit self-designation as a "militant politician"? In January 1934 he unsuccessfully tried to have the essay "About the Present Social Position of the French Writer" reprinted in *Littérature Internationale,* the journal of the International Association of Revolutionary Writers in Moscow.[56] During the following three years, he vainly attempted to participate in the various antifascist political endeavors of both the French left-wing intelligentsia and the German intellectual emigrant community. Chryssoula Kambas has plotted Benjamin's inconclusive efforts to engage in "literary politics;"[57] I summarize her account.

Benjamin's first venture into the Paris left-wing literary scene was his lecture "The Author as a Producer," delivered in late April 1934 at the Institute for the Study of Fascism, a foundation sponsored by leading French intellectuals who would later join the Popular Front. In defending the antifascist significance, or even utility, of modern art, Benjamin took issue with the political critique of modern art as "bour-

geois" advanced by the Association des Écrivains et Artistes Révolu-
tionnaires, the writers' organization of the French Communist Party,
and by the Bund Proletarischer und Revolutionärer Schriftsteller, the
organization of exiled German writers in Moscow. Less than two years
later, in his essay "The Work of Art in the Age of Its Mechanical Re-
producibility," he polemicized more overtly against the revalidation of
traditional art and literature propagated by the leadership of the French
Communist Party at the Congress for the Defense of Culture held in
Paris, June 21–25, 1935, in the name of a Popular Front–type coalition
of antifascist forces. In early 1936, he vainly attempted to have this es-
say published in Moscow party journals, in German in *Das Wort* or in
Russian in *Littérature Internationale.* Eventually the *Zeitschrift für Sozial-
forschung* published the essay in a French version defanged by the re-
moval of its Communist political vocabulary. Benjamin nonetheless
submitted the text in this edited form to a public debate in two meet-
ings of the Paris Schriftstellerschutzverband, held on 22 and 30 June
1936. But the debate was obstructed, in his opinion, by Communist
Party members in the audience. By 1937, at the latest, the failure of his
efforts to engage as a writer in the political struggle against fascism must
have dawned on him. The speculative political goals he still envisaged
for the art of the avant-garde, as he had in his cultural critique during
his last years in Germany, ran counter to the restorative policies for lit-
erature newly enforced in the Soviet Union and promoted without
compromise by the Comintern in Western Europe. From now on the
only publication with a self-declared antifascist stance in which Ben-
jamin could regularly place his work was the journal of the Institute of
Social Research in New York. Its editor, Horkheimer, adhered to a pol-
icy of keeping it aloof from any specific political controversy, in com-
pliance with the professional self-restraint of academic institutions in
the United States and independent of his own political convictions or
judgments on current events. Benjamin was thus offered an institu-
tional setting for his long-term work that as a matter of principle cur-
tailed his political range of expression. His hesitant adaptation to this
constraint, with its well-known attendant controversies, was expressed
when he recast his personal leading figure *Angelus Novus* as the Angel of
History.

Benjamin first formulated his views about the task of a "materialist"
historian, the eventual subject of the *Theses,* in his essay on Eduard

Fuchs, which was published in the *Zeitschrift für Sozialforschung,* probably in October 1937,[58] with Horkheimer's express agreement.[59] He first devised the visual metaphor of the view from above in his introduction to a digest of *About the Regression of Poetry,* by the early nineteenth-century German writer Carl Gustav Jochmann, published in the same journal in early 1939, again with Horkheimer's personal assent.[60] Finally, he wrote the clear copy of the *Theses* on the concept of history in the second half of February 1940[61] as a position paper in order to reach an understanding with the journal's editors about the theoretical premises of a second essay on Charles Baudelaire he intended to submit. The year before, they had rejected an earlier version of the first Baudelaire essay, making Benjamin completely rewrite it. Because the second was to form a chapter of an entire book Benjamin now planned to write about Baudelaire,[62] it was particularly urgent for him to make sure there would be no further disagreements about his approach.[63] Through his work on these three texts—"the Fuchs," "the Jochmann," and "the Baudelaire," as he was wont to call them—his most important contributions to the *Zeitschrift für Sozialforschung* during the years 1937–39, Benjamin developed the allegory of the historian in his ninth thesis.[64]

From Fuchs to Jochmann

In the first two sections of his essay on Fuchs, Benjamin addresses his subject's lifelong cultural-political activity on behalf of the workers' movement. Following Engels's critique of "bourgeois" cultural history, he validates the advance of "materialist" cultural history as a gain in the class struggle. He pictures the contest between both concepts of history with a militant terminology, using expressions such as "smash," "pierce," "detonate," and "blast," and envisaging an "explosion" of "bourgeois" cultural history undermined by cultural critique.[65] Benjamin's terrorist metaphors betray his attempt to transfer the revolutionary designation of the writer to the historian, who through his revolutionary understanding of history's destiny is capable of discerning its liberating potential.[66] Horkheimer's cool rejoinder, "Past injustices have happened and are finished. The slain are really slain. In the end, your statement is theological,"[67] may have come as a surprise to him, since nowhere in the Fuchs essay had he evoked a redress of past injustice. The editor had

taken Benjamin's "saving" metaphors for the recovery of suppressed historical testimony a bit too literally.

When Benjamin wrote his next long essay for the *Zeitschrift für Sozialforschung,* an introduction to his excerpts from Jochmann's *About the Regressions of Poetry,* he was able to address Horkheimer's objections. This essay contains the antecedent of the visual scenery where the Angel of History was to hover one year later:[68]

> [Jochmann] turns, as it were, his back to the future of which he speaks in prophetic words, and his visionary glance lights up at the sight of the mountain tops of earlier heroic human races and their poetry, which are receding ever more deeply into the past.[69]

Jochmann's text provided Benjamin with the critical metaphor of the Angel's frustrated intention to revive the dead: "Vanished ages stand rejuvenated before our eyes, and all the tombs of memory open up and return their dead."[70] Benjamin chose not to include this passage in his published excerpts, perhaps because Jochmann had by no means subscribed to its underlying restorative notion but on the contrary had rejected it as an irresponsible flight of poetic fancy he wanted to see surpassed by a rational, enlightened language suitable for political discourse. Benjamin collapsed these distinctions when he characterized Jochmann with Friedrich Schlegel's term of the historian—retrospective prophet—although he wished to contrast him with the romantics' yearning for the cultures of earlier times.[71] What made Jochmann "one of Germany's greatest revolutionary writers"[72] in Benjamin's eyes was that he did not shy away from calling poetry, and by extension artistic culture, a regression if it was written in disregard of social injustice better to be met by a nonpoetical, politically functional language of reason. Only in an emancipated society of the future did Jochmann assign poetry a nonregressive place.

If Benjamin called Jochmann—an author without public impact who had been all but forgotten until then—a "revolutionary writer," he cannot have used the term in the same sense as in "About the Present Social Position of the French Writer," where "revolutionary" denoted participation in the class struggle. Jochmann's political critique of art, taken on its own terms, may have adhered to rationalist ideals of the French Revolution, but it entailed no political activity, limited as it was to the demand that "spiritual" man should "abandon and unlearn" established culture.[73] Benjamin now revalidated the underlying contemplative attitude he had denounced as germane to "bourgeois" historicism in his Fuchs essay the year before.

This change in judgment allowed him to make Jochmann into a predecessor of his own critique of culture from before 1933:

> In the work of Adolf Loos a consciousness about the problematical status of art is forming which counteracts the aesthetic imperialism of the past century, the gold rush of art's "eternal values." Loos sheds light on Jochmann.[74]

Benjamin's reference to Loos recalls his essay on Kraus of 1931, in which he compared Loos, not to Klee, but to Klee's figure of the *Angelus Novus*. It also recalls "Experience and Poverty" of 1933, where he had directly related Kraus, Loos, and Klee to one another. In the ninth thesis Benjamin proceeded to transfer his characterization of Jochmann onto Klee's image.

From Jochmann to the Angel of History

When Benjamin pictured the *Angelus Novus* according to the metaphor of the prophet turned backwards, he darkened the scenery before the historian's eyes.[75] In the first of three drafts for the thesis he writes:

> The passage about Jochmann's visionary glance. . . . The visionary glance is lit up by the rapidly departing past. That is, the visionary has turned away from the future: he perceives its shape in the dusk of the past that disappears before him into the night of times. This visionary relationship to the future is by necessity part of the attitude, as defined by Marx, of the historian conditioned by the actual social situation.[76]

This draft, which does not as yet identify the subject, is still a confident transposition of Jochmann's "revolutionary" insight onto a description of the Marxist intellectual. In another draft, which takes a more comprehensive form and is inscribed with the title "The Present of the Possibility of Experience," Benjamin directly adapts Schlegel's designation of the historian as a retrospective prophet:

> The saying that the historian is a prophet turned backwards may be understood [thus]: the historian turns his back on his own time, and his visionary glance lights up at the sight of the mountain tops of earlier human races receding ever more deeply into the past. This visionary glance has its own time much more clearly present than contemporaries who "keep up" with the time.[77]

As soon as Benjamin identifies the subject as "the historian," he changes the scenario's time perspective. The subject no longer turns his back on the future, only on the present. This detachment allows him to recognize the present more adequately than being active in it. In both drafts, Ben-

jamin calls history no longer "heroic," as in the Jochmann essay, and not yet catastrophic, as in the *Thesis.*

In a third draft, Benjamin introduces a new, paradoxical time configuration: the "standstill" of the present that results from "past fatalities."

> Materialist dialectics cannot do without the notion of a present that is not transition but in which time . . . has come to a standstill. For [such a notion] defines just the particular present when history is being written at any point in time. [. . .] The historian is a prophet turned backwards. He perceives his own time through the medium of past fatalities.[78]

Marx's idea of a revolutionary end to history's seemingly inexorable course in the wrong direction is here being forestalled by a terminal stage where catastrophe is absolute and therefore permanent. The logic of this metaphor makes a critique of the present politically moot.

Less than a year after his self-assured transfer of "Jochmann's visionary glance" onto the historical perspective of the Marxist intellectual, Benjamin thus abandoned the designation of the materialist historian as revolutionary. His changing metaphors for the retrospective view of history in the drafts of the thesis betray this change of heart. The "mountain tops of earlier generations receding ever more deeply into the past," which Jochmann surveys from above like the wanderers enjoying the view in the foreground of Caspar David Friedrich's mountain landscapes, are still elevated points, fixed monuments that hold receding time, transposed into the vanishing space perspective, present and visible for the historian who has his attitude "defined by Marx." By contrast, "the dusk of the past which disappears . . . into the night of times" is only a dimmed illumination of the course of time as the past recoils into the dark, away from the historian stripped of his Marxist assurance. Finally, for the historian who merely thinks according to "materialist dialectics," history is a dire reiteration of "past fatalities," which would have to be halted to imagine a turn toward the better. The definitive text of the thesis yet surpasses the growing despondency of these metaphors. The correlated movements of landscape and subject are reversed. Instead of vanishing into the past, events propel themselves into the future, and the observer vainly strives to make his way back into the past. Such a course cannot be halted but carries the powerless subject along. He is transfigured into an angel who sees the more clearly the less he can act on his intentions.

The reversal of history that Benjamin's angel vainly wishes for recalls a text of Cendrars that was appended to his novel *Moravagine* as a fictitious film script found among its protagonist's papers after death. The script is called *The End of the World, Filmed by the Angel Notre-Dame;*[79] Cendrars had first published it in 1919.[80] He describes how an Angel of Notre-Dame sounds his trumpet to announce the world's end from the tower of Paris cathedral, whereupon the city collapses with all the cities of the world, burying people under its ruins. But the film reel spools back, the dead rise again, cities rebuild themselves, and the motion return beyond the present into the past, back to when the world was created from chaos. In the last section of the script, "Against the Grain" (*A rebours*), the film of world history is reversed once again. It runs forward with breakneck speed to the moment when the Angel of Notre-Dame puts the trumpet to his mouth. Here the frame is frozen.

There are no sculpted angels blowing trumpets on top of the two flat towers of the west façade of Notre-Dame in Paris,[81] only tourists behind the balustrades of the observation decks who survey the city on both sides of the Seine. Cendrars's scenario of the judgment angel filming recalls nineteenth-and twentieth-century texts, quoted in Benjamin's Baudelaire essays, about brooding writers who stare down onto the historic cityscape of Paris and imagine it in ruins:[82]

> Already [in 1831] the historian Friedrich von Raumer notes in his *Letters from Paris and France in the Year 1830:* "Yesterday, from the tower of Notre Dame, I surveyed the immense city; who built the first house, when will the last one collapse and the ground of Paris look like those of Thebes and Babylon?" [. . .]
>
> A hundred years after Raumer, Léon Daudet takes a look at Paris from the Sacré-Coeur, another elevated place in the city. In his eyes, the history of "modernity" up to the present moment mirrors itself in a frightening contraction: "From above one looks down on this agglomeration of palaces, monuments, houses, and barracks, and one gets the feeling that they are predestined for a catastrophe, or several, meteorological or social . . ."[83]

The eye that not only perceives historical time but mirrors it in a "frightening contraction" recalls the camera of Cendrars's angel. Different from the wistful historical vision of Daudet's mirror image, the film reel's forward and backward run depicts the end of the world as a social-critical grotesque about God, a cigar-smoking entrepreneur facing bankruptcy. It takes an act of sabotage to telescope the symmetrical visions of original and final chaos: "In his cabin, Abin, charged with oper-

ating the projector, sets fire to the machine. A fuse burns out. A spring cracks. And the film rewinds with dizzying speed."[84] Just as Cendrars distinguishes between the angel with the camera and the human projectionist, between the turning and the viewing of the film, Benjamin in his thesis distinguishes between the Angel of History and "us." Yet Benjamin does not reenact Cendrars's playful, anarchistic see-saw between the end and the beginning of the world. For the privileged witness in the sky and the myopic optimists on the ground, all deadly serious figures, the wind blows only in one direction, no matter if they perceive it as forward or backward.

For three years Benjamin thus steadily exalted the "revolutionary writer" to a contemplative distance high enough to sight deliverance. If from the survey of history deliverance was not apparent, Benjamin allegorized the wish for it as a recalcitrance against the course of history. In July 1935, Robert Musil, addressing the International Writers Congress for the Defense of Culture in Paris, used a similar allegory: "The angel of annihilation, who is hovering so close to all the grounds of the earth as never before, allows for no foresight."[85] At a time when Musil attributed his gloomy diagnosis of the present to his historical disorientation, Benjamin was still holding on to the political *parti pris* that allowed him a "revolutionary" perspective on current events. Now he too denied "foresight," yet was not ready to give up speculation. Through a utopian stabilization of historic judgment over and above all paradoxes, he maintained an intellectual posture in which will, if not faith, countered insight. Meanwhile, at the Institute for Social Research, Horkheimer had similarly stabilized a radical critique of society and culture into a philosophy and into a working program. Its categorical consistency was elaborated from myths and fiction of the past, rather than empirical data, exempt from any confirmation or refutation by present experience. Benjamin's Angel of History high in the sky, rather than close to the ground like Musil's angel of annihilation, became a guiding star on this course.[86]

Destruction and Salvation

Keep in mind, however, that Benjamin's angel was once an angel of annihilation too. When Benjamin wrote the thesis in its final version, he blamed destruction on history's anonymous course, but up to and including the drafts he actually hailed it as the harbinger of revolution. He

quoted the Russian terrorist Sergei Netshaev, the historical model for the ruthless conspirator Piotr Werkhovensky in Dostoevsky's novel *The Devils,* as a paradigm of the dissident intellectual's task "to cross revolutionary destruction with the thought of redemption."[87] By 1940, such a commonplace of revolutionary ideology would have led nowhere if taken literally. But in the writing of history, "destruction" and "redemption" could "cross" more easily than in the course of history, let alone in politics: "In a genuine historiography, the saving impulse is as strong as the destructive one." But from what can something that is past be saved?"[88] At last Benjamin had found an answer to Horkheimer's objection of 1937—"The slain are really slain."[89] He abstracted the notion of "saving" to a recovery of what dominant historiography has forgotten, passed over in silence, or suppressed. Yet even within the newly drawn borders between history and historiography he still held onto revolutionary dialectics:

> The interest which the materialist historian takes in what has passed is always in part a burning interest in its having elapsed, ceased, being thoroughly dead. To be assured about this is by and large the imperative precondition for any quotation (animation) of parts of this phenomenon.[90]

By adding "animation" in parentheses to "quotation," Benjamin still glossed over the distinction between historiography and politics. Only in the final thesis did he give up determining what ought to perish and what was worth saving. The Angel of History has no more "burning interest" in the catastrophes he sees.

The dialectics of the *Angelus Novus* posited in "Karl Kraus" of 1931 and in "Experience and Poverty" of 1933 was thus dissolved at last. In "About the Present Social Position of the French Writer," Benjamin had illustrated the destructive intellect's ambivalence about recording and wishing for destruction—the terrorist ambivalence of modern art "animated" by social dissent—with the quotation of Cendrars's bomb-throwing angels. Commitment to communism was to dignify that ambivalence with political responsibility. In "Experience and Poverty," Benjamin had deciphered the "dehumanized" names of Soviet New Man as professions of faith in the Five-Year Plan, the world-historical enactment of the intellectual's self-assured discriminations between what should perish and what should be built. In 1912, Paul Klee, discussing cubist still lifes, had asked: "Destruction for the sake of construction?" with no politics in mind.[91] In 1933, Benjamin styled the

abstract painter as a "designing engineer" of the communist New World who promoted a "positive notion of barbarism."[92] In February 1940, any such confidence in the political enactment of modern cultural critique was gone.

Still, destruction lingers in several of the *Theses on the Concept of History,* but it is now deprived of a constructive outcome. Kambas has read these texts as projections of a transition from world war to class struggle in the wake of Rosa Luxemburg's theory of revolution,[93] but in fact they are about historiography. Theses XIV, XV, and XVI all dwell on the word "blast." In Thesis XIV, Benjamin sets up Robespierre, the master of the guillotine, as a model for the "materialist historian" because he "blasted" ancient Rome "out of history's continuum" to make it into an ideological precedent of the French Revolution. According to Thesis XV, French revolutionaries would fire at church clocks "to blast open history's continuum." In both texts, the "materialist historian" maintains his destructive urge no matter how keenly the imaginary Angel of History wants to put things back. In Thesis XVI, finally, Benjamin writes about the "materialist historian": He "leaves it to others to spend himself with the whore called 'Once upon a time' in historicism's bordello. He remains the master of his strength: man enough to blast open the continuum of history."[94] Benjamin pictures "bourgeois" history of culture as a female sexual object for the deadly potency of the male radical intellect. In *One-Way Street* he had already placed before the section "Books and Whores" a motto from Mallarmé that likens the way a reader cuts open paper-covered books, in token of taking possession of them, to a virgin's bloody sacrifice.[95] Such a violent sexual metaphor for reading recalls the misogynist terrorism personified by Cendrars's Moravagine ("death to the vagina"), who as a youth confirms his maturity through the sexual murder of his bride, as a man becomes an artist by alternately studying music and killing prostitutes, and as a revolutionary leader avenges his pregnant lover's political betrayal by cutting the fetus from her womb. Cendrars's novel belongs to the fantasies of sexual murder recurrent in modern art, where the terrorist ideal of radical artistic self-fulfillment mimics as it denounces brutalized social relations.[96] Georges Bataille and André Masson heightened such fantasies into postsurrealist mythical images during the years Benjamin labored on his image of the Angel of History. For Benjamin, the humane alternative to Cendrars's bloody sexual posturing had been embodied by Breton and Nadja, who, as he wrote in 1929, jointly "redeem everything

. . . into revolutionary experience, if not action," jointly bring "the awesome forces of the 'mood' to the point of their explosion."[97] In "Agesilaus Santander" Benjamin still emulated this ideal by having the angel with his "claws" and "wings . . . sharp as knives" refrain from pouncing on the beloved. Now he let go of any humanized political eroticism. While the Angel of History, a sexless ideal, wishes to awaken the dead, the "materialist historian," a fierce male, broods on sexual murder.[98] Their disparity betrays the broken dialectics of salvation and destruction.

Baudelaire

The Angel of History, finally tamed to peaceable behavior, nonetheless preserves some of his Luciferian origins in "Agesilaus Santander." According to biblical tradition, an angel who has left paradise with mankind, and who works to stem the preordained course of history, can only be a fallen angel. Benjamin's reversal of the history of salvation into permanent catastrophe does not change this. His angel is even presumptuous enough to wish to singlehandedly undertake the task of redemption reserved for the Messiah.[99] Biblical angels, Jewish or Christian, are projections of the will of God and hence have no will of their own. In his texts of 1921 and 1931, it was orthodox of Benjamin to relate Klee's *Angelus Novus* to the throngs of angels who according to the Talmud perish after singing God's praise. But already in "Agesilaus Santander" the angel is disturbed in his chant, becomes derelict of his duty, and turns into an "Angelus Satanas." In the ninth thesis, finally, he quits paradise with humanity and turns from an enforcer of punishment into a witness for the defense.

The references in "Agesilaus Santander" to Baudelaire's ideal of Satan or Lucifer are well known. The angel as a menacing double of the lover on the prowl for the beloved is modeled on Baudelaire's poem "Le Revenant" from *Les Fleurs du mal*. He follows not so much the mere comparison in the plural, as in the original:

> Comme les anges à l'oeuil fauve
> Je reviendrai dans ton alcôve,[100]

but the personified metaphor in the singular of Stefan George's German translation:

> Einen engel mit wilden blicken
> Meinen schatten werd ich dir schicken . . . [101]

Benjamin's point is to renounce the poem's threat of a terrorizing power:

> Comme d'autres par la tendresse,
> Sur ta vie et sur ta jeunesse,
> Moi, je veux régner par l'effroi.

In a note to his Baudelaire studies, Benjamin takes the sonnet "La Destruction" in *Les Fleurs du mal*[102] as an erotic motto for a cultural critique, "whereby allegory itself makes the material world into shattered and disfigured fragments to become the mistress of their meaning."[103] But the sonnet deals with the demon of desire who first possesses the poet and then appears before him in the guise of women, just as in "Agesilaus Santander" the image of the guardian angel splits into male and female embodiments. The difference is that Baudelaire's demon of eroticism will not let go of his victim. The "bloody gear of destruction," the "soiled clothes, open wounds" on which the sonnet ends are the unequivocal spoils of the murderous debauchery to which he inspires the writer.

In his first essay on Baudelaire of 1938 Benjamin interpreted Baudelaire's satanism as an expression of absolute nonconformity without political articulation. Observing that the poem "Satan's Litanies" is the last piece of a cycle entitled "Revolt," he concluded: "Satan appears radiating in the glory of Lucifer: as the keeper of profound knowledge, as the instructor in Promethean skills, as the guardian saint of the stubborn and unyielding, . . . [as] the conspirators' father confessor."[104] In asking himself "what prompted Baudelaire to give a radically theological form to a radical rejection of those in power,"[105] Benjamin anticipates a question that his commentators habitually put to him in retrospect. His gradual transformation of the fallen angel from a destructive rebel into a healing genius, if only in the mode of futility, that is, in the historian's mode of contemplation, paralleled the rampant political disenchantment that drove him from enthusiasm for the Soviet Five-Year Plan in the summer of 1933 to horror about the Hitler-Stalin Pact in the summer of 1939. As long as he saw a chance of success for communism in the antifascist struggle, Benjamin admitted the destructive impulse transfigured by Baudelaire's satanic angel figure. When he no longer did, he replaced it with the impulse to save. In the "reversal [*contrepartie*] of Auguste Blanqui's world view: The universe is the place of enduring catastrophes" that Benjamin envisaged in his Arcades Project,[106] the figure of the saving angel could only be hypothetical.

Scholem has taken the final embodiment of Benjamin's angel figure as proof that his friend eventually returned from his Marxist convictions to a Jewish belief in a "messianic" view of history. Such a view is indeed advanced in Theses II, VI, and XVIII, and, more strongly still, in Theses A and B, which Benjamin eventually deleted from the collection. No matter how religious his messianic speculations, Thesis IX cannot be included among them, for the image of the saving angel does not follow the Talmudic conceit Benjamin related to Klee's *Angelus Novus* until 1933. In its reconfiguration with the angel in Baudelaire, the image has lost whatever religious authority it may once have carried for him. It became a mere *contrepartie,* a pictorial possibility for the literary imagination to think "against the grain." "Theocracy and Communism were to [Baudelaire] not convictions but insinuations which vied for his attention: the one not as Seraphic and the other not as Luciferian, as he probably thought."[107] This critical assessment of Baudelaire's tentative, if not erratic, way of thinking forestalls the judgment of recent commentators who have attempted to harmonize Benjamin's own unresolved ambivalence about "theology" and communism in their preference for the former over the latter. Benjamin did not call Baudelaire on his political and aesthetic vacillations to reconcile them for himself. In his retreat to the posture of the intellectual whose contradictory "insinuations" prompt him to study history in horror, he sided with another sentence of Baudelaire, quoted elsewhere:

> Lost in this wretched world, jostled by the crowd, I am like a weary man whose eyes looking backwards, into the depth of years, see nothing but disgrace and bitterness, and before him nothing but a tempest which contains nothing new, neither instruction nor pain.[108]

Thus the disheartened writer prowling the streets of Paris during the Second Empire set the scenario for Benjamin's pictorial allegory of the Angel of History. It was an appropriate mood for acknowledging the failure of political dialectics spun out of literature. Today we can make the same acknowledgment without grieving over the delusions whose loss it entails.

Appendix: Rededication of Paul Klee's *Angelus Novus*

No sooner was I done than the ceiling was cracking up indeed. Still from high above—I had misjudged the height—, in the semidarkness, an angel, wrapped with golden strings in bluish-violet sheets, was slowly descending on large white wings with a silky shine, stretching out the sword with his raised arm. "An angel, that's what it is!" I thought. "All day he has been flying toward me and I did not know it in my unbelief. Now he will speak to me." I lowered my eyes. But when I raised them again, the angel was still there, to be sure, hanging rather deep from below the ceiling which had closed up again, but he was no living angel any more, only a painted wooden figure from the prow of a ship, as they would hang from the ceiling in sailors' taverns. That was all. The knob of the sword was fitted to hold candles and to collect the flowing tallow. I had torn the light bulb down, in the dark I did not want to stay, a candle could still be found, so I stepped onto an armchair, stuck the candle into the sword knob, lit it, and then sat long into the night, under the angel's feeble light.

Franz Kafka, *Tagebücher,* ed. Hans G. Koch et al., II (Frankfurt, 1990), pp. 540–41, 25 June, 1914.

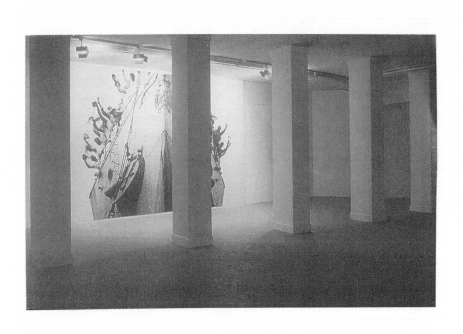

TWO

Eisenstein's Battleship Potemkin *Emerges from a Munich Underpass*

Battleship and Flight of Steps

In March and April 1988, West German photographic artist Rudolf Herz exhibited *Schauplatz* (Scene), a temporary photo installation, in a large showcase room of the pedestrian underpass connecting the Maximilianstraße and the Thomas-Wimmer-Ring in Munich. This exhibition space was and still is maintained by Munich's Municipal Gallery of Modern Art for a program to place contemporary art in the middle of city traffic, and therefore in the everyday environment of urban life. The name *Kunstforum* (Art Forum) denotes a public, civic space for art to be encountered and discussed.

For his installation Herz chose a still of the final tableau from Sergei Eisenstein's film *Battleship Potemkin* (1925). The still shows mutinous sailors waving their caps in a joyous salute as they pass the Tsarist Black Sea Fleet, whose sailors, rather than blocking their passage, fraternize with them. Herz placed a huge enlargement of the still, its black-and-white surface intensely lit by a string of glaring floodlights, behind a row of seven rectangular, crimson pillars. Following the practice of contemporary artists to act as their own conceptual commentators, he also published a statement to clarify his intentions.[1] Here he addressed Eisenstein's film as an "icon of the Russian revolution" and the makeshift pillar facade as a "hall of honor" (*Ehrenhalle*), a notorious feature of National Socialist state and party architecture. He thus explained his

work through the clash of two ideologically charged art-historical terms from mutually antagonistic political systems. Herz intended the resulting "montage of two theatrical fragments" to provide a critical perspective on the Soviet director's interpretation of his film in terms of Greek tragedies and temples.[2] The critical effect of his work depended on the segmented view of the photograph behind the pillars, and on the deliberately makeshift, transitory construction of plywood and cardboard. Both these features were to produce some kind of visual estrangement from, and thus a critical reflection of, the idea of revolution, the theme of Eisenstein's film.

The contradiction between the most dynamic motion picture of its time and its staging as a perennial monument was inherent in *Battleship Potemkin* from the beginning. The film ends with the accelerating advance of the battleship through foaming waves and a splashing wake, with the sailors on tense alert, ammunition in hand, guns and telescopes trained on the approaching Tsarist fleet. Pennants brandished by signal mates and rising on the rigging call out: "JOIN US," and the battleship cuts through the line of the fleet and through the screen, a giant juggernaut that overruns the audience. At the film's first showing 1 January 1926 at the Moscow Bolshoi Theater, when the black-and-white image faded and disappeared behind the red-and-golden curtains, spectators likely perceived the final scene as a picture within the frame of the stage, as observers of Herz's installation sixty-two years later viewed the still photograph behind the crimson pillars. One unrealized plan for the first showing of the film envisaged the canvas of the projection screen physically ripped down the middle to reveal a festive meeting of survivors from the 1905 revolution onstage.[3] But even without such a blending of image into reality, the film showing spilled over into a participatory, ceremonial event. Film team, actors, orchestra musicians, even ushers appeared dressed in uniforms of the *Potemkin* sailors.[4] The audience, like a choir of Greek tragedies, read the intertitles of the silent movie aloud through the accompanying triumphal music of the orchestra.[5]

This staging, monumental and dynamic at once, enacted the theatricality Eisenstein claimed for his work and characterized as "pathos":

> Pathos—this is what compels the viewer to leap from his seat. It compels him to leave his place. It compels him to shout and clap. It makes his eyes shine with delight, before they fill with tears of profound emotion. In one word, all that compels the viewer *to step out of himself.*[6]

By contrast, Herz's installation spoke to a contemporary disengagement from emotional compulsion that makes ideological conviction and aes-

thetic experience compound one another. The Munich pedestrians who in the spring of 1988 passed by his *Scene* may have cast a fleeting glance toward the illuminated window, may have stopped, even entered the showroom through the door to inspect the work. Yet they hardly had any ideological investment in the installation's theme. Herz's calculated, experiential setting, rather than precluding the elation that Eisenstein had intended, already certified its absence or loss. The artist, a committed left-wing intellectual and member of a well-known Munich Marxist circle—since self-dissolved under pressure of the federal political police—expressed the discrepancy between his traditions and convictions and the political atmosphere he saw prevailing in the Federal Republic of 1988. In subjecting a topical, politically defined aesthetic experience from the past to the disengaged, retrospective aesthetic experience of his time, he made his installation into a visual ideology critique. In this sense, the installation was functional. The theatrical styling as classical tragedy, as Greek temple architecture with claims to religious exaltation, on which the Soviet director had prided himself, was shifted into an aesthetic distance, both deepened and destabilized into an experimental reflection about its intended effect.

Sixteen years earlier, in 1972, I had written an article on the Marxist notion of ideology critique as it relates to art.[7] Herz quoted the article in his printed explanation of *Scene*. Hence, in 1990, when his installation, long after its demolition, was to be documented in a booklet, he invited me to write an accompanying text, which was published in 1991 and which forms the nucleus of the present chapter.[8] As I was writing it, the text turned from an explanation of Herz's work to a critique of it, which I debated with him in protracted discussions and correspondences, without altogether reconciling my views with his. He agreed to publish the text in his booklet only because he knew that in today's artistic and intellectual culture meaningful comment is bound to take a perspectival, that is critical, form. Our debate belongs itself to the process through which a work such as *Scene* comes into being, not simply as a spontaneous manifestation of the artist's creative idea, but through a sequence of initiatives, interventions, and negotiations among interested parties on the cultural scene and the public sphere: the Krupp Cultural Foundation, which provided Herz a fellowship to pursue his exploration of Soviet themes; the curator of the Munich Municipal Art Gallery, who controlled the selection not just of the artists, but also of the themes for the subterranean showroom; the interviewers, critics, and editors of the art trade press and the press at large, who made

the work known beyond its location and after the six weeks of its showing. The interaction of these initiatives, including the book I am writing here, constitutes the critical spectrum within which a work such as *Scene* unfolds.

What I missed in Herz's critical oppositions between past and present aesthetic experiences of *Battleship Potemkin* was the motif of the steps, so crucial for both Eisenstein's film and Herz's installation in the Munich underpass. The viewing situation of the passersby in the affluent West German city, as they streamed up and down the stairs, recalls Eisenstein's presentation of the well-dressed people of Odessa as they file down the broad stairway to the quay to welcome the battleship anchored before the port, promising revolution. Moments later, the Cossack Guards, slowly marching down those stairs in packed formation, break up this orderly mass movement with intermittent salvos. The West German public descending in 1988 to Herz's image of the battleship were citizens of a parliamentary democracy with thirty-nine years of constitutional continuity, participants in a market economy thriving on continuous capital accumulation since the end of the Second World War, beneficiaries of an administrative welfare state that mutually accommodated capital and labor. They were converging and diverging up and down the stairs in all directions, going about their businesses through the underpass, past the illuminated image of the triumphant revolutionary battleship from another country, another age. They did not suffer from despotic rule, did not have to fear oppressive measures, did not need to harbor revolutionary hopes. The ambivalent title of the installation—*Schauplatz* in German, which can mean either spectacle or venue—denotes the double distance separating, first, the historic event of 1905 from its ideological glorification in the film of 1925, and, second, the making and showing of the film in 1925–26 from the installation of the still photograph in 1988. The ambivalence is that the Odessa steps were the historic scene of a massacre, whereas the Munich underpass is no historic scene, but a viewing space abruptly placed into an everyday public environment. How had Herz in his installation related the appearance of the battleship to the steps and to the viewers? This was the question on which our debate centered.

Steps of Illusion

In reviewing Herz's previous work, I reminded him of two installations from the late seventies that addressed what I saw missing in *Scene:* a flight

of steps and a self-reflective orientation of viewers in their space. His photo installation *The Steps of Illusion, the Illusion of the Steps* of 1979 consisted of the photograph of a segment of the stairs leading up to the entrance hall of the Munich Art Academy. The photograph, enlarged to actual scale and placed over the very steps it pictured, visually blended into them for a viewer looking up at a certain angle. No one could walk on the segment of the stairs covered by the panel, yet the photograph showed traces of continuous use, dirty imprints of rubber soles, a discarded paper cup. Nine years later, I observed, Herz had exempted the stairs of the underpass from such aesthetic reflections about the movement of people, although the spatial relation of the four stairways with the cross of traffic lanes above lent itself to such reflections. The orientation missing here had been the theme of another of Herz's earlier installations: *Crossing Paths* (1980). It consisted of two narrow photographs printed on 11-meter iron plates placed crosswise on the high-water floor of the Isar River. The photographs showed a 360-degree view of the surrounding landscape, as far as the eye could see, taken exactly from the point of their intersection. A viewer standing upright and looking down on this crossing would have been in a position to raise his or her eyes and verify the photograph's topographical accuracy. Since no paths could be discerned in the surrounding area, the title *Crossing Paths* encouraged the viewer to proceed from the optical comparison between space and picture to an independent decision about which path to take.

The installation of *Scene* in the midst of a public space of city traffic provided no such clues for visual self-orientation, as they had been contrived in the aesthetic experimental settings of a West German art academy during the late seventies. In the underpass, large or small numbers of people would stroll or hasten in whatever direction, sequence, or speed past the illuminated showcase into which the artist had installed his pictorial reflections about an icon of revolution. Whenever they chose to enter the showroom, the seven crimson pillars obstructed their view of the film still. In his published explanations, Herz stresses this effect, which made the perception of the large tableau a piecemeal endeavor, unfolding in time, contrary to the instant panorama of the film still.[9] Viewers had to move back into the underpass in order to see the entire still behind the row of pillars in one glance.

Commentators on recent photographic art seem to agree about changes that have occurred in the artistic use of photographic materials between the seventies and the eighties. From conceptual reflections about photography as a medium and its ambivalent relationship to both

its subjects and viewers, artists have tended to move toward the effect-conscious staging of exhibited photographs as reflections on how photographic images are transformed by the act of their exhibition. By way of learned references to Denis Diderot or Roland Barthes, this development is grounded in eighteenth-century notions of theatricality and related to the self-staging reflexivity of postmodern art. Herz participated in this development[10] with his installations from the eighties, many of them devoted to a critical reflection on Soviet themes,[11] a left-wing artist operating in a postmodern artistic culture. The ensuing political contradictions informed our debates about my question "Where are the steps in *Scene?*"

The question is addressed in a story about which the participants still disagree, told to me by Helmut Friedel, then curator of the Municipal Gallery of Modern Art in charge of the Art Forum, who was responsible for the selection of *Scene.* As Friedel recalls it, the planning of the project took several years. Herz proposed various installations centered on Russian documentary photographs. One of these was taken on 4 July 1917 from a third- or fourth-floor Petrograd apartment. It shows a crowd of demonstrators under fire, dispersing in all directions over bodies fallen on the pavement. In Herz's planned installation, the photograph was to be asymmetrically split by a bulky crimson mockup of the wedge in El Lissitsky's famous poster *Beat the Whites with the Red Wedge* (1919), making it appear as if the Bolshevik symbol was crashing like a bomb into the crowd. One year later Herz realized the installation in his picture *The Red Wedge,* which hangs vertically on a wall. In the Art Forum the installation would have laid on the ground. Although Herz recalls having pondered and rejected exhibiting the work in the Art Forum, he denies that Friedel faced him with a choice between *Red Wedge* and *Scene.*[12] In any event, *Red Wedge* would have presented the passersby in the underpass with an image of mowed-down civilians, that is, the theme of Eisenstein's celebrated stairway sequence, to which the soaring prow of the victorious *Potemkin* is the triumphal counterpart. Here the artist would hardly have been able to avoid including passersby in his reflections about the visual impact of manipulated ideological imagery.

From a Failed to a Successful Revolution

The political theme of Eisenstein's film is the relationship between soldiers and civilians during the failed Russian revolution of 1905. Eisenstein asserted in 1925 that the *Potemkin* mutiny had been largely

forgotten as a significant event in the revolutionary history of Russia.[13] Yet in just this year the mutiny's revolutionary significance was the subject of a vigorous public debate in the Soviet Union. The most significant publication of this debate, V. Nevsky's *Uprising on the Battleship 'Knyaz Potemkin Tavrichesky,' Memoirs, Materials, Documents,* had been issued by the Soviet government in 1924.[14] Taking the form of a dossier of documents for an evaluation of the reasons why the mutiny eventually failed, Nevsky's publication featured a reprint of the book-length memoir by Konstantin Feldmann, the Social Democratic Party's organizer on board the *Potemkin,* first published in London in 1908.[15] In his memoir Feldmann subjects the mutiny to an implacably categorical critique from the standpoint of the party. Failure to coordinate it with the organization of striking workers at Odessa, he argues, forestalled a full-fledged local revolution that was to be carried out by the workers and protected by the battleship. In Feldmann's view, only workers are in a position to organize politically. In Odessa they did not prevail because of the oppressive surveillance under which they had to operate. And from the sailors they received no help. No matter how openly Feldmann acknowledges his and his activist comrades' errors of judgment under pressure, it is the sailors he indicts for their lack of revolutionary perspective and political resolve. In his account, First Shipmate Matyushenko, the protagonist of Eisenstein's film, behaves as a hero but does not act as a leader.[16] The sailors' revolutionary committee on board the battleship never operates consistently. In the end, rather than landing and taking the town, as Feldmann implored them to do, the crew took flight to Romania, leaving defenseless workers behind.

Nevsky's dossier takes partisan issue with the undeniable historical fact that during the Russian revolution of 1905 and 1906, mutinous soldiers and revolutionary civilians often worked at cross purposes, which was one of the reasons why the revolution was eventually suppressed.[17] It reaffirms the historic Social Democratic concept of a "revolutionary army" of armed workers led by the revolutionary party. Faced with the political determination of such a force, Social Democrats envisioned that the army's peasant soldiers would balk at defending Tsarist autocracy against the working class and come over to its side. This was the message of the proclamation issued by the *Potemkin*'s crew before their surrender at Constanza: "But the autocracy forgot one thing, namely that the army, that powerful prop of its bloody schemes—that this army is the same people that is resolved to attain its freedom."[18] In this case, however, political resolve had come too late. Since the mutiny of the

sailors against their oppressive officers had been a premature, and hence aborted, outbreak of large-scale rebellion planned for the entire Black Sea Fleet, Social Democratic leaders assumed that the army might indeed be made to spearhead revolutionary action. But during the rest of 1905 and in 1906 these leaders had to observe how mutinous soldiers continued to suppress civilian strikes and uprisings. Hence the party fell back on its doctrine of workers' unrest as the sole violent action apt for revolutionary change. Nevsky's book upheld the Social Democrat view of the *Potemkin* uprising as a case for the political primacy of civilian party organization in the pursuit of revolution.

What made for the difference between the failed revolution of 1905 and the victorious one of 1917 was the subversive mobilization of the army as part of the revolutionary proletariat. Since the October Revolution followed from Russia's defeat in the First World War, it seemed to confirm notions that defeat of autocratic regimes in war was a precondition for revolutionary victory, as outlined by Communist theoreticians from Friedrich Engels[19] to Rosa Luxemburg and Leon Trotsky. The crucial role of soldiers in the revolutionary upheavals of 1917, which culminated in the Bolshevik military takeover of an elected parliament, informed Lenin's new strategy of revolutionary warfare, which he had derived from his study of Carl von Clausewitz, the nineteenth-century Prussian strategist.[20] For a world revolution that would take the form of an "international civil war," the traditional socialist concept of a people's militia would not do. In such a war, the social disparity between soldiers and civilians, rooted in soldiers' peasant origins, would give way to their inclusion in a revolutionary proletariat along with workers. The Civil War of 1918–20, which pitted the Soviet government not just against internal insurrection, but also against foreign intervention, seemed to confirm Lenin's notion of revolution as an inevitable worldwide armed conflict between socialist and capitalist powers.

Thus was the Bolshevik doctrine of a homogeneous proletariat composed of workers, peasants, and soldiers as discrete social groups coalescing in a unified revolutionary force imposed as Soviet social policy. The attendant political validation of soldiers was continually adapted to changing domestic and international circumstance, from the military enforcement of collectivization on a hostile peasantry in 1929–30 to the military armament and strategic deployment of the civilian population against the German invasion during the Second World War. Ever since the European revolutions of 1848–49 were contained by autocratic governments relying on their armies to suppress their people, the deci-

sive function of the military in revolution has been consistently confirmed. Soldiers conscripted from the peasant or working class could be turned from an oppressive into a subversive force, making common cause with the revolutionary civilians they were deployed to hold at bay. By the same token, revolutionary governments could enforce their rule over the dissident political aspirations of civilians through a politically indoctrinated army, which is what has happened, more often than not, in the world history of communism. Both these variants of revolutionary politics have shown that military discipline can overrule, if not suspend, class solidarity as the driving motive of political action.

Revolutionary Drama, Military Doctrine

The historically variable political equation between soldiers and civilians within Communist revolutionary strategy underlies the dramatic juxtaposition of the battleship *Potemkin* and the Odessa flight of stairs in Eisenstein's film. The corrections Eisenstein made in this equation, compared to the events of 1905, are more trenchant than those pertaining to his one-sided selection of positive episodes, the only ones he has acknowledged. His is a "victoriously drawn picture of a defeat,"[21] an interpretative presentation of one historic event in light of an overarching world-historical dynamics, the "tendency" of history, that vindicates temporary failure as a sacrifice on the advance to final victory. When Eisenstein shows the *Potemkin*'s cannon hit the army officers' meeting place at Odessa, making the stone lions of the balustrade rear up and roar under the detonating shells, he anachronistically forecasts the cruiser *Aurora*'s shelling of the Winter Palace at Petrograd in October 1917. In reality the *Potemkin* sailors refused to shell Odessa with live ordinance and merely fired blanks. Eisenstein's political harmonizing of the relationship between soldiers and civilians is at odds not only with the historical record, but also with Nevsky's semi-official critique of the *Potemkin* mutiny drawn from the account of Feldmann, the party organizer acting on the scene. Eisenstein shows nothing of the political agitation by Social Democratic Party activists who came aboard the *Potemkin* nor of the subsequent, futile efforts of Feldmann and his comrades to goad the sailors into supporting the revolt ashore. He thus omits the give-and-take in the formation of revolutionary sentiment between soldiers and civilians, between the ship and the town. The absence of party direction underscores the sailors' own revolutionary determination, which contrasts with their political disorganization, indecision,

outright counterrevolutionary resentment, and fear, according to the record assembled in Nevsky's book. Feldmann writes that First Ship Mate Matyushenko was no political activist, not even a Social Democrat, yet Eisenstein pictures Matyushenko as a deliberate conspirator and then a determined leader who takes command of the ship, which he never did. Conversely, the well-documented strikes and uprisings of the Odessa workers that were underway when the *Potemkin* moored before the port are never shown.[22] The revolutionary initiative emanates entirely from the military, to whom the civilians, a classless mix with few workers—hardly a show of "cross-class solidarity,"[23] as has often been remarked—flock in admiration. When the Association of Revolutionary Cinematography screened *Battleship Potemkin* before an audience of workers in 1926, "a miner named Shipukov found the 'happy' ending in which the mutineers appear victorious 'unrealistic,' while one Povesky wondered about the absence of revolutionary organizations from the picture."[24] Whereas Shipukov merely noted the obvious, Povesky voiced a political critique that touched upon the core of the revolutionary message carried by the film.

How closely that message was tied to current revisions of Soviet military policy becomes apparent in the switch of introductory epigraphs in *Battleship Potemkin* between 1926 and 1930.[25] The original epigraph reads:

> The spirit of insurrection hovered over the Russian land. Some enormous and mysterious process was taking place in countless hearts. The individual was dissolving in the mass, and the mass was dissolving in the outburst.

There follow five shots of waves crashing onto a breakwater. The text is taken from Leon Trotsky's often reprinted article "The Red Fleet," part of his book about the 1905 Revolution, *The Year 1905,* which appeared in 1922.[26] The text goes on:

> Each day brought to their feet new strata [of society] and gave birth to new opportunities [for revolution]. As if some gigantic pestle were stirring a social cauldron down to the very bottom.

Here Trotsky defines revolution as a social movement transcending and unifying all segments of the proletariat, or even the populace, with no one segment in the lead. He ultimately ascribes the defeat of 1905–6 to a lack of political analysis and direction in an overwhelming but diffuse revolutionary sentiment. In his view political leadership, and hence responsibility, falls to the party. This is the revolutionary morality advanced in Nevsky's government-sponsored documentary account of 1924, at a time when Trotsky was commissar for war. In January 1925, Trotsky re-

signed, and on 19 March 1925 the Central Committee authorized the production of Eisenstein's film.

The new epigraph was taken from Lenin's article "Plan of the St. Petersburg Battle," published 31 January 1905, five months before the *Potemkin* mutiny:

> Revolution is war.
> It is the only legitimate,
> reasonable, just, really great war
> of all the wars
> that history has known.
> In Russia this war has been declared and begun.

The substitution did not merely cancel the authority of Trotsky, who in the intervening years had fallen from power. It replaced Trotsky's sense of revolution as a socially indeterminate mass movement with Lenin's principles about the military preconditions of revolution, which the Social Democrats of 1905 had disregarded to their peril. In 1918 Lenin had fashioned this principle into philosophical and political theory, defining the Bolshevik revolution, in contrast to that of 1905, as a worldwide protracted struggle-in-arms against capitalism. The new epigraph for Eisenstein's film fits its presentation of revolution in military terms, in line with the original epilog, also derived from Lenin:

> The battleship *Potemkin* . . .
> remains an unconquered area of the Revolution.
> An attempt to form the nucleus . . .
> of revolutionary armed forces has been made.
> The whole of Russia . . .
> the whole world now knows . . .
> that the Revolution . . .
> may enlist the support of the armed forces.

In 1905, these words may have proclaimed no more than the revolutionary consciousness of soldiers that will make them renounce their repressive function on behalf of state authority and go over to their own class. Now, read as a sequel to the new epigraph inserted at the start, they proclaimed world revolution to be a global warfare led by Soviet power.

Eisenstein himself has called *Battleship Potemkin* one of the first artworks of the "New Economic Policy,"[27] which the government declared after 1921 to rally middle-class support for the Soviet Union's economic recovery from the Civil War. He deliberately made his theatrical concept of emotional film experience play to middle-class conventions of sentimental identification, just as he took care to preserve a coherent pictorial perception of the film no matter how dissolved or telescoped by the montage technique. *Battleship Potemkin* was the para-

digm of an emotion-laden presentation of revolutionary spirit for such an audience. It even affected the "classical" form of a five-act drama. Accordingly, the topicality of the film for its own time had nothing to do with historic class analysis of revolution. Before the film was released to the general public, sometime between December 21 and 26, it was shown to the full membership of the Fourteenth Communist Party Congress who, as Eisenstein contentedly stated to the press on 1 February 1926, rated it "successful, unanimously and with no objections."[28] This was the same congress that had just ratified the "military doctrine" of newly appointed War Commissar Mikhail Frunze. Its resolution to take "all necessary measures to bolster the strength of the Red Army and Navy,"[29] elevated Lenin's theory of an inevitable conduct of world revolution by means of international warfare into a policy of national defense, and set the build-up of an arms industry as the ultimate geopolitical goal for the projected industrialization of the country. Frunze's military doctrine made Bolshevik revolutionary ideology the guiding principle of economic planning predicated on a long-term correlation of political and strategic theories. Frunze's predecessor Trotsky had been averse to making military strategy part of policy decisions, which would have given soldiers a decisive say in party matters. After Frunze, then Trotsky's deputy, first prevailed with his own policy and then replaced Trotsky in January 1925, Soviet military doctrine drew on the expertise of professional soldiers in formulating a political strategy of world revolution. In the public realm of political culture, the doctrine entailed a sustained propaganda effort of casting revolutionary into military sentiment, into public enthusiasm for the military as the role model for revolutionary fervor. It is this "militarized socialism"[30] that Eisenstein, in his glorification of sailors as the determined leaders of revolution, brought across in a near-absolute pitch to excited viewers.

And yet, the principled opposition between the battleship as the scene of revolutionary resolve and the flight of steps as the scene of revolutionary defeat haunted Eisenstein in later critical discussions of his film. In 1931 it served the critic Ivan Anisimov as the dialectical scheme for a trenchant ideology critique.[31] Anisimov was already heeding the growing political regulation of the arts after three years of Soviet debates about a Communist art committed to the propaganda of the Five-Year Plan. He noted the disparity in the expression of revolutionary consciousness on the part of Eisenstein's sailors and civilians. Only in the middle-class crowd streaming down the stairway of Odessa toward the port, he maintained, had Eisenstein succeeded in making revolutionary

consciousness apparent in the diverse feelings of individuals. The proletarian sailors, on the other hand, performed their revolutionary and military actions in choreographed group movements as if obeying orders. Herein Eisenstein still proved to be a "petty-bourgeois" sympathizer according to Anisimov, not a truly "proletarian" artist. Anisimov's critique entailed the charge that the director had not succeeded in making the militarization of socialism from a professional military posture into a heartfelt expression of political enthusiasm. It was just this expressive difference between soldiers and civilians that became the formula of triumph once *Battleship Potemkin* was shown in Germany and Western Europe. Here, the "petty-bourgeois" enthusiasm of the class-transcending crowd on the Odessa steps mirrored the mindset of dissident audiences, of workers and intellectuals alike.

"That Feeling of Assent and Triumph"

The international distribution of *Battleship Potemkin* was collaboratively managed by the propaganda division of the Communist International Workers' Aid in Germany and several state-owned Soviet film production companies.[32] Thus was the film's launch on the German and Western European market inserted into the cultural policy of the Comintern and its long-term strategy of world revolution. Protracted efforts by Western European governments to censor the film seemed to validate its political mission, by making the mere demand to screen *Battleship Potemkin* into a political cause for the Communist Party and for sympathizing working-class organizations. Censorship of the film generated a political sentiment that projected the struggle on behalf of the film onto the revolutionary struggle as a whole, and in the name of artistic freedom. With left-wing intellectual audiences in particular, such a sentiment touched upon a tenet of modern art: the transfiguration of the public success of artworks with dissident content, against conservative resistance, into political breakthroughs. In 1939, Eisenstein himself voiced this commonplace of the avant-garde by celebrating his film's worldwide success as a revolutionary victory:

> Over the heads of the battleship's commanders, over the heads of the admirals of the Tsar's fleet, and finally over the heads of the foreign censors, rushes the whole film with its fraternal 'Hurrah!,' just as within the film the feeling of brotherhood flies from the rebellious battleship over the sea to the shore.[33]

When in 1926 Paul Levi, the attorney acting on behalf of *Battleship Potemkin*'s German distributor, brought a successful court challenge

against the German Film Censorship Office's efforts to ban the film, he presented a political argument against such ideological self-delusions. He pointed out that an uprising with no guidance by a Communist Party organization, such as is depicted in the film, was at variance with Lenin's revolutionary strategy. The socially indeterminate crowd on the Odessa steps, he insisted, consisted mainly of middle-class citizens, not rebellious workers.[34] The German lawyer thus turned the political critique of the Soviet miner Shipukov into an apology for the film's suprapolitical transcendence. Exempted from political orthodoxy, *Battleship Potemkin* could be featured as a mere revolutionary spectacle.

Testimonies from the Communist workers culture of the Weimar Republic speak to the aggressively militant political resolve sparked by Eisenstein's image of the revolutionary battleship. In Berlin, within six weeks of the film's opening, a Red Front workers' group rented a steamboat, painted the name *Potemkin* in large red letters on the prow, and sailed down the Spree River on a summer weekend. They were headed for the town of Beeskow where a year before Reichswehr soldiers, in a political brawl, had tried to wrest a red flag from them. Steaming past fisted salutes of fellow-workers lined ashore, the Red Front activists flew the tattered flag from the prow of their makeshift *Potemkin,* determined to carry the flag back into Beeskow, as if Beeskow were Odessa all over again.[35] When the film was screened in the miners town of Johanngeorgenstadt, two young Communist workers built a large-scale model of the battleship and paraded it on a horse cart through the town, donning Red Army uniforms and carrying a banner inscribed "Hands off the Soviet Union!" Two years later, they trotted the model out once again, this time in protest against the construction of two battleships planned by the German government,[36] as if those projected vessels were the Tsarist fleet on an imaginary horizon.

The enthusiastic response to *Battleship Potemkin* on the part of German liberal intellectuals—by no means solely Communists or Communist sympathizers—was essentially different from such straightforward working-class identifications with the Soviet Union. That response hinged on the equation between the film's overwhelming artistic effect and the irresistible advance of the revolutionary cause it pictured, which was experienced as all the more compelling since the story was taken for the historic truth. The belief that successful defiance of the film's censuring by the authorities reenacted, as it were, the revolutionary triumph of the sailors on the screen, suited the ideological mindset of middle-class artists and writers longing for political validation of artistic

achievement. The film director Friedrich Wilhelm Murnau confessed to having been so aroused by his viewing of the film that "he was ready to grab his revolver, rush into the fray along with the sailors, and fire away."[37] The writer Lion Feuchtwanger published a story about a reactionary police chief who inspects the film before having it banned and who finds himself swayed to root for the revolutionary cause, against his better judgment.[38] Left-wing intellectuals who opposed capitalism from within a capitalist society, with no apparent chances of overturning it, saw *Battleship Potemkin* as a paradigm for the axiomatic Communist distinction between temporary setbacks and future victories. Such a distinction was essential for keeping their ideological faith, anchored as it was in their claims to possess an "objective" view of history, to be upheld for the long term, over and against the historical experience of the present time. After their parti-pris for Communist revolutions beyond the Soviet borders during the first three years after World War I was disappointed, the existence of the Soviet Union as the one state with a successful socialist revolution—"the first," they thought—compensated for their lingering political malaise at home. In *Battleship Potemkin,* they applauded not just revolution but the Soviet state. For some of these intellectuals, the axiomatic connection between the revolution and the Soviet state was suspended after the Moscow show trials of 1936–38 but mostly recovered after the Soviet armies' defeat of National Socialist Germany in 1945 and the U.S. nuclear challenge to the Soviet Union after 1948.

It was in the assurance of such convictions that Walter Benjamin, writing in 1927, expressly disregarded Eisenstein's historic license and applauded the film for being "ideologically cemented, correctly calculated in all details, like the span of a bridge."[39] Benjamin equated Eisenstein's artistic breakthrough with the revolutionary "tendency" in the "representation of a class movement shaped in a severe and principled manner." This sounds like an aesthetic transposition of the *Potemkin* sailors' revolutionary discipline and military resolve. Confusing the *Potemkin* revolt with another Black Sea Fleet mutiny in November 1905 led by a Lieutenant Schmidt,[40] Benjamin asserted that Eisenstein had omitted this officer in the film so as to enhance the collective pursuit of the mutiny. What Benjamin did not address was the prominent role of political leadership Eisenstein assigned to First Ship Mate Matyushenko in the film, at variance with the facts. In the end, what he determined to be the revolutionary form of Eisenstein's film, not the specifics of its content, guaranteed to him its truth. Adapting Eisenstein's own defini-

tion of the word "tendency" from a press release by the Soviet director in the *Berliner Tageblatt* of 7 June 1926,[41] Benjamin ascertained a flawless fit between *Battleship Potemkin's* montage technique and the historical dynamics of the class struggle. Benjamin's friend Bertolt Brecht, in a poem of about 1930, evoked "that feeling of assent and triumph, which moves us before the images of rebellion on the battleship Potemkin," and admonished his readers "not to waste a thought on what cannot be changed" but rather to yield to "the irresistible seduction of the possible and the severe joys of logic."[42] Just as Benjamin's "tendency," Brecht's "logic" was to project the future course of history in defiance of the present. Reversing the Marxist founding of political judgment on historical experience, both German authors validated political speculation as the ideological principle of artistic form. This ideologically predetermined aesthetics has styled the cultural-revolutionary worm's eye view on the prow of the battleship *Potemkin* with its waving sailors, which Herz was to freeze in his 1988 installation.

The Bottom of the Air Is Red

In 1977 French filmmaker Chris Marker produced the four-hour-long film *Le Fond de l'Air est Rouge,* which in 1988 was re-released as a video feature under the title *Grin without a Cat.* The film is a montage of documentary material about worldwide historical events that during the years 1967–76 appeared to herald revolutionary changes in capitalist states: the guerrilla war in Venezuela, the Paris student rebellion, the Communists' brief democratic regime in Czechoslovakia, the cultural revolution in China, the popular front government in Chile, and the neocolonial war in Vietnam. The same decade saw a transitory military détente between the two nuclear superpowers that ended with the political stabilization of capitalist democracies in the West and socialist party regimes in the East. The détente reestablished a worldwide strategic balance to be upset again in the Second Cold War. When Soviet President Leonid Brezhnev, in his speech at Tula of January 1977, recognized the geopolitical status quo as the basis of Soviet defense policy,[43] the Soviet Union stood discredited as a leading revolutionary power in the eyes of its Western sympathizers. Many of these turned to the People's Republic of China, to the Viet Cong, and to other third-world liberation movements for new, seemingly more radical, ideals of revolution, soon to be disappointed in turn. Marker documents this decade of inconclu-

sive political upheaval through dramatic if stereotypical film clips: tanks moving into position, lines of soldiers in battle dress, assault rifles pointing up for safety, massed police units with visor helmets charging crowds with tear gas and batons, demonstrators reeling under their blows, coffin carriers, their fists defiantly raised, in funeral processions.

Marker's film opens with a female voice-over reminiscing about *Battleship Potemkin*. The speaker evokes the scenes of the sailors' round-up on the stern for execution, Vakulintchuk's call to refuse fire, with the intertitle "BROTHERS!" flashing over the entire screen, and of the tent ashore, where the killed mutiny leader is laid out for the population to pay their respects. Then a funeral march sounds to a breathtaking montage of shots from Eisenstein's film. The outrage of the people at Vakulinchuk's bier, and the massacre of the Odessa steps, are interspliced with documentary footage from 1968–72 that show police and troops breaking up popular demonstrations, irate protesters shouting at them, speakers haranguing crowds, and mourners filing past the dead. A young Soviet Intourist interpreter is interviewed sitting on the Odessa steps, oblivious to their historic monumentality. Marker's flashbacks to *Potemkin,* by contrast, put the visual record of recent events into the continuity of a revolutionary history. But his montage of images of angry or suffering civilians lacks revolutionary confidence. The images only express the rage against the superior strength of those in power. At the beginning of Part Two, the sullen expression of a young Soviet tank commander, emerging from his hatch to face Czech citizens' angry recriminations on a Prague street in August 1968, is interspliced with Vakulinchuk's determined outcry and the silent intertitle "BROTHERS!"—the word filling the entire screen—in a display of bitter irony.

Marker's world-historical survey of revolutionary movements during 1967–76 is woven from four distinct trajectories of left-wing politics: strategically isolated and politically disoriented guerrilla wars; rhetorically overdetermined cultural revolutions with no political goals; socialist governments frozen in power without popular support; and cynically maneuvering Communist parties in capitalist states that will disown spontaneous rebellions they cannot keep under their control. The four trajectories neutralize one another. For the media consciousness of world opinion, the ensuing stalemate is personified in the ambivalent relationship between Fidel Castro, the shifty Communist dictator pursuing global politics, and Che Guevara, the self-sacrificing guerrilla in the jungle who dies a Christ-like death in revolutionary pu-

rity. The solitary guerrilla in Latin America, with neither popular support nor Communist backing, proves no match for the counterinsurgency tactics of American officials who have him hunted down. Marker did not have to address the issue of mutinous soldiers, since throughout the decade the military stayed on the side of power. His film is a threnos to the suppression of civilians, the opposite of Eisenstein's paean to a soldiers' revolution.

Marker's counterpoint of documentary reportage and sarcastic voice-over comes to a head in his portrayal of a Belgian medieval pageant in which folk dancers disguise as giant cats. Marker features it as the parody of politics, which stages public spectacles of enforcing power as programmed documents of history. The heartfelt revolutionary sentiment as filmed in scenes of confrontational outcries and tearful funeral marches becomes an involuntary stereotype. Played out on, or for, the television screen, these scenes reenact Eisenstein's drama on the Odessa steps, already anticipating the inexorable squelching of protest, just as in Greek tragedies the choir has a license to bewail the blatant lack of justice in predetermined fate. In a sequence that gave the title to the British television re-release, Marker intersplices the antics of the Belgian folk dancers in cat's costumes with Eisenstein's trick sequence of three lion sculptures on pedestals at the gate of the shelled military headquarters at Odessa, carved in variable positions, and sequentially telescoped in the film as if they are rising up to roar. Marker's own montage illustrates the performative futility of cultural revolutions. He has not used Eisenstein's concluding apotheosis on the prow of the battleship, the theme of Herz's *Scene*.

Marker produced his film in time to match the political sobering-up of left-wing intellectuals setting in at the end of the seventies. In 1978, Herbert Marshall, the British filmmaker and left-wing activist, who during the thirties had gone to the Soviet Union to study with Eisenstein and had later promoted Eisenstein's work abroad, published a book-length political critique of *Battleship Potemkin*.[44] Disabused of his enchantment with the Soviet Union under Stalin, he disavowed the film as a propagandistic deception, as a quasi-religious celebration of doctrine. "But instead of static icons, these were dynamic films," Marshall wrote exasperatedly. Two years after Marker's feature, the film historian D. J. Wenden first confronted Eisenstein's fictional revolutionary story with a critical reconstruction of the historical events.[45] Had Wenden's work been read more widely, the film's political credibility would have been impaired already at that time.

And the Ship Sails On

Six years later, the Italian director Federico Fellini created the film *And the Ship Sails On*. It was first screened on 10 September 1983, at the height of the renewed nuclear stand-off between NATO and the Warsaw Pact. In the Federal Republic and in England, U.S. Pershing missiles were being deployed, and Soviet President Yuri Andropov had responded with a threat to convert the Iron Curtain into what he called "a missile palisade." A "hot summer" of mass demonstrations against the missile installations, contained by masses of riot police, had just gone by. Fears of an impending world war were running high. In this situation, Fellini, ostensibly concerned with nothing but his customary representational and aesthetic explorations of film, and of art in general, presented a tale about art confronting war, casting modern art's traditional ambivalence about its revolutionary potential in the comic mode.

The film is set during the last days of July, 1914, when the First World War was breaking out. A party of opera singers, directors, conductors, musicians, impresarios, and buffs have chartered a luxury liner, the *Gloria N.*, to bury the ashes of the greatest soprano of her time at sea, before the shores of the Adriatic island where she was born. During the voyage the captain is obliged to take aboard a throng of Serbian peasants and students who have taken to sea in small boats off the Serbian coast to escape the Austrians who have invaded the country in response to the Sarajevo assassination. An Austrian battleship intercepts the luxury liner and demands the refugees' surrender. As the lifeboats of the *Gloria N.* are shipping them over, one of the Serbian students hurls a hand bomb into the gun bay of the battleship, which retaliates with all its cannon, sinking the musicians' ship. At this point in the action, Fellini presents the viewer with no less than four possible conclusions.[46] In the first, the artists' party goes down defiantly, singing at the top of their voices. In the last conclusion, however, they step forward on deck of the sinking ship, like soldiers in tight formation, and their fierce chant makes the battleship explode and sink. As a militant avant-garde, determined to face down the armed forces of oppression, they embody the ultimate ideal of modern art.

Fellini's repeated assertions that he never saw films by the great directors of the past[47] read disingenuous, given the similarities between *And the Ship Sails On* and *Battleship Potemkin*. (Fellini did consider opening his next film, *Ginger and Fred,* with an image from a classic, *Battleship Potemkin* being among his choices).[48] When the Austrian battleship first

confronts the *Gloria N.,* a close-up shows its name written across the prow in indecipherable Cyrillic letters, perhaps the modern artist's way of simultaneously marking and covering his tracks. The entire sequence of the confrontation at sea is a detailed reenactment of the face-down between the rebellious *Potemkin* and the Tsarist fleet at the end of Eisenstein's film. Here is the silhouette of the battleship that looms on the horizon like a giant building in the cold dawn; the actors in their bunks, jumping to their feet to rush on deck; the straight signal mate on the bridge brandishing his colorful flags; the mechanized ammunition lorries inside the gun bays, moving packs of ordinance quickly into position. Just as in *Potemkin,* the confrontation at sea is about whether the intercepted ship will be allowed to sail on. Only the outcome is reversed, despite Fellini's hyperbolic title. The flag signals from the bridge and on the masts do not announce the ceasing of hostilities, fraternization of adversaries, and free passage, but the implacable pursuit of an armed mission. In the final tableau on the prow of the *Gloria N.,* exalted, idiosyncratic opera musicians take the place of Eisenstein's disciplined sailors as the heroes of resistance. Dressed in black evening gowns, overcoats and white scarves against the stiff morning breeze, they assemble to sing the final choir from Verdi's *Force of Destiny* in a furious confrontation with the battleship on the horizon. Artists side with refugees and anarchistic bomb-throwers, share the fate of the oppressed. Coal-smeared stokers deep in the damaged hull, the waters rising fast, join in the opera stars' *fortissimo,* confirming the class-transcending force of art to challenge power.

Unlike Eisenstein, and just like Marker, Fellini associates soldiers with oppression rather than revolution. If Marker's revolutionary counterfigure is the guerrilla in the jungles of Venezuela talking to the television camera, submachine gun in hand, Fellini's is the bomb-throwing student and lover, a projection of the unarmed but militant artist. Embracing a beautiful girl, Fellini's student bests the battleship's cannon. "Are we really sure it was the youth who tossed the bomb?" asks the perplexed Orlando, the reporter-historian aboard the *Gloria N.* "If he was living a love story, why would he run toward destruction?"[49] Orlando might have read the answer in the Second Manifesto of Surrealism, in which André Breton extols the convergence of love and revolution.[50] Walter Benjamin, who in 1933 timidly embraced this convergence (see p. 21), needed the high-handed assurance of Communist theoretical discipline to give it political validation. "Their unsettled economic status matches their political function," he wrote of terrorists still in 1935.

"This appears most tellingly with professional conspirators, all of whom belong to the Bohème. [. . .] The Communist Manifesto puts an end to their political existence. Baudelaire's poetry draws its strength from the rebellious pathos of this social stratum. He sides with the social outsiders."[51] While Benjamin may have felt he was in a position to outdo Baudelaire in political determination on the strength of the Communist Manifesto, Fellini in 1983 reenacted Baudelaire's artistic partis-pris.

Raymond Williams recalls that August Strindberg, in 1882, "had declared that in a time of social eruption he would side with those who came, weapon in hand, from below. In a verse contrasting Berthold Schwarz, the inventor of gunpowder—used by kings to repress their peoples—with Nobel, the inventor of dynamite, he wrote:

> You, Swartz, had a small edition published
> For the nobles and the princely houses!
> Nobel! you published a huge popular edition
> Constantly renewed in a hundred thousand copies!

The metaphor from publishing makes the association between the radical, experimental, popular writer and the rising revolutionary class explicit."[52] But at a time when in politics both gunpowder and dynamite have been superseded by the nuclear charge, the metaphor no longer holds. Hence Fellini has kept his anachronistic persiflage of revolutionary art in a historic scenario from the past deliberately hypothetical. "I have no temperament of a revolutionary . . . I need order because I am a transgressor," he has said of himself.[53]

From World Revolution to World Peace

In 1988, when Herz exhibited his *Scene,* public culture in Western Europe was no longer spellbound by the threat of war. The new Soviet defense policy initiated under President Gorbachev had canceled the political equation between war and revolution underlying the artistic ideology of *Battleship Potemkin*. War Commissar Frunze's military doctrine, which had envisioned the triumph of revolution as dependent on victory in the inevitable world war between socialist and capitalist states, could no longer be sustained. The aggressive, militaristic propaganda designed in the Soviet Union to orchestrate implementation of this doctrine, beginning with Eisenstein's film, generally emphasizes its defensive origins. Despite the offensive strategic, tactical, and operational planning it required, the doctrine never stipulated military expansion as a means of world revolution, only as the forward defense of the Soviet

Union under an anticipated attack by the capitalist industrial states.[54] It still determined Soviet defense policy between 1941 and 1956 under the impact of the German invasion and the subsequent U.S. nuclear threat. It was the strategic goal of withstanding global nuclear war that prompted Soviet plans of overrunning Western Europe so as to deny a bridgehead to U.S. forces moving into striking distance for a nuclear assault.[55] The growing awareness that nuclear war was not winnable for either party prompted the political leadership to change this goal for that of preventing war through negotiated strategic parity.[56] But the unexpected upset of such parity by NATO's installation of intermediate-range missiles in Europe since late 1983 and the development of the Star Wars anti-ballistic defense system in the United States eventually put the Soviet economy under so much strain that even last-minute unilateral disarmament could no longer prevent a disintegration of the social order. Thus ended the "militarized socialism" extolled in *Battleship Potemkin.*

As Soviet critical culture became self-emancipating under *glasnost* on the heels of these historic changes, it was not slow in updating its appreciation of Eisenstein's film. In June 1988, the All-Union Party Conference ratified the revisions in Soviet defense policy that gave priority to political over military solutions to global conflicts.[57] The resulting ideological revisions were certified at the International Conference on the Contemporary Concept of Socialism held in Moscow in late July and early October 1988.[58] And in due course, on December 7 of that year, the film research group of the Institute of Visual Arts followed through with an Eisenstein conference, during which *Battleship Potemkin* was subjected to a trenchant ideology critique.[59] Now the compelling power of ideological persuasion sustaining Eisenstein's notion of revolutionary art was rejected as totalitarian propaganda:

> Is it coincidence that Goebbels demanded of his artists 'the National-Socialist Battleship'? Is art a machine for emotional and ideological enslavement, psycho-technics—and psycho-training?[60]

With such rhetorical questions, Soviet film historian Oksana Bulgakova declared Eisenstein's art form obsolete for the critical thinking of a socialist democracy she envisioned. Nine months earlier, Rudolf Herz, with the installation of his *Scene,* had reached a similar conclusion.

To appreciate the topical coincidence of Herz's work with the revisionism of Soviet film critique, we may recall a fundamental feature of the critical culture, artistic and intellectual, in the capitalist democracies of the eighties, that is, this culture's failure to perceive, let alone antici-

pate, the rapidly accelerating terminal phase of the Second Cold War, which ended with the dissolution of the Soviet Union in December 1991. My own book *Citadel Culture* (1991) also fell short on this point. In retrospect, it appears as if the obsessive sensitivity to the threat of nuclear war, the venue of the final showdown between the two power blocs, made for an aesthetic and ideological urgency that hampered political analysis and judgment. Yet during the years 1985–89 Herz was at work transposing Soviet photographs and artworks from the revolutionary years into cool, enigmatic, or satirical installations such as *Scene.* The political dynamics of the ongoing process of Soviet decline, as long as it was not being judged with doctrinal certainty from either Left or Right, at best could be gauged dimly. That no certainty is apparent in Herz's works of 1985–89 enhances the intensity of their visual impact and may be part of the strength of their contemporary public appeal. These works subject Bolshevik ideology, which the original Soviet photographs proclaim with so much proud assurance, to a visual alienation that keeps political critique in abeyance. That Herz's artistic posture should have emerged from the debates within a group of Marxist intellectuals, whereas the actual work was underwritten by a grant from the Krupp Foundation, characterizes the ambivalence of left-wing culture in capitalist society. Without reflecting on this ambivalence, Herz and his commentators, in published texts of their own, have drawn ideological rather than political conclusions from his deliberately uncertain form of visual presentation. Herz's works themselves, to his credit, do not lock the beholder's judgment into those conclusions. They are artistically compelling paradigms of the decisionless conflict presentation pursued in the Citadel Culture of the eighties, which honored any artistic statement, no matter how provocative, as long as it did not commit itself to identifiable political propositions.

In October 1985, seven months after Gorbachev's appointment as General Secretary of the Soviet Communist Party, Herz won first prize in a competition for a temporary conversion of thirty-three large advertising panels in a Munich subway station, Marienplatz, into works of art.[61] The theme of the competition, "Pictures in Passing," referred to the advertising panels' function to draw the attention of people in mass transit. Herz's prize-winning entry consisted of an enlarged photograph of three issues of the Soviet party newspaper *Pravda,* suspended from wooden holding rods, each issue displaying a portrait photograph of one of the party secretaries who succeeded one another in 1982, 1984, and 1985—Andropov, Chernenko, and Gorbachev. The overlapping news-

papers on their obliquely hanging holders recalled the ubiquitous Soviet row of banners bearing portraits of revolutionary leaders Marx, Engels, and Lenin. Herz titled his work *Without Title,* in critical reference to the three-times repeated newspaper title *Pravda*—Russian for "truth." The jury chose it even though Herz was the only participating artist to ignore the stipulation of the competition brief to work on his assigned panel in the subway station during traffic hours under the eyes of the passing public. *Without Title,* the only photographic project among the submissions, could be produced nowhere but in the dark room and atelier. Herz thus did not draw the public into the conceptual design of his work any more than he would three years later in the Art Forum below Maximilian Street. Through the sheer visual poignancy and political topicality of its subject, the exhibition mode of artistic work prevailed over the action-and-process mode adhered to by the other competitors. Perhaps the giant *trompe-l'oeil* photograph of the three Russian newspapers hanging from the wall—as if they could be unhooked, unfolded and read—appealed to the public's ignorant fascination before the long-term Cold War adversary, which began to blend into diffuse hopes for a relief from the nuclear threat since Gorbachev's ascendancy. All three *Pravda* issues featured the headline "Communication" beside or above the portraits of the newly installed party secretaries in their iconlike similarity. The repetition enhanced the illegibility of the narrow Cyrillic newsprint, undoubtedly making German viewers uneasy about their inability to decipher historic texts that may have touched upon their lives. The more emphatically the layout of the three newspaper front pages seemed to underscore the urgency of these pronouncements, the more impenetrable did they look.

The picture panel with a Soviet theme in the Munich subway station recalls the first Moscow subway stations, built during the years 1936–53, the most ambitious Soviet project of a didactic and monumental political art addressed to a mass public. Hosts of pictures, mosaics, sculptures and symbol-laden decorations presented the economic, technical, cultural, and military achievements of the socialist state. The *Potemkin* tableau Herz exhibited three years after *Without Title* in the pedestrian underpass resembles triumphal groups of over-life-size soldiers or partisans at the head walls of connecting halls between some Moscow subway platforms. No doubt in Munich the passengers changing trains or the pedestrians walking through the underpass perceived Herz's images with more perplexity than the politically indoctrinated Soviet citizens viewed the propaganda art of Stalin's time. Their reac-

tions were never recorded. Any substantive engagement with Herz's So-
viet images was most likely confined to the art scene and its press.
Anonymous crowds of subway passengers or street pedestrians, whose
views are of no account, were an adequate public for this art from the
terminal phase of traditional left-wing culture. An art that anticipates its
own political inconsequentiality can afford to forego being politically
accountable to its public.

Soldiers against Civilians

Herz's installation of the *Potemkin* tableau marks a historic transition
that has deprived Eisenstein's film of its artistic rationale: the conver-
gence of political and artistic revolutions, one of the tenets of early
modern art. With its critique of this tenet, *Scene* contributed to post-
modern revisions prevailing in the eighties. Yet even though *Battleship
Potemkin* has come to be drained of its political persuasiveness, it has per-
sisted as a visual scenario, a paradigm for understanding the revolution-
ary confrontations between soldiers and civilians recurrent in our time.
Rather than making a case for the inevitability of revolutionary victory,
resulting from the solidarity between soldiers and civilians as con-
stituent elements of the proletariat, the film validates historical experi-
ence, which has proven that soldiers, not civilians, are the decisive social
force that determines whether revolutions are accomplished or state or-
der is maintained.

How are we to assess politically Eisenstein's image of enthusiastic
citizens acclaiming a heavily armed military force, only to be mowed
down by another moments later? Television cameras showed the most
recent images of that ambivalence when during the failed Soviet coup-
d'état of 19–20 August 1991, masses assembled before the Russian par-
liament in Moscow, first raising barricades against advancing armored
troops, then regaling them with flowers once they turned away. By con-
trast, the most recent revolutionary confrontations actually occurring
between soldiers and civilians in major countries of the world—in Bei-
jing in 1989 and Los Angeles in 1992—were unambiguous. The tightly
packed phalanx of tanks, armored personnel carriers, and infantrymen
advancing across Tiananmen Square at a speed of three miles an hour,
and the lone white-shirted youth facing down a column of seventeen
tanks to a stop on the middle of East Chanan Boulevard[62] have replayed
on worldwide television Eisenstein's Odessa steps episode of the be-
spectacled schoolmistress pleading with the advancing line of Cossacks.

What was different from Eisenstein, both in Beijing and in Los Angeles, is the civilians' determination to fight back. That their exasperation should have escalated to the ferocity of guerrilla war, is consistent with the blurring of the dividing line between soldiers and civilians in wars of our time (see p. 72). The Chinese military crackdown on students and citizens in which a minimum of six to seven hundred unarmed people were cut down by machine guns and run over by armored vehicles, was infinitely more brutal than the relatively bloodless military pacification of the American city against assault, arson, and looting by impoverished segments of the populace, where the military were deployed behind police lines so as not to directly confront civilians.[63] Yet in both cities regular army units were charged with restoring public order, after civil disturbances had touched upon the core of the social and political systems of two leading countries on today's geopolitical scene. The malfunctions of both systems—political oppression in China, social inequality in the United States—had to be repaired by force of arms.

Chinese President Yang Shangkun called the Beijing student protesters "hooligans"[64] and U.S. President George Bush denounced the Los Angeles riots as "purely criminal."[65] Both leaders, by making the riots into a problem of law and order, refused to acknowledge their political nature. Only after the police force had proven inadequate were troops brought in. But despite the legalistic rhetoric of their political leaders, the soldiers and their commanders sensed or knew that they were being committed to a political confrontation. At Beijing, a commander of departing troops told civilians: "We are soldiers of the people and will never suppress the people."[66] And in Los Angeles, a colonel of the National Guard stated to the press: "This is a lot different from attacking an Iraqi bunker. There you know where the enemy is. . . . This is citizen soldiers facing citizens."[67] Before their landing in Constanza in 1905, the historical *Potemkin* crew had issued a proclamation to the effect "that this army, this powerful pillar of [the Tsarist government's] bloody plans, is the same people resolved to strive for its freedom."[68] Eighty-four years later, an open letter from an anonymous "old soldier," distributed as a flyer in Tiananmen Square, advised the rebellious students:

> You must believe in the basic quality of the people's soldiers. Do careful ideological work with them. Don't just tell them not to come into the city: tell them to turn their guns and stand on the side of the people.[69]

In both instances, military commanders were initially reluctant to commit themselves to the task of quelling civic disorders. General Xu Jing-

xian, who commanded the Beijing-based 38th Army, reportedly re-signed when asked to suppress the uprising, and more than one hundred of his officers signed a letter vowing to disobey orders to crack down. General Covault, who commanded the federal troops deployed in Los Angeles, refused numerous missions because he did not realize that the "President's Proclamation" to the populace to disperse peacefully legally overrode the constitutional prohibition of charging federal troops with law enforcement tasks.[70] Both Chinese and American generals ac-knowledged the political quandary of the enduring *Potemkin* scenario.

In Beijing, the deadly confrontation between soldiers and civilians was particularly detrimental to the political order. The Chinese Revo-lution had been won as a military victory by the People's Liberation Army. The conscript army of 1989 was integrated fully into working society by means of its manifold economic, cultural, and political ven-tures. Now it stood politically compromised, even though the system-atic convergence of units from all regions of China for the final assault on the city had been designed to make the oppressive military force rep-resentative of the country at large.[71] The social solidarity of soldiers and civilians postulated by Communist ideology disintegrated when sol-diers came infiltrating the city disguised as civilians, with false identity cards, on unmarked vehicles, or through the defensive subway system, or when uneducated peasant units from far away were sent into the capital because it was thought they would not sympathize with a city popula-tion. In the United States, the relationship between soldiers and civilians was fundamentally different. After the conscription of unwilling sol-diers to fight the losing colonial war in Vietnam had weakened the mil-itary's political support in society at large, the armed forces of the United States switched to all-volunteer recruiting. The new professional army was more integrated racially than any other professional organization in the United States. Thus, in Los Angeles, a socially consolidated military force was deployed against a racially divided, mutually antagonistic city population that was largely unemployed, socially disintegrating through union decline, family breakups, and drug addiction, and ever more tightly controlled by a highly technicized, confrontational police force from outside their communities. This low-class, multiethnic mass had become disenfranchised from the electoral process of municipal dem-ocracy, politically inchoate, even devoid of anarchistic ideological lean-ings, upon their taking to the streets. Accordingly, and different from the political sacrifices made for the sake of stability in Beijing, the political risk of making U.S. soldiers contain their fellow-citizens was mini-

mized. The technical task of a controlling of the populace by force of arms had already been taken on by the police, "literally comparable to Belfast or the West Bank, where policing has been transformed into full-scale counterinsurgency (or 'low-intensity warfare,' as the military likes to call it), against an entire social stratum or ethnic group."[72]

Both these full-scale civilian uprisings in major industrial states where soldiers subdued civilians never raised a doubt that the military would eventually stand by the government, no matter how reluctant their engagement. On the other hand, civilians' resistance against soldiers took such violent forms—gruesome retributive murders of Chinese soldiers in Beijing, ubiquitous gunfire by Los Angeles looters armed to the teeth—that neither the polarity of murderous soldiers and peaceful civilians nor its reversal by a revolutionary class solidarity—the rationale of *Battleship Potemkin*—was in evidence.

Conclusion

With his *Scene* of 1988, Rudolf Herz, the West German artist, never claimed to affect the political thought, let alone behavior, of a hypothetical public he had no way of knowing. His installation was confined to a showcase window, where it did not aesthetically engage, let alone mobilize, the movements, expectations, and feelings of the passing viewers on the staircases and in the subterranean corridor. Herz's self-conscious reflections about the visual impact of the installation, compared to that of Eisenstein's film, presupposed the disjunction of image and viewers. All the more consistently did he take a cool, historicizing distance vis-à-vis Eisenstein's theatrical pitch to jerk his viewers from their chairs, to make them break out in tears. What a contrast to the political determination projected by *Battleship Potemkin* and confirmed by its first audience, the delegates to the XIV Party Congress who were deliberating about the militarization of socialism! The suspended enthusiasm monumentalized in Herz's installation acknowledges the exhausted topicality of Eisenstein's film.

In his article "The Montage of Attractions" of 1923, Eisenstein coined the metaphor "Cine-Fist" to distinguish the aggressive propagandistic drive of his work from fellow-director Dziga Vertov's emphasis on perceptual reflection as expressed by the metaphor of the "Cine-Eye."[73] The psychological subjugation of spectators by way of "shocks" to which he aspired—"cracking skulls," in Lenin's words[74]—recalls the forced psychiatric reeducation of political dissidents in Soviet mental

institutions (see p. 114). Such was the intent of the final film still Herz chose for his installation, the prow of the battleship plowing out of the screen and overrunning the audience, submerging it, as it were, under the water surface. When Herz caged that violent motion behind crimson props, he broke the spell of an icon that has held disenfranchised Western intellectuals on the Left spellbound for so long, made them submit to its welcome shocks, to hail overwhelming Soviet military power as the harbinger of a generic revolution. Once images of advancing soldiers are no longer acclaimed as embodiments of a politically righteous avant-garde, the political aesthetics of emancipated civilians pursuing left-wing politics in a radical democracy can be redefined.

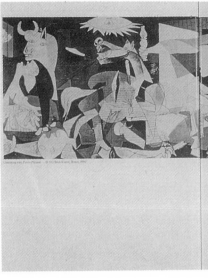

Gemälde von Pablo Picasso · © VG Bild-Kunst, Bonn 1991

Feindbilder

sind die

Väter des

Krieges.

Darum haben wir keine. Denn das ist der uralte Trick aller totalitären Regime: Sie zeichnen das Bild vom bösen Feind, um die Opfer begründen zu können, die sie dem Volk ständig abverlangen.

Feindbilder erzeugen Angst und Mißtrauen, Haß und Aggressionen. Sie sind die Saat, aus der Erbfeindschaften entstehen, die das Zusammenleben der Völker belasten. Und die oft genug zu Kriegen werden.

Die Bundeswehr hat ihren Auftrag nie auf Feindbildern begründet. Nicht „Wogegen?", sondern „Wofür?" lautet die Frage nach dem Sinn ihres Einsatzes. Denn es gibt viel zu verteidigen: Freiheit und Bürgerrecht, Selbstbestimmung und Unabhängigkeit von fremdem Druck. Und den Frieden.

Dafür steht die Bundeswehr. Sie ist unsere Versicherung gegen Wechselfälle, die niemand vorhersagen kann. Auf diesen Schutz müssen wir uns verlassen können, wenn wir Herr unserer eigenen Entscheidungen bleiben wollen. Heute und in Zukunft. **Die Bundeswehr.**

Möchten Sie mehr zu diesem Thema erfahren? Schreiben Sie an: Info-Dienst-Öffentl., Postfach 142930, 5300 Bonn 1.

THREE

Picasso's Guernica *Returns to Germany*

The *Guernica* Advertisement of the *Bundeswehr*

In September 1990, some three weeks before the accession of the German Democratic Republic for the unification of the country, the five major national weeklies of the Federal Republic, *Hör zu, Bunte, Der Spiegel, Stern,* and *Die Zeit,* carried a two-page advertisement issued by the *Bundeswehr,* the Federal army, with a color reproduction of Picasso's *Guernica,* captioned "Foe Images Are Fathers of War." The accompanying text read in part:

> Foe images produce fear and mistrust, hate and aggression. [. . .] The *Bundeswehr* has never founded its mission on foe images. The question for the purpose of its deployment is not "Against What?" but "For What?" For there is much to be defended: freedom and civil rights, self-determination and independence of foreign pressure. And peace . . . This is what the *Bundeswehr* stands for. It is our insurance against hazards nobody can predict.

This text proposed a deliberate decoupling of two political components of military preparedness: enemy definition and domestic support. For NATO strategy, a topographically specific targeting of the forces and territory of the Soviet Union and the Warsaw Pact had been a matter of course, pointedly underscored by the 1986 installation of U.S. intermediate nuclear missiles on West German launching ramps. Once these missile sites became bargaining assets in the geopolitical rapprochement

between NATO countries and the Soviet Union only two years later, the accompanying public relations campaigns had progressively reduced anti–Soviet Cold War propaganda. Now, after continuous, accelerating, and partly successful efforts at a gradual arms reduction, the disparity between strategic planning and public policy had widened to a maximum. The Federal army advertisement thus proposed to the public a new rationale for keeping military defenses up. It was one in a series of ten ads, all designed in the same format and published at regular intervals between the spring and fall of 1990.[1] When it appeared, all Communist governments in Eastern Europe had long collapsed, and the Warsaw Pact was on the verge of dissolution. The advertising campaign stressed the necessity of maintaining a strong conscript military force despite diminishing geopolitical tensions. Another installment showed a color photograph of joyous Berliners standing atop the Berlin Wall the night of 9 November 1989 captioned "We have helped to open the door." The text credited NATO's and West Germany's resolute defense posture with this political success. Yet the advertising campaign attempted to strike a balance between triumphant assurance of accomplishment and a lasting need for caution.

West German Left-liberal intellectuals were outraged by this official use of Picasso's world–famous picture of protest against the German air force bombing of the Basque town of Guernica on 26 April 1937 to promote the current German army, particularly since the *Bundeswehr* keeps cultivating *Wehrmacht* traditions. Even more outrageous, the invocation of *Guernica* in support of a strong military provocatively inverted the pacifist significance the painting had acquired in the visual culture of our times. Since the end of the Second World War it had been brandished as a banner of Left-wing protests against capitalist rearmament with an antifascist ideological thrust. Even more broadly, it had become an icon of antiwar sentiment in general, with no political specification. Published reactions to the *Bundeswehr* ad remained scattered and without resonance[2] until 22 March 1991, when *Die Zeit,* which had carried the ad, published a scathing broadside by Günter Grass, one of Germany's foremost novelists, under the headline "The Desecrated Picture: How the *Bundeswehr* Misuses Picasso's 'Guernica' in a Series of Ads."[3] A few days earlier the author had delivered the text in person as an address to then German Federal President Richard von Weizsäcker at an author's reading at the President's official residence in Berlin. Grass demanded that the Federal defense minister apologize officially to the inhabitants of Guernica for the advertisement.

In taking exception to the ad, Grass argued from his well-publicized, long-term opposition against the policies of the Christian Democratic government. He had publicly opposed the precipitated German reunification and the collusion, as he saw it, between the West German Defense Ministry and arms industry to provide weapons to Iraq before the Gulf War. Thus it was surprising that he should not have expressed himself one way or another on the issue of military policy addressed by the ad campaign. What Grass denounced most stridently was the use of Picasso's *Guernica* as an "exemplary" illustration of a "foe image," that is as an illustration of the idea condemned by the text of the ad. Several rejoinders in *Die Zeit,* one of them written by the Defense Ministry official responsible for the series, pointed out that the ad suggested nothing of the kind.[4] Grass had misperceived the visual point. The designers of the ad had drawn merely on a feature of Picasso's painting often commented upon: it does not show the enemy responsible for the calamity, although viewers will know who he is. The one-sided depiction of victims, their historical identity transfigured in an expressive abstraction, has subsequently made the painting suitable for adaptation as a symbol for a never-ending string of military aggressions against civilian victims, from Vietnam to Nicaragua, from Lebanon to Bosnia. *Guernica* has become imbued with a vague but poignant sense of the perpetual recurrence, and ever-present danger, of war. The *Bundeswehr* ad followed this convention in relating the invisibility of the aggressor in the painting to the disappearance of an identifiable enemy after the end of the confrontation with the Soviet Union, with the implication that the danger of war continued to exist.

The Partisan Picture

In its original setting, the Spanish Pavilion at the Paris World Exposition of 1937, Picasso's *Guernica* was part of a coherent war propaganda program conveyed by posters, images, graphic displays, and an art exhibition.[5] This program was based on the polarized propaganda principle of twentieth-century wars of defense against foreign aggression: the civilian population's sufferings from the enemy's brutal warfare only steel its resolve for defense and confidence in victory. The efficacy of such propaganda has traditionally depended on the calibration of the themes of enemy atrocities and fighting morale: suffering does not impair resistance, does not preclude rebound. Accordingly, above the entrance of the Spanish Pavilion, removable panels with giant enlargements of pho-

tographs depicting soldiers in parade formation were placed above boards carrying encouraging quotations from President Manuel Azaña's speeches. Below a close-up view of three steel-helmeted soldiers looking up with expressions of confidence, there appeared Azaña's words: "In the trenches there are over half a million Spaniards with bayonets who will not let themselves be overrun!"[6] The president's defiant statement proclaimed the fundamental readjustment of Spanish Republican defense policy that had been accomplished in the early summer of 1937: the "militarization" of the republic's fighting force, its conversion from an antimilitarist workers and peasants militia into a regular army with a firm command structure. In his memoirs, Azaña has characterized this policy:

> To induce those masses [of armed workers and peasants] to discipline, to incorporate them in a military organization of the state, with orders dependent of the government, in order to sustain the war in conformity with the planning of a General Staff, constituted the foremost problem of the Republic.[7]

In contrast to the unequivocal statements of military resolve on the Pavilion's outside panels, the war theme of the art and propaganda exhibitions inside was polarized between the heroism of the military and the plight of the civilian populace. Fierce figures of defiant soldiers were counterpoised with screaming, mostly female victims of the indiscriminate bombing and shelling perpetrated by the nationalist insurgents and their German and Italian allies. The thematic polarity raised the fundamental question of the relationship between soldiers and civilians in what was proclaimed to be a people's war, the government's propaganda concept in the face of a putsch by its professional army. At the war's outbreak, Left-wing parties and trade unions had rallied white-shirted workers without uniforms, issued them rifles and, under the ambivalent designation of "militias," rushed them to the front. The "militarization" program illustrated in the photographs on the outside of the Paris Pavilion was intended to correct ensuing problems. These problems pertained not only to the unprofessional conduct of war, but also to the risk of making civilians into combatants and thus exposing them to retaliation. If the new republican military policy restricted fighting to regular units but continued to demand active involvement of the entire population in the war effort, what was the civilians' contribution to be? It was a military as well as a political question. Militarily, militia warfare had failed to stem the army insurrection, compelling the government to organize from scratch a professional army of its own. Politically, the fight-

ing morale of the civilian populace had to be sustained in the face of the insurgents' incessant conquests and devastations. Hence the need for a balanced propaganda view of the relationship between soldiers and civilians.

Since in Picasso's *Guernica* a dead warrior is prominently visible among devastated women, the painting opens up the relationship between soldiers and civilians in the so-called people's wars of the twentieth century for debate. The bombing of Guernica on 26 April 1937 spurred Basque President Aguirre to issue a defiant declaration that this war crime would harden the people's resolve to fight back,[8] but in his image Picasso joined the soldier with the civilians in common peril. In the two earliest stages of his work, which his companion Dora Maar recorded in atelier photographs, the warrior, though prone, raises his fist straight up to heaven in a gesture of defiance. The reasons why Picasso changed this image of resistance into one of plain disaster have been pondered often. Some authors have seen the change as a pessimistic assessment of the war situation; others have ascribed it to a critical detachment on Picasso's part from the new, Communist-controlled Spanish government that had come to power on 18 May 1937. Officials of the new government are said to have opposed the mural's final version, ostensibly because they found its relatively abstract form unsuitable for propaganda, but perhaps also because they perceived its implicit defeatism. In the end *Guernica* effectively served as a pictorial outcry against war as such. It jibed with the pacifist propaganda injected into the Paris World Exposition by the Popular Front government of France, which culminated in the last-minute building of a Pavilion of Peace at the northernmost point of the exposition grounds. This environment made the painting's message resonate far beyond the propaganda program of the Spanish Pavilion.

Soldiers, Civilians, Partisans

In the art exhibition of the Spanish Pavilion, the most intransigent image about the relationship between soldiers and civilians in a people's war was Santiago Pelegrín's painting *Evacuation of the North*.[9] It dealt with the loss to the Nationalists of much of the Basque country in the spring of 1937 and was a defiantly activist counterpart to Picasso's mural downstairs in the auditorium. Pelegrín's didactical composition hinges on the encounter of a man and woman turning from a stream of refugees who flock diagonally out of the picture. The woman harangues the

crowd to turn back and join the steel-helmeted, uniformed regulars holding out in a trench, but of the three men in the throng of refugees, only one heeds her call. He is the *dinamitero* in a black undershirt, the symbolic figure of anarchist guerrilla warfare, ready to hurl an explosive charge at the advancing Nationalists who remain invisible beyond the trench, like *Guernica's* enemy bombers in the sky. The man and the woman's clenched fists express their resolve to fight as guerrillas alongside the soldiers. Such an implementation of people's war ideology canceled the distinction between combatants and civilians maintained in Europe up to and including the First World War. It made civilians a military target for the enemy, not just to be caught fighting but be sapped of political morale from the start. Pelegrín's *Evacuation of the North* heralded the all-out partisan warfare practiced during the Second World War and fully supported by the governments involved, with its attendant, mutually escalating, reciprocal atrocities between soldiers and civilians.

The Spanish Republican imagery of the people's war circumscribed the argumentative visual field in which Picasso's lone soldier lying on the ground in the midst of perishing civilians had to be evaluated. The disembodied, fragmented statue in the final version of *Guernica* flies in the face of the photographs atop the Pavilion's entrance, displaying victory-confident Republican soldiers in dress uniform. Although *Guernica's* first stage was a far cry from the people's resistance fortified by suffering promoted in Pelegrín's *Evacuation of the North,* it was as upbeat as circumstances allowed. After all, its declared subject was no battle, but the well-publicized air-raid on a town that had to be represented as a defenseless civilian settlement for the counterpropaganda to be credible. The inclusion of a fighting warrior figure would have vindicated the attack. Its depiction as a prone body with clenched fist lifted up converted the symbolic depiction of a war atrocity into a pictorial rallying cry for a people's war, in line with Basque President Aguirre's press release in the aftermath of the attack. Yet in his subsequent methodical changes of the painting before its completion on 4 June, Picasso progressively fragmented the warrior figure until it was aligned with the doomed civilians, all of them women, in what amounted to a collective image of doom. In one of the posters he designed for the government's war propaganda, José Luis Bardasano, Spain's leading Communist propaganda artist, provided an image to the contrary.[10] The poster's caption, "Catalans! It is better to die on your feet than to live on your knees" is from Aeschylus' *Agamemnon.*[11] It shows a fully-equipped, steel-helmeted soldier, his arm raised, standing upright, dying from a bullet, while a shack-

led, live civilian kneels before him. Picasso, in the third through the fifth of the recorded stages of his work, in effect turned his warrior around from challenging the sky to facing the ground, a progressive assimilation to Bardasano's civilian. When he, in the final version, turned the warrior's severed head back up again, the warrior was unequivocally dead. The figure's final significance remains obtuse.

In no stage of its elaboration was *Guernica* merely an artistic protest against a bombing raid. It was a propaganda picture for a people's war. It proclaimed no pacifism, but the necessity to take sides, the will to fight. The subsequent history of its growing popularity after the end of the Spanish Civil War has tended to obliterate this original significance. Under the impact of the republic's defeat the painting was sentimentalized into a meditative image of lament, of accusation. This historic obfuscation suited the ideological double vision of Left-wing commentators, whose abstract antifascist posture allowed them to glamorize partisan warfare and at the same time condemn retaliation against civilians, oblivious of the ineluctable moral contradictions raised by total warfare. Such disjointed thought made for the one-sided pacifism of many Leftists, including myself,[12] in dealing with the military stand-off between the two blocks of the Cold War. It has also informed Grass's protest against the *Guernica* ad of the *Bundeswehr*.

Modern Self-Reflection and Historical Topicality

"Picasso used to say, at that time, that he was only just one more militiaman, wielding his brush as the others did their guns."[13] If this recollection of one of the Spanish officials at the Paris World Exposition of 1937 is accurate, Picasso would have characterized his fighting posture for the republic with an appropriately problematical term. Irregulars of the voluntary militias, who had gone to the front under the spell of propaganda and enthusiasm and fought without military discipline and political control, had posed the problem to be addressed by the government's new militarization program. An avant-garde artist's use of the word "militiaman" implied that he was ready to fight, but out of conviction, on his own terms, and without submitting to government control. In Picasso's case, this meant painting without conformity to the iconographic and stylistic directives of propaganda art imposed by the republican art administration on the artists working in Spain itself for the Pavilion's shows. The word "militiaman" was an ideological metaphor for the thematic freedom Picasso had been granted when the Spanish

representatives in Paris in January 1937 commissioned him to paint a mural—any mural—for the pavilion of the republic. Picasso was thus enabled to adhere to what must have been an unwritten code of modern artists whenever they decided to commit their work to a political cause. After having repudiated any official designation for their art, such artists now insisted on deriving political statements solely from their pictorial imagination. This often meant that they drew from an existing repertoire of forms and motifs developed for other expressive purposes. Such a politicization of autonomous modern art for reasons of conscience was already fraught with its own contradictions, but it was altogether at odds with the demand for ideological clarity in the new government art of the Depression years, Bolshevik, Fascist, and Democratic alike. What could modern art, rejected and criticized by these regimes as self-referential, self-indulgent, obscure, and irrelevant, contribute to the political issues of the day?

The bombing of civilians had been one of the themes prescribed by the Spanish art authorities for the art exhibition in the Pavilion at the beginning of the year and was duly taken up by several of the participating Spanish artists. Picasso in Paris, on the other hand, reportedly had been unable to make up his mind about the subject of his mural until the news of the bombing of Guernica on 26 April 1937 all of a sudden prompted him to adopt the theme as well. Thus, although eventually he adhered to the official program, his contribution could count as an existential act, "modern" in the sense of Arthur Rimbaud's famous sentence "One has to be absolutely modern."[14] The eighteen-year-old poet had written the line in the concluding section of the 1873 prose poem *A Season in Hell,* his last work, entitled "Departure." And, equally categorically, he had continued: "The struggle of the spirit is just as brutal as the battle of men,"[15] written in response to the bloody suppression of the Paris Commune in 1871. Rimbaud had opted out of any equation between rebellious art and revolutionary politics by a radical recoil from both and never written another line. But André Breton concluded his address to the Popular Front Congress for the Defense of Culture, held in Paris in June 1935, with a joint invocation of Rimbaud and Marx,[16] demanding the opposite: the unconditional political radicalization of modern art. In 1938, one year after Picasso completed *Guernica,* Leon Trotsky, in his essay "Art and Revolution," called for the same: "In the face of the era of wars and revolutions which is drawing near, everyone will have to give an answer: philosophers, poets, painters as well as simple mortals."[17] Pi-

casso styled his contribution to the Spanish Pavilion as such an "answer," as if its accord with the official program was sheer coincidence.

How could Picasso assert instant topicality for his *Guernica* while taking almost all its imagery from the bullfight repertoire he had been developing for several years in his pictorial reflections about the ties between artistry and love? Much of this imagery was already in place in the etching *Minotauromachie* of April 1935, in which Picasso's interconnected notions of sexuality, aggression, and murder are related to the bullfight as a ritualized spectacle of death. Here he had joined the endeavor of his surrealist friends in Paris to contrive a sexual mythology in reach of personal fulfillment, for which they adapted the key symbolic figure from the Greek myth of the Minotaur.[18] Robert Melville's apt comparison of Picasso's etching "to a pack of Tarot cards whose separate figures are brought together into a permanent configuration" fits *Guernica* just as well.[19] History and politics seem incommensurate with the dreamlike, uncertain imagination underlying such a variable field of imagery, an imagination only momentarily and metaphorically stabilized by the obsessive repetition of sexual, mythological, and folkloric stereotypes. In *Guernica,* Picasso staged from his artistic road-show, as it were, a multifigured live picture, to be played out as dramatic performance on the grandest scale in the auditorium of the Spanish Pavilion. Here, in a place of maximum public impact, his work would seek to answer fundamental questions of the representational significance, of the historical topicality, and of the public comprehension of his art, and of modern art in general. Could Picasso's poetic associations of love and the bullfight, which were then focused on his simultaneous, conflict-ridden relationships with two women of contrary character, Marie-Thérèse Walther and Dora Maar, do justice to the drama of the historic moment? Breton had given a categorical answer to such questions in his 1930 Second Manifesto of Surrealism, where he wrote from a self-centered male perspective:

> The woman problem is all there is in this world of wondrous and disconcerting things. And even to the extent of the faith an uncorrupted man must be able to place not only in Revolution, *but also in love.* . . . Some who call themselves revolutionary would like . . . to persuade us that love is impossible within the bourgeois order, others pretend to be committed to a cause more demanding than even love: in truth hardly anyone dares to confront with open eyes the great day of love in which . . . the obsessive ideas of salvation and damnation are bound up with one another.[20]

In observance of Breton's dictum about love and revolution, Picasso painted *Guernica* not as a pictorial allegory of war, but as a personal profession of political sentiment. While making the mural he worked in the steady presence of his companion Dora Maar, the Leftist painter and photographer, who shot the photographs of the six intermediate stages with the trenchant changes he made. The almost instant publication of these photographs in the journal *Cahiers d'Art* of summer 1937[21] presented Picasso's working process itself as a historic statement. The record of their sequence, not just the final result, became the fundamental subject of all later commentaries on the picture. In the course of work, conversations, and perhaps debates, between both artists must have been as lively as in their life together. What impact if any they had on the making of the picture cannot be ascertained. In any event, by staging his working process as a dialogical performance for the *Cahiers d'Art,* Picasso was living up not only to his own, habitually erotic understanding of artistic creativity but also to the surrealist demand for an erotic validation of revolutionary politics.

However, the sexual imbalance of the modern artist's lifestyle, focused as it was on the age-old artistic objectification of women, from the Pygmalion myth to Balzac's novella *The Unknown Masterwork* (1831), proved to be at odds with the ideological message of the people's war in the propaganda program of the Spanish Pavilion. The squirming, running and gesticulating women in Picasso's *Guernica* in their abject lament are cast as helpless victims. As Paul Eluard's quasi–authorized poem, published in the *Guernica* issue of the *Cahiers d'Art,* has it:

> Women, children have the same treasure
> In their eyes
> Men defend them as best they can . . .[22]

Such an archaic polarization of male warriors and female victims contradicted the women's active involvement in the defense of the republic, as promoted in Pelegrín's *Defense of the North.* It also contradicted the Spanish republican government's policies of woman's emancipation, as they were advertised in Josep Renau's photomontage *Woman, Capable of Taking an Active Part in the Elaboration of the Future,* on exhibit in the Pavilion.[23] If Picasso's *Guernica* addressed the ideology of the people's war, it was in a negative sense, through the disembodied warrior on the ground, sharing in the women's victimization. Did Picasso question the ideology of popular combat resolve? Perhaps the autobiographical terms of his picture exempted him from being measured by the republican propaganda concept. In any event, through his politically obsolete

representation of twentieth-century warfare, he programmed his *Guernica* for the ideological abstraction that has made for its continuing prominence.

The Abstract War Image

On 25 April 1991 the parliamentary state secretary of the German Defense Ministry responded before the Bundestag to a procedural inquiry by a Social Democratic deputy, who had taken his cue from the controversy surrounding Grass's broadside: "Pablo Picasso's 'Guernica' is perhaps the most impressive antiwar picture in existence. It denounces the horrors of war as the last consequence of hate and of thinking in foe images."[24] The state secretary was acknowledging *Guernica's* ascendancy to the status of most popular all-purpose image about the horrors of war in the capitalist public sphere. This ascendancy had its origins in the diplomacy the Spanish republic had been obliged to observe with its pavilion at the Paris World Exposition of 1937, and with Picasso's mural in particular. Although the targets, nationalists or Germans, of the republic's pictorial denunciations against war crimes were unmistakable, nowhere in this or any other image on view were they identified. A diplomatic code of conduct in force at the Paris World Exposition proscribed international polemics in the displays. The German Pavilion was as devoid of anti-Bolshevik as the Soviet was of antifascist statements, although mutually hostile propaganda was being whipped up to the highest pitch in both countries at this time. Moreover, *Guernica's* representation of a war catastrophe that might happen anywhere was in tune with republican propaganda that the Spanish Civil War was only the first phase of Fascist aggression threatening Europe, France being next in line. The text on the official postcard reproduction of *Guernica,* on sale at the Spanish Pavilion's bookstall, read:

> *Guernica.* The great Spanish painter Pablo Picasso, creator of Cubism, who so powerfully influenced contemporary visual art, has wished to express in this work the dissolution of the world that has fallen prey to the horrors of war.[25]

Such a generalized message suited the pacifist reorientation given to the Paris Exposition by the new Popular Front government of France in 1936. And the mural's adjustment by the artist from a defiant signal of the people's war to an outcry about war atrocities in general, also served the Spanish government's effort to establish a nonpartisan worldwide debate about the bombing of Guernica, as well as worldwide support for

its demand of an international investigative tribunal to decide the question of guilt. All these political preconditions for the propagandistic exploitation of the painting at the Paris Exposition facilitated its progressive detachment from its historic origins in exchange for its continuing topicality. It was invoked in the denunciation of ever greater bombing atrocities in the Second World War—"Warsaw, Rotterdam, Nancy, Coventry,"[26] Dresden, and Hiroshima. It has continued to illustrate outcries about civilian casualties in the never-ending succession of ongoing wars, large and small, over the globe. For a while, its origins in the antifascist confrontation of the Spanish Civil War seemed to allow the Left to lay special claim to its meaning. But by now no political judgment, no political partisanship is any more involved in its continuing citation.

In the fall of 1987, the American comic strip magazine *Heavy Metal* printed a story by the comic artist Herikberto about a terrestrial mission of androids from outer space.[27] On the observation screen of their spaceship, Picasso's *Guernica* comes into view. The captions read:

> After ten months of careful investigation, I have been able to accumulate in the earth-cube a great quantity of interesting and accurate data, that cannot really be compared to that collected on other planets we have visited. . . .
>
> All this will enable us to build the most powerful and sophisticated extraterrestrial computer. Then we can destroy the rest of the world.

Guernica provides the visual symbol for Herikberto's moral satire on the destructions envisaged by electronic and nuclear strategies designed to reach into outer space. I still remember the vague, persistent fears of people in Europe and the United States that nuclear war could break out at any moment, not as a result of deliberate strategy, but as an unforeseeable catastrophe, due to accidental misunderstandings. Such fears pervaded the artistic culture of capitalist states between 1979 and 1988, when the Second Cold War was driven to its peak. Just as Herikberto featured Picasso's *Guernica* as an electronic paradigm of a utopian war in the universe, West German designers of the *Bundeswehr* advertisement two years later thought they could use the same pictorial citation to conjure an unspecified *casus belli* of the future as reason enough to stay armed.

When it decided to focus the advertisement on the words "foe image," the McCann-Erickson ad agency at Düsseldorf may have relied on Rudolf Arnheim's influential monograph of 1962, which has most cat-

egorically promoted the absence of the enemy in Picasso's one-sided depiction of civilian victims.[28] Officials of the agency showed me preparatory materials for the campaign, including earlier versions of ads not included in the series. One of these was a design illustrating the slogan, "Foe Images are War's Fathers," with the caricature of a sixteenth-century battle painting showing two lines of mercenary infantry clashing at close quarters in packed formations. In replacing the caricature with *Guernica*, the designers were not only getting serious rather than satirical, they were also opting for what they took to be an image of "modern" warfare, an alternative to the antiquated one—an image including civilians along with soldiers in actions of war.

Revisions of the Left

The antimilitary tone of Günter Grass's protest against what he perceived to be *Guernica's* "desecration" at the hands of the German Defense Ministry testified to a tradition of equivocation about the military in the Left-wing culture of capitalist democracies. Since the Second World War, Communist and Left-liberal writers had to reconcile their allegiance to the antifascist partisanship promoted in Picasso's painting to their habitual pacifism. They were loath to admit that antifascism is by definition militant rather than peaceful, that it once prompted contemporary intellectuals to take up arms as part of the International Brigades in Spain. Moreover, their *Guernica*-inspired pacifism was one-sidedly aimed against capitalist in disregard for Communist rearmament. Soviet, and hence Communist, politics, from the time of the Spanish Civil War to the ascendancy of Gorbachev, was not based on pacifism, but on a resolute military posture.

It was in the years from 1975 to 1979, when nuclear escalation in the midst of an economic recession forced the two superpowers into a temporary process of détente, that *Guernica's* use as a banner of the Left first came to be thoroughly questioned. The revisions were triggered by two decisive events in Left culture: the appearance of the first volume of Peter Weiss's *Aesthetics of Resistance* in the fall of 1976,[29] and the public exposure of Sir Anthony Blunt as a Soviet spy on 15 November 1979. Both Weiss and Blunt used *Guernica* as a paradigm for reassessing Marxist political aesthetics. Their recognition of the Spanish Civil War as the defining historical experience of Marxist intellectuals in capitalist society made them deal with the painting. Art historian and critic Blunt's dramatic career as a Communist has entailed equally dramatic changes of

position in this reassessment. In early publications he was still able to state openly his Leftist political views. But after he started to work for Soviet intelligence, he turned art history writing into a politically meaningless professional activity, if not a cover. Weiss, an activist writer never bound by party discipline, let alone by ties to any government, was shaken in his support of Communist national liberation movements in Southeast Asia by revelations of the massacres perpetrated in Cambodia by the Khmer Rouge. In response, he wrote the three-volume *Aesthetics of Resistance,* a reckoning with the doctrinal self-assurance of Communist culture. In the first volume Weiss discussed *Guernica* as a key example of the historic ambivalence inherent in a millennial artistic tradition of picturing resistance against oppression. Both authors wrote their critical revisions of *Guernica*'s antifascist—in the Communist understanding of the term—impact during the waning years of Left-liberal governments in Britain and West Germany. These revisions formed part of a retrenchment of Left-wing culture in capitalist societies that was precipitated by the electoral victories, between 1979 and 1983, of conservative parties in Western Europe and the United States.

During late summer and fall, 1937, in the British journal *The Spectator,* Blunt and Herbert Read waged the first ideological debate about *Guernica,* which they had seen in the Spanish Pavilion during visits to the Paris World Exposition. In the August 7 issue, Blunt wrote:

> Fundamentally [*Guernica*] is the same as Picasso's bull-fight scenes. It is not an act of public mourning, but the expression of a private brainstorm which gives no evidence that Picasso has realized the political significance of Guernica.[30]

For over four years, the young Cambridge lecturer in art history had advanced a critique of modern art from a Marxist theoretical position. He had upheld the ideal of an engaged art which addresses politically recognizable subject matter and speaks to an aesthetically uninitiated political constituency. The Mexican muralists Diego Rivera and José Clemente Orozco personified such an ideal for him. By the time of the Paris World Exposition, Blunt shared his engagement in Communist political practice with numerous other European intellectuals who went to Spain to fight in the International Brigades, but his response was to work as a Soviet agent underground. In the short article for the *Spectator* he repeated current Communist critique of Picasso, although the artist had come to participate in the cultural program of a Popular Front government. Blunt was the first to point out that Picasso had assembled the mural from his repertoire of bullfight iconography, forgetful of the

historic reality suggested by the title. He therefore saw the mural as a typical example of subjective self-confinement in the art of the modern tradition. Three months later, on 8 October 1937, in a second essay about Picasso's pair of etchings *Franco's Dream and Lie,* Blunt once again returned to "the political significance of *Guernica:*"

> Picasso should have seen more than the mere horror of the civil war, . . . he should have realized that it is only a tragic part of a great forward movement; and . . . he should have expressed this optimism in a direct way.[31]

Blunt was following the Communist Party line then prevailing in aesthetics as well as in politics. He saw the Spanish Civil War as a phase in an overarching strategy of the worldwide, antifascist struggle plotted by the Comintern since 1935. In the service of such a strategy, art was to have an agitational effect, sustaining activism and optimism, even in the face of adversity.

In the next issue of the *Spectator,* on 15 October, Herbert Read wrote a rejoinder to Blunt's critique:

> Here is the best kind of evidence of the close cooperation and mutual understanding which exists between the artist and the democratic government of his native country. . . . Hundreds of thousands of people have seen [*Guernica*] and, as I can testify from personal observation, accepted it with the respect and wonder which all great works of art inspire.[32]

Read interpreted "respect and wonder" as expressions of a democratic assent to Picasso's picture. "Hundreds of thousands of people" ratified modern art as a politically forceful alternative to "the drab realism" of totalitarian propaganda art concurrently on view in the German and Soviet pavilions at the Paris World Exposition. Such admiration exempted modern art of any direct political engagement. *Guernica*'s ascendancy to a banner for the cause of the Spanish republic in public culture has confirmed his judgment. Blunt's condemnation, on the other hand, became the model for continuing challenges to the painting's political relevancy advanced by authors on the Left.

Twenty-nine years later, Blunt switched sides in the debate. In 1964 he had made a secret confession about his work as a Soviet agent, joined the British secret service, and started working at the center of international espionage. In 1966, he delivered a lecture at Oxford about *Guernica,* which he enlarged and published as a book in 1969. Along with Arnheim's monograph of 1962, this book has decisively contributed to the picture's transfiguration from a historical parti-pris into a timeless masterpiece. Now Blunt characterized Picasso as a "great revolution-

ary" and "great traditionalist" at one and the same time, an artist who was continuing a "great tradition in European art" of painting "the Apocalypse or the Last Judgment as symbols of the evil of the world and the doom which must befall it."[33] He had dropped both the activism and the optimism of his earlier Communist posture and embraced the fascination with doom that has sustained the aesthetics of historical terror in the modern tradition. In a lecture of 1972, Blunt acknowledged his change of heart, but he did not own up to its reasons. His reinterpretation of *Guernica* followed on the heels of his secret accommodation with the British government, and it remains an open question whether it represented a conversion, a resignation, or merely a cover. In his book of 1969, Blunt had written about the Spanish Civil War: "Even for the most ivory-tower intellectual it meant that the time of not taking sides was past; the conflict was too near and involved too many of one's personal friends."[34] "Taking sides" did not mean taking a stand, as the unsuspecting reader of that time might have assumed. On the contrary, for Blunt it involved the sacrifice of intellectual credibility to covert practice, at a time when art no longer served as a weapon in the political struggle.

Peter Weiss's *Aesthetics of Resistance,* a treatise on the liberating potential of art, written in the form of a novel, arrives at the same conclusion. Its hero is a young, Communist worker from Berlin who pursues autodidactic studies of art and literature while simultaneously working against the National Socialist regime with the underground Communist Party. Within the book's imaginary, experimental scenario, Weiss subjects the emancipatory perspective of traditional Marxist aesthetics to a historical endurance test, which it does not pass, even as a utopian proposition. His revisions of traditional Marxist tenets about artistic culture are largely based on Trotsky's writings, and hence critical of the Communist International's and the German Communist Party's historical record in the antifascist struggle.

In the novel *Guernica* takes the final place in a world-historical tradition of outstanding monuments, from the Pergamon Altar to Géricault's *Raft of the Medusa,* which reveal an "aesthetics of resistance," although they were created within an artistic culture of power. The underlying assumption is grounded in the famous passage from Karl Marx's *Critique of Political Economy* about the humanism and enduring topicality of Greek art despite its having served a slave society.[35] The young worker's studious if fruitless efforts to politically pinpoint in those art-

works the expression of a "resistance" against the oppressive conditions of their own culture run parallel to his growing disenchantment with Communist politics during the years 1936–39, when the Popular Front was followed by the Spanish Civil War, the Moscow show trials, and the Hitler-Stalin Pact.

At the end of the first volume of *Aesthetics of Resistance,* the young worker, now a member of the International Brigade in Spain, discusses with a severely wounded comrade the special issue of *Cahiers d'Art* devoted to Picasso's *Guernica.* The time is late 1937, when the friends already envisage the defeat of the republic and their departure from Spain. As they are poring over black-and-white reproductions of *Guernica* in the colorful light of an orange grove, the picture only mirrors their imminent defeat, not the will to fight promoted by the publication's text. They are compelled to vindicate its manifest hopelessness as some sort of negative monumentality. They note that "the painful disfigurement of man under the impact of destruction contradicted the Party's view that the fighter had to maintain his strength and unity in any situation" but credit Picasso for enabling the viewer to rely "only on his own perceptions, his subjective associations."[36]

> The attacking force remained invisible in his picture, only the overpowering was there, only the stricken showed themselves. Bared, unprotected, they were exposed to the enemy who was not visible, whose strength was growing beyond measure.[37]

The enemy's invisibility confirms the historical veracity of the painting, which in turn makes up for its political refutation. The viewers relate *Guernica*'s subjective ambivalence, between a sense of defeat and the will to fight, to the political disorientation of the International Brigades. To them, the struggle for the republic had not proved the struggle for freedom they had hurried to join. Weiss dwells on the imprisonments, interrogations, and executions the volunteers endured from the republican authorities dominated by Spanish Communists and Soviet advisers. In the subsequent two-track narrative of alternating sentences, the Moscow show trials of 1937 and 1938 are synchronized with the accelerating republican defeat. If the young Communist worker in Weiss's novel in spite of everything holds on to a defiant understanding of Picasso's *Guernica,* it is because of his own resolve to continue the antifascist struggle. The resolve gets the better of insight to the point that even a defeat like that depicted in *Guernica* is discounted as a temporary setback. The first volume of *The Aesthetics of Resistance* concludes with this

implacable posture. Subsequent volumes continue the chronicle of dis-illusionment. They never return to *Guernica*. At the end of the third and final volume confidence in overcoming oppression within the parame-ters of Communist politics stands disproved, because Communist poli-tics has revealed its own oppressiveness. The Marxist "aesthetics of resistance" remains without a political venue.

Media Strategy

The agreement between the West German Defense Ministry and the McCann Advertising Agency about the "media strategy" to be pursued in the ten-part ad campaign for the *Bundeswehr* stipulated a budget of six million marks and identified the target group as "the total population over age fourteen (48.82 million people)" of the Federal Republic. It was estimated that 63.8 percent of that target group, that is, a total of 31.12 million people, would view the ads. After a two-month period of preliminary talks with the agency, the Defense Ministry commissioned the campaign on 23 August 1989. At this time, the exodus of East Ger-man citizens to Hungary that would trigger the political changes in Eastern Europe two months later was already under way. Yet the min-istry was still operating on the premise of the political and military sta-tus quo, that is, the strategic balance between NATO and the Warsaw Pact, reached on 15 January 1989 at the Third Follow-Up Conference on European Security in Vienna. This conference had been followed up by the Negotiations about Conventional Forces in Europe, begun 9 March 1989, also in Vienna, and concluded on 19 November 1990, with a far-reaching agreement on troop reductions. Thus the ad campaign in-tended to re-enforce preparedness for defense came in the middle of a decisive bilateral disarmament initiative. The formal, semipublic brief-ing book for the McCann agency was issued on 3 December 1989;[38] and the ad campaign ran through the summer of 1990, concurrent with the second Vienna Conference. The classified record of political delib-erations the agency held with representatives of the Defense Ministry, and within the agency itself, has remained inaccessible to me, but I as-sume the campaign was intended to provide an instant domestic politi-cal counterweight to these disarmament initiatives. It was to safeguard public support for a conscript army at a time when combat functions of the *Bundeswehr* were being reduced, and when West German diplomacy abroad was working toward troop reduction. The policy exposé agreed

upon by the Defense Ministry and the ad agency described the public attitude to be corrected by the ad campaign with the sentences: "The *Bundeswehr* is redundant. It no longer fits into a phase of general détente."

As the Vienna Conference deliberated and the ad campaign was being prepared, the precipitated collapse of socialist governments in Eastern Europe made German reunification the declared policy goal of the Federal government almost from one month to the next. The main problem resulting from this policy reorientation was continuing NATO membership of a unified Germany, to which the Soviet government was initially opposed. Only by offering a sharp unilateral troop reduction of the *Bundeswehr* from 500,000 to 345,000 men, far beyond any agreements previously reached, could Chancellor Helmut Kohl, in a dramatic meeting with Soviet President Mikhail Gorbachev at Stavropol on 16 July 1990, overcome Soviet security concerns. Accordingly, it would appear, the Defense Ministry and the ad agency adjusted the campaign in mid-course, stressing both disarmament and military strength as factors contributing to the agreements reached. The most extreme statement was to be an ad consisting of nothing but the slogan "To become redundant is our highest goal," printed white on black. Here, the political ambivalence of defense and détente would have reached the point of paradox. The ad was never produced, and the campaign was prematurely stopped. All concerned agreed that the propaganda no longer fitted the new political situation.[39]

The advertisement most directly illustrating the notion of a defense posture without an identifiable enemy featured a photograph of a West German army officer hosting three officers of the Warsaw Pact, one Soviet and two East Germans, as official observers of a military exercise, certified by laminated security badges dangling from their uniforms, all studying their maps of the terrain. The headline "We are happy to let [others] look into our cards [or maps]" played on the double meaning of the German word *Karte,* which denotes both a map and a playing card. The accompanying text was a short summary of the agreements reached at the Conference about Measures to Establish Confidence and Security held in Stockholm between 1984 and 1986 and confirmed in a final document to take effect at the beginning of 1987. The agreement gave signatory states the right to perform ground and air inspections on each other's territories. Military observers from signatory states had to be invited to military exercises involving more than 17,000 soldiers six weeks ahead of time. In the case of military exercises involving more than

75,000 troops, notification periods of two years were stipulated. When the Vienna Conference of March 1989 proceeded to allocate precisely limited numbers for five categories of heavy weapons—tanks, armored personnel carriers, artillery, fighter planes, and assault helicopters—to meticulously circumscribed areas of the entire European continent, the mutual accountability of defense positions between the potential enemies of the Second Cold War was completely regulated. Military security was abstracted from threats to potentials, from potentials to force counts, and from force counts to mathematical equations of mobility and firepower. But when the multilateral agreement was finally signed in Vienna on 19 November 1990, the confrontation had ceased to exist. On 25 February 1991, the military command structure of the Warsaw Pact was formally dissolved. As far as the Federal Republic was concerned, it had absorbed its former opponent, the German Democratic Republic, including its armed forces, of which some residual, politically screened personnel, and usable equipment were fitted into the *Bundeswehr.*

To insert Picasso's *Guernica* as an abstract image of a hypothetical war without identifiable enemy into the ad campaign was consistent with this security concept. The painting projected as a modern phantom the event no one wanted in the military cooperation between the antagonists of the Second Cold War. The geopolitical arrangements conceded parity of military strength for general pacification. Yet in fact the displacement of war from actual battle into a steady modernization of arms and surveillance technology—to be calibrated in the no-man's land of security conferences, intergovernment telecommunications, spy satellites, and hot lines—made it possible to sustain the ongoing conflict in which capitalist eventually triumphed over socialist powers. One of the official briefing books for the ad campaign made it clear that even after retreating from Eastern Europe the Soviet Union would continue to be not only the dominant military power in Europe, but a global nuclear power.[40] But although in the popular visual culture of capitalism Picasso's *Guernica* had been habitually invoked to visualize fears of nuclear war, the ad campaign never touched upon the question of nuclear armament. A reduction of conventional forces was sufficient to forestall the Soviet military doctrine of driving U.S. forces out of Europe in order to deny them launching areas for land-based nuclear strikes. Since concurrent negotiations about intermediate nuclear missiles eventually removed the threat of such strikes as well, the doctrine had become

moot. The end result of all these agreements was a strategic readjustment that allowed the Soviets to sacrifice socialist governments in Central Europe.

Accordingly, the official and commercial framers of the *Bundeswehr* ad campaign were faced with a political quandary. It resulted from the unexpectedly speedy success of their ideological formula. On the one hand, they sought to convey to the West German public the political payoff resulting from the increasingly abstract processes of foreign and military policy driving the Second Cold War during its final phase. On the other hand, they sought to persuade it of the continuing danger posed by possible breakdowns of these arrangements. Picasso's *Guernica,* which in the course of its fifty-three-year-long rise to fame had turned into an abstract image of total war with no combatants in sight, proved to be an apt visual devise for this ambivalent propaganda. The ad campaign even touched upon the painting's original theme: the common fate of soldiers and civilians in a people's war. It postulated the participation of the people in a conscript fighting force as society's politically enlightened assent to a merely hypothetical strategic mission that would not have protected them were it ever acted out. A group photograph of radiant soldiers and sailors representing various branches of the *Bundeswehr* was inscribed with Federal President von Weizsäcker's words: "Our soldiers belong to society and come from society. Society must let the soldier recognize that it wants and needs him." The photograph presented the *Bundeswehr* as a place for professional self-fulfillment and advancement. Thus it restated the notion of a society prepared for total war, which since the Great Depression pertains to the ideologies of capitalist as well as socialist industrial states. People qualified to work on the high-tech level of advanced industrial society are equally useful in war and peace.

Abstract Warfare

The ideology of capitalist productivity as equally beneficial for economic affluence and military security had sustained democratic support for the policies pursued by the conservative governments of the eighties in the United States, West Germany, and elsewhere, who were challenging the Soviet Union for a decision in the Second Cold War. The attendant risk of these confrontational policies was not unintentional, short-circuit nuclear warfare, which haunted Europeans in particular.

The security arrangements themselves posed a greater immediate threat to the capitalist states' own populations than to those of their adversary. Maladjustment of the correlation between military policy and civilian technology prompted two spectacular reenactments of the deadly configuration of airplanes and civilian victims pictured in Picasso's *Guernica*.

On July 3, 1988, at the height of the international proliferation of the six-year-long border war between Iran and Iraq, the U.S. destroyer *Vincennes* patrolled the waters of the Persian Gulf to protect Kuwaiti tankers sailing under the U.S. flag from attacks by Iranian speed boats. The ship's electronic battle station, geared up for all but automatic operation, had been designed for integrated warfare on the Atlantic or Pacific Oceans, where the operations of battleships, submarines, and aircraft are coordinated with one another in the growing spaces of hundreds of nautical miles and the shrinking times of minutes and seconds for almost instantaneous alternations between threat and guard, attack and defense. Such a weapons technology was not suitable for the narrow topography of the Persian Gulf. Moreover, the electronic battle station of the *Vincennes* was incapable of automatically distinguishing between radar signals of large passenger and small combat aircraft. A radar signal from an Iranian Airbus passenger plane in transit triggered a breakneck, seven-minute automatic process of flawed observations, decisions, and reactions that led the ship's captain to mistake the passenger plane for a combat aircraft on attack and destroy it with two surface-to-air missiles. All two hundred and ninety passengers and the crew were killed in the crash.

The tactical video equipment of an electronic warship such as the *Vincennes* projects signs for unknown, friendly, or hostile aircraft, surface ships, or submarines, which the computer has generated through processing of the radar tracking information, onto a map of the area, where such signs move in all directions. But, different from a radar screen, the electronic image reproduces neither the objects nor their relations in space. It is an interpretative translation of radar data into a fictitious, and, as it turned out, erroneous computer picture. In the narrow topography of the Persian Gulf, to distinguish a passenger from a combat aircraft would have required a voluntary response from the potential target on a so-called transponder to identify itself as friendly or hostile. In the absence of such a communication from the presumed enemy—which might be compared to the unequivocal color codes of the uniforms on eighteenth and nineteenth-century battlefields—the task of telling

friend from enemy was left to the collective interaction of a group of people relying on a self-circuiting array of electronic machines.

A commission of the U.S. Congress apparently has determined where exactly in this electronic net of observation, evaluation, and response the human lapse occurred that resulted in the targeting of a non-hostile aircraft for erroneous destruction. In the division of functions between the receptive SPY1-A observation radar installed at the front and rear of the ship, the interactive SLQ-32 hostile radar-tracking radar at the ship's sides, and the proactive missile guiding radar installed on top of the bridge, the extreme contraction of response time between jet aircraft and missiles on a diametrical collision course likely disrupted the regular identification process. In any event, it is this "real-life video game," as the press called it,[41] which, just as in the video games of real life, was destined to be lost sooner or later in the eyes and hands of those who were both observers and actors, since human eyes and hands were in the end no match for the equipment.

On 28 August 1988, eight weeks after the Airbus catastrophe, at the annual U.S. Air Force show held at Ramstein Airfield, the Italian aerobatics squadron Frecce Tricolori performed a program of coordinated demonstration flights of such calculated recklessness that three of the aircraft collided at the lowest possible altitude and crashed right into the audience. Seventy civilians and all three pilots were killed. It was, and still is, the practice of NATO air forces to garner political support in the populace of industrial democracies by capitalizing on the aesthetic mass appeal of advanced arms technology. In West Germany, the task of strengthening political support was particularly urgent, since increasing numbers of citizens had come to resent the practice flights of screaming jet fighters over densely populated residential areas with their attendant crashes.

The colorful visibility of jet fighter squads emitting smoke trail patterns in the sky at medium altitudes is the opposite of their near-invisibility in combat, which is dependent on flight at either extremely high or extremely low altitudes. Flight in high altitudes gives the aircraft the advantage over others who will not match their speed and uplift in changing conditions of atmospheric pressure. Flight in low altitudes less than a hundred yards above ground cuts the visibility and target angle of surface-to-air missile batteries, and allows an aircraft to slip under radar barriers. The closely packed formations in which military aerobatics teams such as the Frecce Tricolori perform are anachronistic reminiscences of the dogfights in the First and Second World Wars. There a suc-

cessful kill required a fighter pilot to position himself close to the tail and under the belly of the enemy airplane and take visual aim at the target above with cannon and machine guns configured in the shape of the airplane itself. Conversely, head-on flight toward an enemy was the surest evasive maneuver of an airplane on the escape. Combats of contemporary jet aircraft operating at multiple supersonic speed, on the other hand, are so keyed to long distances that proximity to the target, even its visibility, must be avoided. These aircraft shoot across several miles with heat-seeking or camera-guided missiles, aided by electronic far-range video viewing and radar tracking devices that substitute direct vision with the study of electronic images on cockpit screens. Hence the Frecce Tricolori were flying in a manner alien to their combat function and contrived for the artistic display of the machines. Packing spectators in the stalls of Ramstein airfield so closely that an instant mass killing was assured in case of accident, the show of the Frecce Tricolori highlighted the destructive configuration of the people with the technology of their alleged defense in a nuclear war. Dramatic press photographs showed amateur photographers on the run from flames, camera with zoom lens dangling from their neck. One of them was turning back to shoot the burning aircraft wreck at close range, the glow of the flames illuminating a white polo shirt, clicking to the last.

The targeting display screen in the battle station of the *Vincennes* recalls the video image of *Guernica* on the observation screen of Herikberto's comic an extra-terrestrial spaceship (see p. 78). The visual representation of events, real or imaginary, which such electronic images convey is apt to obscure the dynamic connections between the calculating conceptualization of contemporary warfare, the systems-bound, decisionless automatism of its preprogrammed operations, and the economic preconditions of their technological development from the production processes serving industrial society at large. Since electronic imagery has become an operative mode of this society, it acquires a pseudo-documentary authenticity that makes events appear automatic, with a profusion of victims, to be sure, but without identifiable perpetrators. Picasso's *Guernica* might still serve to illustrate this state of affairs if the absence of the enemy in the painting were taken at face value. That the enemy is in fact identified, outside the picture, for all to know if not to see, has invested the picture with a judgmental force to which the image of the event itself is incidental. Today, the conventional pathos formulae displayed by three animals and five human beings in black and

white, contrived by an artistic individual after months of reflection, no longer holds up to the comprehensive colorful visual documentation of war catastrophes, instantly filmed, printed, and electronically transmitted worldwide. The disparity between image and reality served *Guernica*'s critics already at a time when all-out photographic documentation of war atrocities, although technically feasible, was not yet generally admitted to the public sphere. It is the painting's Manichean topology of political crime bearing down from heaven onto defenseless, suffering victims on the ground, the certainty of good and evil, of right and wrong, which makes it obsolete. Nobody wished to wage war against the unsuspecting passengers of the Iranian Airbus; only the excessive projection of military power to protect the oil supply for the advanced industrial states took precedence, in the judgment of U.S. officials, over the safety of civilian aviation. Out of admiration for up-to-date war technology, West German spectators of the Ramstein air show with their cameras and video recorders congregated to airplanes that were crashing into them; only the public relations policy of NATO strategy failed to allow for the high-risk recklessness in such a dysfunctional show of arms. In both cases, investigative committees, like those vainly demanded for the bombing of Guernica, were expeditiously installed. These committees merely posed technical, not political, questions. It was easy enough for them to prove and to concede that no one had wanted, much less planned, those war catastrophes in peacetime, that they were merely the outcome of human error. The staging of an aggressive confrontation policy as preparedness for defense remained exempt from questions of guilt.

Political Partisanship and Ideological Contemplation

No matter how firmly the program of the Spanish Pavilion at the Paris World Exposition of 1937 set the terms for an understanding of Picasso's *Guernica* as a propaganda image on behalf of the armed struggle for a just cause, it has remained an open question to this day whether the mural was in compliance with that program, especially considering its manifest lack of assurance about the victorious outcome of the struggle. When Eluard concluded his *Guernica* poem with the defiant words "Nous en aurons raison"[42]—"Our cause will be proven right"—he reaffirmed the traditional, "objective" world-historical calculus of Communism, which postulated that defeats would ultimately be re-

deemed by victory. From the same point of view Blunt rejected the picture, insisting that Picasso "should have realized that [the mere horror of the civil war] is only a tragic part of a great forward movement."[43] For Blunt and for some of his friends, the alternative posed by *Guernica* was no longer that between a contemplative and an agitational art, but between ideological culture and political practice. They joined the International Brigades, he worked for Soviet intelligence. Prime Minister Margaret Thatcher had it right when on 20 November 1979 she declared to the press: "The question in the Blunt case is not what views people hold but what actions they undertake."[44] Left-wing intellectuals in capitalist democracies after the Second World War, with little opportunity for action beyond demonstrations and declarations, introverted the call for partisanship into writings and debates. They clung to the orthodox Marxist equation between the course of world history, the progress of rational experience, the radicalism of artistic avant-gardes, and the worldwide progress of socialism.

In the moral distinction between good and evil, in the political assignment of Left and Right, and in the historical dynamics of defeat and victory, *Guernica* was equivocal from the start, not for its lack of realism, but for its lack of an articulate political judgment. The contrary responses of Eluard and Blunt, both committed Communists who drew assurance from the same orthodoxy, paralleled the political disorientation Picasso shared with Left-wing artists and intellectuals during the three years preceding the Second World War. Under the pressure of fast-moving historical events, of abrupt tergiversations by European governments with a stake in the Spanish Civil War, of expedient adaptations to changing cultural policies by artists and intellectuals in search of work, and of vacillations of opinion on the part of individuals trying to make sense of history, no answer offered more than transitory assurance. When in 1937 the world's most famous modern artist engaged himself for a political cause which a majority of Left and liberal constituencies judged progressive and just, his commentators instantly celebrated *Guernica* as the topical and monumental confirmation of a revolutionary art of the avant-garde, whereby Picasso continued the tradition of Goya, Delacroix, and Courbet. Within two years this ideal of an unconditional, and at the same time politically effective, rallying to the antifascist cause of freedom stood exposed as an expeditious ideology and existential self-delusion. This was not just because of the defeat of the Spanish Republic, but because of the policies of the democratic states

and the Soviet Union, which almost until the first day of World War II could not decide whether to fight Hitler or deal with him. Disappointed about the betrayals of those times, Leftist intellectuals have often argued against *Guernica*'s claims with much exasperation. To them, Picasso's picture seemed to mirror the powerlessness of their own confinement to a dissident culture.

Günter Grass's misunderstanding of the term "foe image" in the *Guernica* advertisement of the *Bundeswehr* illustrates this exasperation of Left-wing culture about its political dysfunctionality under capitalism. His demand for an apology by the German defense minister to the people of Guernica was a call for an empty gesture without political purpose. The end of the confrontation between capitalist and communist states left him no political target to protest. The misunderstanding itself is symptomatic of how a self-referential, self-confirming ideology can turn dyslexic. Grass did not even touch upon the military situation for which the advertisement was intended, no matter how extensively this subject was being debated in the public sphere. An abstract Left-wing pacifism such as his errs on both sides of a reasoned correlation between the historical past and the political present. Historically, Picasso's *Guernica* was no antiwar picture, but a propaganda picture for a people's war, a denunciation of war crimes in the name of political partisanship and military resolve. Politically, the Second Cold War was conducted in the form of abstract strategic calibrations that could no longer be translated into a convincing military policy for the public sphere. It was no longer possible to take a stand for a palpable political goal, such as the demand for unilateral disarmament made by the peace movement in which I participated during the eighties. It had become pointless to protect *Guernica* from desecration, as Grass wished, because the picture no longer offered the visual coordinates for reasoning out the required connections between historical processes, political judgments, and visual experience.

Historical Objectivity and Political Critique

Picasso's *Guernica* has been the most significant piece of evidence for the moral revalidation bestowed on modern art after the Second World War as the result of its suppression by the National Socialist regime. The pacifist abstraction of this morality has made the painting into a mindless visual formula for denouncing mass killings of civilians and wholesale

destructions of their habitats in the unending chain of regional wars all over the world. The visually inaccurate assumption that the picture shows merely civilians victimized by the military has depoliticized the notion of the people just as thoroughly as it has demonized the military and has left the political nexus between the two forgotten. In 1968–74, the international protest movement against the American war of intervention in Vietnam and against the American-supported toppling of the popular front government in Chile invoked *Guernica* once more. It was the last time the painting would be embraced by a tradition-conscious political culture of the Left. This was a culture of active partisanship for a clearly defined goal, no matter how hypothetical that goal remained, founded in a mutually reenforcing assurance about what one fights against and what one stands for. With communism's fall, this kind of assurance has gone, even though the cause remains. Since then, *Guernica* has been reabsorbed in the politically inconsequential, periodically dissident mentality Grass shares with Left-liberal culture everywhere.

As long as it is not calibrated on the ideological coordinates constituted by communism and democracy, the debate about the relationship between modern art and progressive politics inaugurated by *Guernica* remains inconclusive. Since communism and democracy have been mutually exclusive until now, and since the political ambitions of modern art depend on democratic politics, the political field of conflict for which *Guernica* was made was bound to be ignored. And the picture's detachment from its historical origins has furthered its removal from a pertinent debate. For forty-eight years the artworks, photographs, graphic charts, and installations of the Spanish Pavilion at the Paris World Exposition of 1937 were presumed lost. Their historical memory was all but narrowed to Picasso's painting. All the more readily was the artist transfigured into the sole author of its message. *Guernica*'s poster-like effect intensified the enigmatic spell it acquired by default. Its rectangular composition of eight figures, simplified to maximum clarity, cast in black, white, and shades of bluish gray, as if illuminated by a spotlight, has burnt itself into the public conscience. The accompanying historiography has canonized it as the absolute paradox of an antifascist, and yet nonpartisan, masterwork.

The rediscovery, in 1986, of most of the art of the Spanish Pavilion in a forgotten or concealed depot of the Barcelona Art Museum has changed all that. In 1986 and 1987 these materials were made available to the public in two large exhibitions and accompanying catalogs.[45] Neither the German Ministry of Defense and its advertising agency nor

Günter Grass seemed to know them, however, when in 1990–91 the *Guernica* ad of the *Bundeswehr* was created and debated. Even today, the rediscovered art of the Spanish Pavilion is only marginally taken into account in the *Guernica* literature. Yet it allows the first opportunity to pinpoint *Guernica*'s political significance historically and thereby to release the painting from the incongruous topicality of its afterlife.

FOUR

A Comic Strip about the Communist Reversal of History and Its Attendant Neuroses

Self-Diagnosis of a Politburo Member

In the spring of 1993, Günter Schabowski, the last Berlin Communist Party secretary at the end of the German Democratic Republic and a member of the East German Politburo, published a self-critical essay, "Self-Delusion."[1] In it, he attempted to come to terms with the failure of his way of thinking as a leading Communist politician. Schabowski diagnosed this thinking as a "power neurosis," to which he ascribed "the paranoid quality in Communist world view and thought." What he had in mind was the reckless self-assurance of leading Communist elites to hold onto a categorical socialist world view over and against all experience. The claim of these elites to act on behalf of true political doctrine on the one hand and their unassailable control of party power on the other functioned as mutual reinforcements. Doctrine justified power, and power enacted doctrine with no regard to the credibility of doctrine and with no political accountability for failures of power. In several books and articles, Schabowski has since attempted to define the typology of the Communist leader operating on this premise: He "personifies the syndrome of delusion, which is widespread in politics, is curable in a democracy, but ends in self-destruction in a socialist dictatorship."[2] The disintegration of a political system whose leaders are shielded against their refutation by reality results in a particular mix of experiential blindness, moral self-abandon, and psychic deformity.

Schabowski circumscribes the reality-blind vision of his past political work with the metaphor "iconostasis of the communist future,"[3] in memory of the resplendent iconostases he used to admire in Russian Orthodox churches when he was attending party schools in Moscow.[4] The picture-laden screen before the sanctuary bars the community assembled for the Orthodox service from witnessing the liturgical proceedings of the priests inside. Schabowski's metaphor draws on the commonplace understanding of Communism as a religion rather than a rational theory. He compares Communism's speculative projections, based on presuppositions that remain exempt from verification, with the suggestive power of sacrosanct images to substitute for the perception of an invisible truth. The discrepancy between those projections and the actual course of history results in a "neurotic understanding of power."[5] The interrelated metaphors of neurosis and icon circumscribe the fundamental problem of Communist governance: "Once legitimization and power were elevated into ideological categories, Communism entered an area where mounting problems could find no solution, because they could not be perceived."[6]

In his 1993 essay, Schabowski makes it appear as if Communist leaders and the disenfranchised people of their states shared in the blindness vis-à-vis the political process. He describes it as "a classical Kafkaesque situation" when his government was unable to consistently enact its own passport laws regulating travel to the Federal Republic and therefore left visa applicants in the dark about the reasons for their acceptance or rejection.[7] When Schabowski was visiting Moscow, his counterpart, Moscow Party Secretary Boris Yeltsin, told him about a political remedy to the housing shortage: "Isn't that a scandal? I have telephoned the minister of health. In the dead of night. See to it at once that two hundred psychiatrists from all over the Union be deployed in Moscow!"[8] Schabowski represents the psychological afflictions caused by the enforcement of a policy without rational foundation, without verification in reality, and without accountability as a closed circuit of reciprocity between the rulers and the ruled. Communist regimes fell when in the end a majority of their populations broke the circuit.

Elsewhere Schabowski relates that he was dispatched on an official fact-finding mission to China shortly after the massacres on Tiananmen Square. He was stonewalled by the new General Secretary Jiang Zemin but did not find the declarations of the rebellious students "objective enough" either. As he would not rely on reports in the press of capitalist

countries, Schabowski ended up with no view of the event at all. As a result of this lack of perception, the East German Politburo was able to act in a contradictory way. Alone among party leaderships of the Soviet bloc, it conveyed to its Chinese counterpart its solidarity with the military crackdown of the uprising. But it did not take similar action when the time came to face the uprising of its own population two months later.[9] Only during his last year in office as a Politburo member, Schabowski maintains, did the irrationality of this mode of operation dawn on him. Then he proceeded to scheme against his superior, East German Party Secretary Erich Honecker, and, to believe his account, succeeded in bringing Honecker down. But he was unable to change, and thus preserve, the system.

Christin's and Bilal's *Hunting Party*

Schabowski's essay "Self-Delusion" reminded me of a famous comic strip album I had been concerned with for many years: Pierre Christin's and Enki Bilal's *The Hunting Party* of 1983.[10] In 1984 this album had been the first to alert me to the contemporary-historical relevance of the comic strip medium,[11] but not yet to the systemic problems of communism that form its theme. *The Hunting Party* deals with the "neurosis" of Communism in a melodramatic story spanning the history of the Soviet Union until then. It narrates the assassination of a newly appointed, hard-line member of the Soviet Politburo who is in charge of relations with satellite parties in Eastern Europe. His predecessor assembles a conspiratorial group of old, disenchanted party functionaries from Poland, Bulgaria, Hungary, Rumania, and Czechoslovakia for a hunting party, in the course of which the successor falls victim to a feigned shooting accident. When the album first appeared in 1983, in Poland the first Communist government of Eastern Europe had lapsed into a prolonged crisis. It could only maintain itself by means of a military state of emergency and never regained legitimacy, until in the summer of 1989 it became the first to be brought down. The Poland crisis inaugurated the historic decline and, finally, collapse of Communist governments that took place everywhere in Eastern Europe during the fall and winter of 1989–90. Less than a year later, *The Hunting Party* was republished in a new edition as part of Bilal's collected works.[12] Its newly acquired topicality prompted the authors to add a nine-page appendix of texts and images, entitled "Epitaph (1990)," which takes the historical develop-

ments into account and brings the story up to date. Seven years after the hunting party, the surviving participants meet at the same place to hatch out another conspiracy. But they are all killed in an explosion of the hunting lodge.

This key work by two of the leading masters of the *bande dessinée* pertains to a particular genre of the contemporary adult comic strip that illustrates contemporary history in a fictitious or fantastic form. In a sophisticated plot to suit its intellectual readers, *The Hunting Party* denounces the Communist mentality as a psychological or even neurotic aberration. The attempt of the old, demoted Soviet functionary and his Eastern European comrades to change policy by murdering his Politburo successor is presented as an effort at correcting the course of history in a subjective defiance of the historical logic embodied by the party. But the underlying individual judgment is in turn distorted by the biographical experiences of Soviet history as a personal trauma common to the participants of the conspiracy. For all of them, historical memory is a bloody nightmare. It steels the leader but makes his followers nervous and depressive. Their attempt to change course in 1983 turns out to be just another political crime, which will come back to haunt them fatally in 1990 when they try to repeat it. What would Schabowski say to this popular illustration of his self-diagnosed "power neurosis"? To find out, I sent him the German edition of *The Hunting Party* along with a rudimentary version of the present essay, which had just appeared in a German comic-strip almanac.[13] Then I traveled to the small western German town where he worked in retreat, as sole editor and typesetter of a local ad paper, to discuss the relationship of Christin's and Bilal's comic strip to his "Self-Delusion" essay.

Story Line

The hero of *The Hunting Party* is the octogenarian Soviet party official, General Vasily Aleksandrovich Chevchenko. As a member of the Politburo, he had been in charge of the "brother parties" in Eastern Europe for thirty years after the Second World War. He now has been replaced in this capacity by a younger functionary who pursues a policy of tighter control. A group of second-tier party functionaries from each of the Eastern European satellite states assists the general in murdering his successor. All of them have come to owe him their political or even physi-

cal survival at critical moments during their careers. Ever since they have been beholden to him by personal bonds of unconditional allegiance. Only one, the East German Günter Schütz, is not in on the conspiracy. He threatens to denounce the murder but is blackmailed into silence. After the plot has been accomplished, Chevchenko's personal secretary takes the express train to Moscow to succeed the murdered politician.

Bilal's picture story is set in the sunless countryside of Eastern Poland, with blue-gray brushwood and white snow flurries, and in a luxurious prewar hunting lodge decorated in fading hues of brown and yellow. It unfolds through the variable panel sequences of the classic comic strip emulating film, with abrupt montages of shots from varying distances, dramatic intercuttings of telling physiognomies, and speech bubbles bursting with poignant lines. Historic flashbacks to the old general's biography and political career, extending from his childhood to the most recent past, interlace the story line. They add up to a miniature history of the Soviet Union, from the pan–Slavic movement of the nineteenth century to the Second Word War. Additional flashbacks from the biographies of the Eastern European functionaries continue the historical timeline up to the Soviet political domination of the Eastern European states. At the beginning of the album, Chevchenko's secretary explains to his young French interpreter, an ardent Communist, how much of a share his superior, a "Hero of the Revolution," has had in the triumphs of Soviet history and, by the same token, how much he was implicated in its crimes. "In our camp, it so happens that history is a changing thing," the secretary explains to the young man, referring to the selective writing of history which determines what is remembered and what is consigned to oblivion. As a twenty-year-old youth, Chevchenko was in exile at Lenin's side. During the Bolshevik assault on the Duma he was a soldier holding the deputies at bay. In the Civil War he mobilized peasant volunteers for the Red Army. During the First Five-Year Plan he helped push the breakneck industrialization of the country. And in the Great Patriotic War he served as a troop commander at the front. Yet Chevchenko also had a hand in the bloody suppression of the sailors' revolt at Kronstadt, in the military annexation of Soviet Republics in the Caucasus, in the forcible collectivization of peasants, and in the rounding up of victims for the Great Purge. After the war, finally, as a plenipotentiary of the Cominform, he intervened in East bloc countries to enforce ruthless Soviet control. It was in the course of this

activity that Chevchenko took the Polish, Czech, Hungarian, Bulgarian, and Rumanian functionaries, his personal friends from the time before the war, under his protection when they ran afoul of political trends.

The old general and his companions share an understanding of political assassination as an individual's political initiative to correct the Soviet system, and, by implication, the course of Communist history. Here, the secretary's dictum "that history changes" acquires a new sense, transcending from historical memory to political practice. Chevchenko's adroitness at chess, which he learned as a child, and at the hunt, where no one can match his marksmanship, have shaped his understanding of politics, where individuals must act deliberately. In the return train to Moscow, his secretary explains the assassination to the young interpreter: "His last political gesture is that of a great Marxist, the opposite of what you think. It's the gesture of a man who believes in the reversibility of history." Three speech bubbles in the close-up panels of this dialog sum up the answer to a debate waged in Communist theories of history and revolution. The political adversary's liquidation is to prove that history does not necessarily follow from collective actions by the masses. A determined individual such as the old general has it in his power to give history a new direction—"precisely because he always thinks about the masses and their sufferings."

This is how Schabowski, during his years as the party district secretary of Berlin, tried to act when faced with chronic complaints from the populace about the increasingly dysfunctional Communist administration. His determined stopgap measures were meant to be a principled override of the system. Eventually, Schabowski resigned himself to the "Kafkaesque" futility of any such efforts.[14] As he and I turned the pages of the comic strip, Bilal's gruesome pictures of political crime in the Stalinist tradition prevented him from making the connection with his own regime, which had maintained a flawed but nonviolent socialist legality. We failed to reach an understanding on the point of principle, which is that coercive power need not be violent to damage people.

When General Chevchenko's secretary maintains that his superior is acting on behalf of the masses, he characterizes him according to Lenin's principle, claimed by revolutionary avant-gardes, of leading the masses in their interest despite their lack of assent. With savage irony, *The Hunting Party* illustrates the contrary. Peasants of the surrounding countryside are depicted in squalor watching with dull resentment as their

political masters adopt the lifestyle of the dispossessed aristocracy for whom the castle was built originally. The politicians in turn revel in sarcastic quips about them. Thus, the Bolshevik leadership principle has already been belied when it is finally enunciated in order to justify a political crime. The moral of the picture story is that Communist self-subversion cannot escape the compulsory perpetuation of the course of history it intends to reverse. "You are crazy," the young French interpreter exclaims in exasperation. With unswerving optimism, or total cynicism, the secretary delivers the upbeat answer: "But no, we are not crazy! On the contrary, full of hope." At this point the presumptive readers of the comic strip must surely be convinced of the secretary's self-delusion.

When *The Hunting Party* was reissued in 1990, the pseudo-documentary portraits and brief biographies of the main actors that had been printed on the end papers of the original edition were updated to include information about their fates after their regimes had fallen. The newly added "Epitaph (1990)" consists of free verse printed in small caps, illustrated by one large, tableaulike picture on each page. At the end, a mock collage of international newspaper clippings allows the reader to reconstruct the story obliquely suggested by the verse-and-picture sequence. Enhanced in white, three articles torn out from *Le Monde, Libération,* and *Le Figaro* report a mysterious event in need of clarification. Bilal used the same device in his album *The Woman Trap* (1986),[15] in which a loose-leaf insert in the form of a mock copy of *Libération* carries articles and commentaries elucidating the story line. While the fictitious correspondents of *Libération* must engage in probing speculations, readers of the comic book are in the picture about what has really happened. In the "Epitaph (1990)," conversely, reading the mock press coverage helps to make sense of the picture story.

The printed text of the "Epitaph (1990)" reproduces a speech by Günter Schütz, the East German official who in the story of 1983 is left out of the conspiracy and blackmailed into silence. The speech is addressed to his former comrades, who have gathered again in the hunting castle, unaware that he too has returned to the scene. Schütz knows the secret mechanism for blowing up the castle. It is hidden in the gardener's shack. He presses the button, and the castle explodes in a fireball along with the conspirators. The two-page layout of tableaus and printed verse retains only a single device from the actual comic-strip format: a sequence of small close-ups of the detonator button, repeated on each

pair of pages, which marks the countdown of the explosion. A hand in a leather glove appears pressing the button. Then the button only is visible, its red warning light flashing before it. Finally the button appears alone in an even smaller segment of the room aglow in red catastrophe lighting at the moment of explosion. This subordinate set of panels marks the breakneck timeline of the speech, whose main conceits and subjects are illustrated by the large tableaus. Only the last tableau illustrates the actual scene. It shows a back view of the white-haired orator and perpetrator, as he looks down on the exploding hunting lodge. In the bottom right-hand corner is an insert with the aged version of his portrait from the biographical appendix: Günter Schütz.

Once again, a Communist individual has attempted to correct the course of history singlehandedly. This time, however, it is the most obdurate hard-liner, who wishes to turn history back, rather than move it forward. After the democratic revolutions in their countries, the old conspirators have rejoined in a plot to bring ousted Communists back to power. They seem to be in league with the government of President Gorbachev, for whom Chevchenko's former secretary now works as an adviser. What they do not know is that Schütz is lying in wait outside. After East German Party Secretary Honecker's ouster he had gone insane, had been confined to a mental institution, but had been set loose, and now works as a gardener in the park. Schütz knows the hidden detonator mechanism that allows him to turn the tables on his former comrades. The printed verses of the "Epitaph (1990)" are his address to them, although they cannot hear it. They are a silent soliloquy during the short moments between the push of the button and the explosion, during the seconds when the red warning light is flashing. Paradoxically, this contraction of speech into a flash of the mind takes the form of protracted reasoning.

The title "Epitaph (1990)" establishes the ancient Greek funeral oration as the rhetorical genre of the text. Christin, the learned writer of *The Hunting Party,* observes the genre with mock precision. Schütz addresses his unwitting former comrades down below, as they are gathered in the castle bar nursing gloomy memories over drinks, holding onto bottles and glasses that are half-submerged in crystalline blocks of a salted crust, as if they were petrified fossils, somehow still moving. Reversing the ancient Greek practice of praising the *polis,* which imbues the heroes' death with the significance of a sacrifice to the community, Schütz bitterly dwells on the decay of the socialist state. As he denounces

the opportunistic career moves of each of his intended victims after the historic turn of 1989, he transforms the ancient eulogy of the fallen hero into a contemptuous condemnation. While ancient Greek epitaphs praise the greatness of the present as a result of civic culture by comparison to the undeveloped past, Schütz conjures up the socialist ideals of old against current expediency. Consistently sustaining the reversal of the epitaph genre, Christin parodies the notion of history's reversibility for which General Chevchenko's secretary extolled his superior back in 1983. The desperate obduracy with which Schütz wishes to revive the pure socialism of the past is caricatured as a deranged self-delusion. It appears even more absurd than the expectation of his victims seven years earlier that their conspiracy would lessen political oppression. Yet again, the attempt to reverse history leads to murder.

Neurosis and Nightmares

For all his calculating resolve, the old general is no less neurotic before the fall of Communism than the deranged East German functionary is afterwards. The general is depicted as suffering from mutism, a loss of speech conditioned by schizophrenia, hysteria, and depression. Behind his paralyzed but fierce and craggy features, in his mute but stern and looming presence, his friends can fathom a long life history as the mysterious reason for his suffering and endurance, as the historic as well as existential experience that drives his political schemes. It is not only the simultaneous conscience of historical achievement and political crime—Communism's fundamental contradiction—on General Chevchenko's mind. In 1937 his fiancée, the learned, beautiful Vera Tretyakova, fell victim to the purges of the N.K.V.D., in which Chevchenko himself occupied a leading position. He was not able to prevent her imprisonment and murder, and perhaps was even obliged to acquiesce in it. The short biography attached to Tretyakova's portrait in the appendix describes her as a brilliant theoretician of the Bolshevik Revolution, whose book *Psychoanalysis and Dialectical Materialism,* published in 1926, was removed from Soviet libraries after her purge in 1937. In crucial moments of the story her image arises in Chevchenko's mind. She is his enduring obsession, the erotic personification of his suppressed conscience as a survivor, the driving force of his compulsion to intervene in history. In one flashback the general associates the circular close-up view of his assassinated opponent through the aiming tele-

scope, blood flashing from his forehead as the bullet hits him, with a blood-drenched view of his bride as she must have looked standing before a wall in the cellars of the N.K.V.D. at the moment of her execution. *The Hunting Party* concludes with the lovers' imaginary reunion in death. As the train speeds the general back to Moscow, his scheme accomplished, he turns the murder weapon on himself. The final picture shows him blood-splattered in his train compartment, melodramatically sinking back into the arms of his nude fiancée, a ghostly apparition from the past. On the iced train window the lovers' names, and the dates of their birth and death, appear inscribed as on a tombstone. Murder and suicide have rejoined their erotic biography, which was torn asunder by the deadly contradictions of Soviet history. In the original edition, the back end papers show only Vera Tretyakova's portrait and short vita, as if she were the secret inspiration of the story. In the edition of 1990, another portrait of her, looking emaciated, ostensibly from the N.K.V.D. prison, appears enlarged on top of the page reserved for the three protagonists, opposite the general, above his murdered successor.

With historical plausibility, Christin has dated the appearance of Tretyakova's *Psychoanalysis and Dialectical Materialism* 1926, the heyday of debates about psychoanalysis in the Soviet Union. Wilhelm Reich gave a vivid account of these debates reporting from his Moscow lecture tour in 1929, when Soviet psychoanalysis was already under attack,[16] until it was implacably suppressed a few years later. Since psychoanalysis explains basic character traits through early childhood configurations of family and sex, it removes character from the reach of Bolshevik socialization. A psychoanalytical definition of the individual personality would preclude its transformation into the "New Man," the party's indoctrination scheme of mobilizing a recalcitrant populace for the enforced modernization of the country through the First Five-Year Plan. Soviet psychology true to its political calling had to make slight of any biological, let alone sexual, conditioning of social attitudes. Psychoanalysis, by contrast, in asserting the fundamentally repressive impact of any socialization on the personality's instinctual makeup, could only be skeptical of the character formation to be accomplished by Communist education. Psychoanalysis calls repression by its name in whatever political or social system. In the years preceding the First Five-Year Plan, protracted debates about its compatibility with Communist politics were waged inside and outside the Soviet Union. Eventually the social psy-

chology sponsored by the Soviet government could no longer be disputed on the negative outcome of these debates. This must have been the theme, and the fate, of the imaginary book written in 1926 by Vera Tretyakova, the comic character of *The Hunting Party*. In 1937, when its fictitious author fell victim to the Great Purge, suppression of psychoanalysis was no longer a current theme.

At the time of the "Cultural Revolution" of 1968–73, Marxists in the capitalist West attempted to revalidate psychoanalysis, yet with little or no reconsideration of earlier Soviet debates. Since they worked without any prospects of having their results politically validated, much less enacted, their speculations about connecting sexual and political freedom could do without historical specificity. Herbert Marcuse's *Eros and Civilization* (1955), his representative statement about the relevance of psychoanalysis for the Left, contains no reference to Soviet psychology. His *Soviet Marxism* (1958) contains no reference to psychoanalysis. The essentially utopian outlook of both books dispensed the author from engaging in any realistic consideration of how Marxist political practice would deal with the psychosexual emancipation of the individual. Marcuse's broad public impact during the years 1968–73 put earlier, more complicated efforts at a nonpolitical alignment of Marxism and psychoanalysis, made by authors of the New York Institute of Social Research such as Erich Fromm, Max Horkheimer, and Theodor W. Adorno, to a belated reality test. Christin's psychoanalytical scenario of Soviet oppression, which Bilal has animated with his deliberately corny, melodramatic images of the old general's erotic dreams and memories, makes short shrift of all those psychosexual speculations. Historically accurate, Christin represents psychoanalysis as the nemesis of Communism, to the hyperbolic point of revealing it as the driving force of Communism's self-destruction. The murdered Tretyakova, "one of the most sublime figures of the Revolution," as Chevchenko's secretary remembers her, embodies the unity of revolutionary and erotic experience, commitment, and fulfillment insisted upon by André Breton in his note to the Second Manifesto of Surrealism (see p. 75). It is a unity vainly reclaimed by the New Left and victimized by Communism, at least according to *The Hunting Party*. The general, determined to hold onto the conduct of politics, has lost, forsaken, or perhaps even betrayed it. He has lived the self-denial for the cause, the all-but unbearable split of political action and personal sacrifice. The resulting neurosis has left him speechless. All the more cunning are his schemes, all the more deliberate are his

actions. Communism has become his "reality principle," which the psychoanalysis of the comic strip exposes as repressive. He succumbs to it just when he attempts to regain the initiative and to singlehandedly reverse the course of history at the end of his life.

The five Eastern European functionaries who conspire with the disempowered Soviet general to assassinate the upstart Soviet politician, act with an absolute loyalty founded on a common life history that extends over forty years. With historical accuracy, the conspiracy illustrates the pervasive social structure of Bolshevik Party rule, where long-term, mutually protective networks of officeholders routinely worked together and against one another in continuous power realignments, to either brutally enforce or stubbornly resist party policies. Ever since the first systemic purges of 1931–32, such "family" networks have served as vehicles for the political and physical survival of competitive ruling elites in the Soviet Union.[17] In *The Hunting Party,* five extended flashbacks recall critical moments in the history of the Soviet bloc, when General Chevchenko intervened to rescue the careers of his Polish, Czech, Hungarian, Rumanian, and Bulgarian protégés. Those moments come back to haunt them as hallucinations, nightmarish scenes of crumbling walls, inhabited by terrifying monsters, splattered or flooded with blood, set off in pale-orange lighting from the dark, gray-blue or reddish-sepia tones of the main story.

In a tour de force of comic psychoanalysis, Christin and Bilal stage the history of General Chevchenko's "family" into a quasi-orthodox anthropological scheme of Freudian observance. The Bolshevik powerholders' network is portrayed as an aboriginal horde whose every member is tied to the father by bonds of absolute allegiance. The general's "orders have the force of law," as his secretary reminds them. He is the supreme hunter, unsurpassed as a shot. He alone is privileged to have his life, actions, and death founded on a sexual bond: the possession and loss of the beautiful Tretyakova, the only woman in the story. The subordinate functionaries form a male clan of sons whose power codes and rivalries are clean of libidinous aspirations. The absence of women facilitates the perpetuation of the patriarchal power structure. The preeminent politician in the group of sons is Chevchenko's personal secretary, a Russian. His ties to the father figure reach farther back than the rest. He is the first-born, as it were, chosen to replace the outside usurper, whose death the father plots and executes as his last gift of de-

liverance to the horde. Yet in the end, only the father finds deliverance. He is reunited with the female revenant in a transfiguration of love and death, while the sons remain locked in the vicious circle of oppression and crime. Unlike their leader, they have neither a historic consciousness nor a love story, only the visual obsessions of past bloody deeds, triggered by association with environments and objects. Their blind loyalty to the father and the clan, the tested guarantee of their survival, has replaced their sense of history.

In *Eros and Civilization,* Herbert Marcuse attempts to identify the repressive scheme of the aboriginal father who hierarchically organizes the horde's struggle for survival as a model of the historical culture of oppression.[18] The authors of *The Hunting Party* convey to their readers the same scheme for an essentially nonpolitical understanding of history. One of the episodes depicts General Chevchenko's final deployment of the hunters for the assassination in the thick of the snow-covered forest. Writing on a piece of paper with a fountain pen, he assigns each his position. Since the targeted victim alone will not abide by the assignment, he is sure to fall into the trap. In construing Communist social relations on the Freudian scheme, Christin mocks Marcuse's speculations about a Marxist emancipation of society and sexuality for a "libidinous culture" beyond Communist politics.

The aboriginal horde's apostate son is Günter Schütz, the East German functionary, who remains excluded from the conspiracy. When he threatens to denounce the assassination, his comrades confront him, rifles at the ready, but it takes just one deep stare from the general into his eyes to make him keep his silence. Schütz's doctrinal orthodoxy—"brilliant studies of philosophy, then of economy . . . , important theoretical activities, innovative conceptions in matters of production"—sets him apart from the others, political cynics all. He seems to lack their traumatic experiences as well, since the book shows no flashbacks from his past to suggest what memories, if any, he shares with them. Over drinks, the Bulgarian gloomily reminisces about the purges from which General Chevchenko shielded him many years ago:

> Since then, I always have the same nightmare . . .
>
> . . . of an obscene and ambiguous monster that came from I don't know which star, forever frozen. . . .
>
> And that monster, I begin to think, is me . . .
>
> . . . if it is not the Party itself, of which I am merely a cursing mouth, a cruel claw.

Bilal has illustrated the nightmare with a huge female monster, breasts hanging, long teeth protruding from her sea-lion's mouth. "You drink too much," his friends say to console their saddened comrade. But here Schütz steps forth with a categorical rebuttal:

> I have listened to your ramblings . . .
> . . . they don't make me regret to have stood up when I had to against the rehabilitation of Kafka.

Schütz, it seems, was an imaginary participant in the international socialist Kafka conference held at Liblice in 1963 (see page 129), where the East German delegation resisted efforts of their Czecho-Slovak hosts to reclaim Kafka's work for socialist literature.

> But I have always known that [Kafka] was just a bourgeois writer eaten up by pessimism . . .
> I would never have believed that old revolutionary heroes like you could arrive at this kind of idealist nonsense.

Christin's Kafka reference corresponds to interpretations of Kafka current during the Cold War, which has often projected the nightmarish qualities of Kafka's work onto totalitarian regimes.

Reversals of History

In the first edition of *The Hunting Party* the portrait-resume of Günter Schütz was joined to those of his comrades at the beginning of the book. In the new edition, which features Schütz as the hero of the "Epitaph (1990)," it is placed all by itself at the bottom of a plain page that follows the concluding tableau of the "Epitaph (1990)" with the explosion of the castle. Attentive readers will recognize Schütz's portrait as an enlarged section of the episode from the 1983 story, in which the East German politician reaffirms his stand against Kafka's "rehabilitation." In the tableau itself Bilal has redrawn the portrait as an insert, now deeply furrowed by the folds of older age and worry, to reveal the identity of the mysterious perpetrator. It is the final picture in the underlying timeline of small-scale inserts that start with Schütz's gloved hand pressing the detonator button. Is the exploding hunting lodge associated with the castle in Kafka's novel? In this case the repetition of the stern face from the cocktail conversation about Kafka would suggest the orator's obstinate determination to dispel the nightmare of socialist reason.

In the "Epitaph (1990)" the theme of historic neurosis, which afflicts the general and his fellow-conspirators in the original story of *The Hunting Party*, is extended to the outsider of the group. Schütz's lo-

quacity follows upon Chevchenko's mutism in an exact reversal of extreme behavior. His mock eulogy to his unwitting former friends conforms to the somnambulist dialectics of the revenant:

> You have forced me into silence in the name of a pretended future to build.
> Now it is me who forces you into silence in the name of a true future to rebuild.

It is the dialectics of a reversible history which back in 1983 General Chevchenko's secretary had explained to the French interpreter as the guiding principle of his superior's actions. Now it serves the crazed doctrinaire as a reason for his ultimate act of destruction. The same "revolutionary" dialectics drove Benjamin's inconclusive speculations about the Angel of History fifty years earlier (see pp. 29f.). The comic strip exposes this dialectics for what it has become, if not for what it has always been. Christin and Bilal have illustrated it with the rhetoric and imagery of the First Five-Year Plan, already Benjamin's ideal of 1933:

> Like our hydraulic engineers, we wanted to make
> Rivers back up to their fertile source.
> Like our soul engineers, we wanted to prevent
> History from flowing down the bad descent.
> The rivers are sick. History too . . .

The first two tableaus of the "Epitaph (1990)" counterpoint these rhetorical visions with fantastic landscapes from the salt-encrusted surface of Lake Aral, where the forced industrial manipulation of the Soviet territory has caused one of its greatest environmental disasters. Steel hulls of abandoned fishing cutters are stuck in the salt crust, their lifeboats in tow. The head and shoulders of a giant Lenin statue, its arms broken off, emerge from underneath. Desolate Kasakh or Uzbek children sullenly watch. A girl clasps a red Soviet star to examine it as if it were a fossil picked up from the beach. With deadpan triviality, Christin spells out the political symbolism: "Has not the 'real socialism' itself come to resemble an unreal sea?" The red star recurs in another tableau that depicts the hunting castle's drained swimming pool. There the old functionaries linger, heads lowered, drinks in hand, looking down the dry stairs at a huge carved star emblem propped up in a puddle of black mud. "A smell of a sea star about to die," says the caption.

Moments later, after Schütz has blown up the hunting lodge, he restates his revolutionary creed:

> But as for me, I still believe it is possible to make the rivers back up to their fertile source,
> To prevent history from flowing down the bad descent.

Below the last printed line of the "Epitaph (1990)" there appears an abstract, narrow horizontal panel, furrowed by white and grayish streaks. It is imprinted with the last words of Schütz's monologue: "I comprehend myself." Ostensibly the panel is a close-up view of Schütz's brow: white hair, pale ochre skin, and dark-gray eyelid. Yet, turning back to the first tableau, the reader can identify it as a cut-out from the cloudy sky above salt-crusted Lake Aral. The text of the earlier picture concludes with the words: "There is this salty wind in my head, sometimes." The subsequent monologue of the deranged German Communist intercalates this sentence with the sentence, "I comprehend myself." The intercalation yields the verbal clue for the visual blending of cloud and brow. It makes the narrow strip into one of the most radical images of current comic literature, an emblem of the socialist *Cogito sum* at the moment of its dialectical disintegration.

Neuroses of History

Both in the *Hunting Party* (1983) and in the "Epitaph (1990)," the time dynamics of the comic strip with its montages and flashbacks is applied to express the time continuum of history in Marxist theory. The revolutionary movement toward a socialist society makes retrospective sense of history and orients its course toward the goal of progress. On the strength of this reciprocal teleology, Communists have claimed to discern in history a "tendency" toward the victory of socialism even in the face of manifest defeat; to frame their political projections as scientific conclusions from historical analysis; and to justify their policies as the outcome of history itself. Marxist intellectuals in capitalist society held on to this self-serving historiography without the political power of self-confirmation, and thus were obliged to anchor their ideological certainty in a more or less qualified loyalty to the Soviet state. Once the loyalty was shattered, "utopian" projections took its place. Christin and Bilal subject both the coercive as well as the utopian variants of Marxist teleology to dead-pan psychoanalytical clichés. They hold against Communist politics what in 1925 a Soviet critic had held against psychoanalysis: "For Freud, psychic life in its pure form is the life of memories. Neurotics are afflicted by memories—that is the dictum of psychoanalysis."[19] The crazed time inversions of the "Epitaph (1990)" are founded on engineering metaphors from the rhetoric of the First Five-

Year Plan. During that time, contrary to orthodox Marxist projections of a revolutionary transition from industrial capitalism to socialism, the socialist industrialization of an agrarian country was accomplished through political terrorization of an economically undercapitalized and technologically underdeveloped society. This precipitated enforcement of a course of history in 1933 inspired Benjamin to fashion his New Angel in the image of Soviet New Man, whose "humanity . . . proves itself by destruction" and "who would rather liberate men by taking from them than make them happy by giving them [anything]" (see p. 19). Fifty years later, the conviction that the course of history can be forced still motivates Christin's and Bilal's octogenarian Soviet general to assassinate his political adversary. The conspiracy is the last of his interventions. Yet only his ensuing suicide brings him liberation, since it redeems the erotic trauma of his biography. The picture story of *The Hunting Party* exposes the conspiracy as a traumatic reckoning with convergent life stories of personal suffering rather than a calculated act of politics. Seven years later the same belief in the reversibility of history inspires the German functionary to his desperate act of revenge.

Christin's and Bilal's erotic martyr figure of psychoanalysis, the beautiful Tretyakova, recalls the historic suppression of psychoanalysis in the Soviet Union, inaugurated during the First Five-Year Plan. In 1936, the Central Committee of the Bolshevik Party declared that then current practices of psychiatric treatment stood "in flagrant contradiction to Marxism and to the whole practice of Socialist reconstruction which successfully reeducates men in the spirit of socialism and liquidates the survivals of capitalism in economics and in human consciousness."[20] The same year Aron Zalkind, principal proponent of a qualified adaptation of psychoanalytic tenets for Soviet psychiatry, was driven to suicide, having lost out in a protracted series of debates about psychoanalysis.[21] Twelve years earlier he had confidently projected a psychogram, a psycho-physiological pattern, of the ideal Communist[22] that would have fitted General Chevchenko, the hero of *The Hunting Party*. The psychogram includes single-minded concentration on revolutionary activity; avoidance of abstract, impractical thought; assumption of leadership and control of subordinates; emotions of constant risk; and recognition that any particular fact must be linked to the goal of revolution. Such traits require a high degree of sublimation for channeling the libido into social activity, a sublimation to be main-

tained by psychoanalytical treatment in case of a neurotic lapse. At the time of the First Five-Year Plan, Zalkind promoted mental health care for party activists, in order "to guard against neuroses, and to seek psychotherapy in case preventive measures proved inadequate."[23] His recommended treatment was to apply Pavlovian reflex therapy to syndromes of psychoanalytic illness. Zalkind thought he could reconcile behavior psychology, required for the individual's successful adaptation to the stressful demands of modernization according to codified party programs, with a Freudian concern for the fateful conditioning of individuals by their preconscious past. He would have been an apt analyst—if not a therapist—for the harried participants of the hunting party. He understood the contradictions of politics and personality in Communist life. In his keynote address to the First Congress on Human Behavior in Moscow, held in 1930, he unequivocally stated these contradictions:

> Now, *for Freud* man exists entirely in the past. This past is at war with the present, and it is more powerful than the present. *For Freud,* the personality poses an elemental gravitation toward the past, and attempts to fight the past from the standpoint of the present lead to profound tragedy.[24]

Zalkind also realized that psychoanalysis would no longer be needed to deal with the neuroses of individuals prepared to function within the Communist system, as long as the system's ideological coherence could be overridden by the necessary social adjustments. Christin and Bilal have issued Zalkind's Freudian diagnosis to the participants of the hunting party without, however, offering any psychotherapeutic cure for the traumas of Communist conformity, and without failing to denounce the repressive Soviet psychiatry installed to make short shrift of those traumas. During a dinner conversation at the hunting lodge one night, talk is about a Polish functionary who could not stand up to the Solidarnosc opposition and who "has left the country to undergo treatment in a clinic at the outskirts of Moscow." Schabowski, too, recalls how a member of the East German Politburo, removed for his dissenting views on economic policy, "disappeared for a while in a psychiatric clinic, deemed in danger of suicide. Nothing bears out the suspicion that this was initiated by Honecker, and that it might therefore have been a case of political psychiatry."[25]

For Bilal, the fantastic format of the comic strip proves an apt device for illustrating the unresolvable political contradictions between analy-

sis and adjustment in Communist psychology. The comic's structural manipulation of timelines allows for a visual mix of experience, memory, and projection that presupposes telepathic or pathological distortions of the mind on the part of both heroes and witnesses of contemporary history. The blending of historical nightmares into the story line mirrors the mindset of political neurotics. In *The Woman Trap* (1986) Bilal has used the technique again to illustrate the mental derangement of the two main characters, witnesses to a futuristic decay of capitalist civilization. Dispatches filed by the beautiful newspaper reporter Jill Bioskop about political gang warfare in London and Berlin in the year 2225 are printed in a fictitious 1999 issue of the newspaper *Libération* as plausible political projections. In the end they prove to have been nothing but drug-induced hallucinations, from which the reporter awakes as from a dream. Jill's handsome male counterpart, Alcide Nikopol, the rebellious astronaut dropped from the sky, sees events through telepathic intuitions while he is confined to a mental hospital. In both "cases," psychically enhanced experiences of contemporary events drive the individuals to nervous breakdowns. He in turn calls even Horus, the god from the Egyptian pantheon who intervenes in political affairs on earth, a paranoiac in need of psychoanalytic treatment.[26] In his picture book *Original Size* (October 1991), Bilal juxtaposes two illustrations of his pair of heroes during moments of their afflictions, both stripped down to their vulnerable nudity. The white-bodied, blue-haired reporter stands before the mirror of a shabby, green-tiled bathroom, as she swallows a red pill, water glass in hand, blue tears streaking down her white cheeks. The tanned, muscular Nikopol in his drab, gray cell, starts up from his iron bed, his face buried in his hands because of the unbearable pain historic telepathy makes him suffer.

In "Epitaph (1990)" Bilal has transferred the experiential mindset of neurotic derangement, which in *The Woman Trap* opens up a vision of the capitalist future, to a retrospective of the Communist past. He has transfigured the comic strip medium into a visionary representation of world history. The shifts and blends suggested by the integrated flow of texts and pictures are no longer just to be decoded as technical conventions. They are justified, realistically as it were, by the psychic empowerment or impairment of the characters themselves. Neurosis as a medium of historical experience is the structural extreme of this transfiguration of a style into a mindset. In *The Hunting Party* the moralizing survey of Soviet history unfolds like a classical film, with the main story elucidated

by flashbacks of memory. It is structured according to the visual logic of a seamless flow, adapted from film montage, of variable connections between larger and smaller panels, close-ups and panoramas, telling physiognomies and loquacious speech bubbles. Within the narrative sequence, flashback visions reveal gruesome revenants of liquidated comrades, hanging from gallows or collapsing before execution walls, haunting the survivors of history. Readers are expected to empathize—psychoanalysts, as it were, themselves—with the historical neurosis of the conspirators so as to understand their deliberations and decisions.

From Comic Strip to Tableau

"Epitaph (1990)" is no longer a comic strip. Texts and pictures are detached from one another. Texts are poeticized into a rhythmic cadence of printed lines, pictures are monumentalized into a gallery of square tableaus. The traditional narrative structure of the comic strip is confined to the sequence of minuscule panels showing the red detonator light flashing ever more urgently. The final page of *The Hunting Party* already comes close to this format. It consists of two large rectangles without text. The one above shows the outside view of the speeding train with the shotgun blast visible in the illuminated window—"Blam!"—and a splash of blood all over the glass. The one below shows the inside view of the compartment with the old general and his nude bride emerging from imaginary swaths of fog and snow.

In a comment about *The Woman Trap,* Bilal has justified the tableau format as a dynamic development from the pictorial premises of the comic strip:

> I don't feel any more like doing stories with little checker squares. For this story, the classical *bande dessinée* appeared insufficient to me. [. . .] . . . the narrow cutting with dialogues, with onomatopoetics, appeared inappropriate. *The Woman Trap* follows a cinematographic design: more horizontal images, as in cinemascope films. With an average of four frames per page we are far removed from the classical [comic strip] cut of twelve frames.[27]

In *The Woman Trap,* however, the tableaus no longer add up to a self-explanatory picture story. They depend for their understanding on supplementary newspaper reports and literary commentary. In the composition of the "Epitaph (1990)," Bilal has raised the concentration on the single picture to the point where fantastic symbolism altogether replaces

cinemascopic veracity. The tableaus are captioned with excerpts from the printed text, which is modeled on an ancient genre of rhetoric, that is, a nondescriptive type of literature. The text can only be understood as a retrospective commentary on the republished story line of 1983, rehearsing its message with didactic explicitness. The tableaus enrich the commentary with symbol-laden pictures.

The first two tableaus illustrate the political decline of socialist government by showing the physical decay of its ubiquitous propaganda culture. The broken Lenin statue sticking out from the salty crust of Lake Aral is most notorious. It recalls the films, photographs, and debates about the demolition of Lenin monuments that in 1989–92 symbolically dramatized the oblivion of Communist rule. In 1991, Rudolf Herz, the artist of the 1988 *Potemkin* photo installation (see p. 37), designed a project to preserve a demolished Lenin monument by piling up its disassembled fragments so as to commemorate both the monument and its demolition.[28] In the same year, Bilal's *Original Size,* a sumptuous compilation of his recent oeuvre intended to extol his ascent from comic-strip artist to all-round film and theater designer, was published. It begins with a summary of his famous comic-strip albums of the eighties, for which Christin has contributed a short memoir about the "Epitaph (1990)." The writer finds that the ravaged environments he saw on recent trips to the formerly Communist countries of Eastern Europe resemble those in Bilal's tableaus. He concludes: "Bilal must never draw the end of the world, since the world would have to disentangle itself to resemble the one he would have drawn."[29] Drawing on the conceit that modern art anticipates future events, Christin hyperbolically endows the comic-strip artist with the capacity not only to foresee but to determine the course of history. He transfigures him into a prophetic historian in the mold of Benjamin's "Angel of History" (see p. 26). Bilal in fact has done no more than caricature the ruined landscape of which the end of Communism has cleared the view.

A Communist Neurosis

It was Communism in the capitalist West rather than in the socialist East that has given the most poignant, short-term confirmation to Christin's and Bilal's melodramatic story of politics and psychoanalysis, trauma and sex. In his autobiographical memoir *The Future Lasts a Long Time,* Louis Althusser, the preeminent Communist philosopher of capitalist

society after the Second World War, attempts to explain how a chronic and severe psychic illness conditioned his life and thought.[30] The memoir was written in 1985 and published in 1992, two years after the author's death. For decades Althusser had been under almost daily psychoanalytic care. About fifteen times he was hospitalized for long spells of drug and electroshock therapy. During this time he wrote books and articles that were to demonstrate Marxism as a scientific theory, unaffected by the vicissitudes of political history, let alone personal biography. In 1980, a judge declared Althusser's mental illness as sufficient reason not to stand trial for his confessed killing of his wife. These facts were known, but only through the posthumous publication of his memoir did Althusser himself force the question of whether his biography was compatible with his life's work and with the claims it raised. After all, Althusser had been explicating the stringency of Marxism with a depersonalized scientific detachment from the life of the mind. Could an author who was mentally sick by his own admission credibly conceive valid propositions about Communism's irresistible logic, independent of its enforcement by Soviet power?

> If, even in the most dramatic dreams and emotional states, the "subject" is concerned essentially with itself, in other words with internal, unconscious objects which analysts refer to as subjective (in contrast with external objects that are objectively real), the *legitimate* question everyone asks is the following: how could the projections of and investments in these fantasies issue in action and in a body of work (books of philosophy as well as philosophical and political interventions) which were totally objective and had some impact in the real world?[31]

Althusser offers no sufficient answer to this question. In a shorter memoir, *The Facts,* written in 1976, he had already dwelt on his psychiatric case history, still insisting on a convergence between Marxism and psychoanalysis because of their common concern for the repetitive compulsion of human behavior.[32] The longer memoir of 1985 is silent on this relationship.

In his autobiographical review of his political past, Althusser marshals childhood and family pressures to account for that mix of fixation on doctrine and idiosyncrasy of mood that the comic-strip characters of the *Hunting Party* also exhibit. Like General Chevchenko, Althusser acquired his key values from his grandfather, who brought him up in the countryside, long before any political experience. The general's complicity in the N.K.V.D.'s detention and murder of his bride, in which po-

litical obedience gets the better of love, is matched faintly by Althusser's vote for his wife's expulsion from a Communist peace committee:

> When it came to the vote, everyone raised their hand . . . and, to my shame and astonishment, my own hand went up. . . . The Party summoned me, and Marcel August, the secretary in charge of "organization," notified me of the order that I should break with Hélène.[33]

Althusser and the comic-strip figure share the emotional strain of having to bear with oppressive party control to keep a venue open for working political change, with all the bitter resentment that expedient conformity builds up in people with the ambition to lead. In each case, the real and the fictional, the man's self-compromising for the sake of engagement requires a woman's sacrifice.

The title of Althusser's memoir, *The Future Lasts a Long Time,* was apparently intended to retain a confident perspective on his life as a Communist despite all that had happened.

> I do not believe in voluntarism in history. I believe, rather, in intellectual lucidity and in the superiority of mass movements over the intellect. On this basis . . . the intellect can follow the lead set by mass movements, prevent them above all from becoming the victims of past errors and help them to discover truly effective and democratic forms of organization. If, in spite of everything, we still entertain some hope of helping to inflect the course of history, it will be along these lines and these lines only.[34]

This conclusion of the book recalls the young French interpreter's objections to the political murder committed at the hunting party: "History is not made by individuals! It's the masses that count!" To which general Chevchenko's veteran secretary replies:

> Tsss . . . the masses! You make me laugh! If Vasily Alexandrovich and these old militants whom you have seen around him have judged it right to put an end to the activities of the new grand master of relations with the brother parties, it's because the masses are incapable of doing it. . . .
>
> [. . .]
>
> His last political gesture is that of a great Marxist, contrary to what you think. It's the gesture of a man who believes in the reversibility of history.

We may read *The Hunting Party* not only as an apt psychoanalytic caricature of Bolshevism, but also as a satirical refutation of the exalted ideological claims to speak on behalf of mankind advanced by "Western Marxists" such as Althusser. Unlike other Marxist authors of capitalist culture, Althusser did not attempt to reconcile the individual's psycho-

logical makeup with Marxist theory. He concealed and suppressed it under the abstraction of thought.

Sleep or Dream of Reason

Günter Schabowski's autobiographical reckoning, *The Crash,* appeared in 1991,[35] six years after Althusser wrote *The Future Lasts a Long Time.* The contrast between the two titles is suggestive of the intervening historical development. Although Althusser advanced his Marxist convictions on their own strength, independent of political events, he rested what was left of his political self-confidence on President Gorbachev's efforts at a Communist reform in the Soviet Union.[36] By the time his book was published, those reforms had failed, and the title merely reads as the stereotypical expression of hope against hope in the Communist tradition. Just as Althusser had, Schabowski took it upon himself to reason out the mistakes of his commitment to Communism. Unlike Althusser, he is no intellectual, but a political leader born from the working class who ended up on the losing side of the Second Cold War. And since Schabowski lacks a psychiatric case history, to him neurosis denotes no sickness but merely serves as a metaphor. Thus, in our 1994 conversation, he balked at confirming the analogy I had noted between his argument about the "power neurosis" of Communist orthodoxy and the depiction of self-destructive political madness in *The Hunting Party.*

I should have expected nothing else. Schabowski had diagnosed Communist ideology to be irrational in and of itself. In a decisive passage of his article, he refers obliquely to Goya's famous etching no. 43 from the *Caprichos* of 1797–98, *El sueño de la razón produce monstruos.* Since *sueño* in Spanish means both "sleep" and "dream," the title may be translated either as "The Sleep of Reason Brings Forth Monsters" or "The Dream of Reason Brings Forth Monsters." The etching shows a host of owls and bats bearing down on the author, who has fallen asleep over his work. The creatures of the night recall Bilal's monsters haunting the Communist politicians of the *Hunting Party.* Originally, Goya called the subject of the etching, more elaborately, "the author dreaming. His only intention is to banish harmful common beliefs and to perpetuate with this work of *caprichos* the sound testimony of truth."[37]

Allowing reason to sleep calls forth the monsters to be banished by the critical mind on the alert. Schabowski, however, subscribing to a popular misperception of Goya's etching, had written: "Thus it was not really a sleeping, but a busy *Ratio,* a socially and humanly strenuous rea-

son, that was to give birth to monsters."[38] Such a metaphorical assertion of Communism's systemic irrationality ignores its historical specificity as a project of political empowerment, whose psychoanalytic pathology Christin and Bilal have caricatured in *The Hunting Party*. Communism has been irrational as long as its political pursuit has exempted it from critical reason. After the historic critique and the political correction of any such exemption, the relationship between reason and socialism can be redefined.

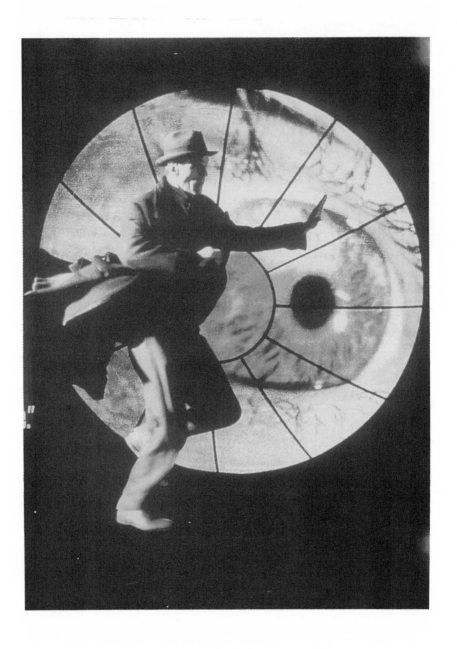

FIVE

Kafka 007

Film

Although the work of Franz Kafka has never yielded an emblematic text or image of use for the culture of the Left, it has been drawn into the field of ideological conflict between Left and Right because of its strong impact on literature and the popular imagination. The word "Kafkaesque" has entered the everyday language of capitalist society, denoting an all-pervasive, menacing incommensurability between the experience and the reality of social relations so fundamental that the question of the political significance of Kafka's work has imposed itself on many commentators since the Second World War. Accordingly, a substantial part of its critical reception and interpretation, insofar as it pertains to social relations, has been conditioned by the Cold War as well. This becomes especially palpable in its numerous cinematic adaptations. One of the last Kafka films, *Kafka,* was produced by American director Stephen Soderbergh in 1990 in Prague, Kafka's hometown and the capital of a recently collapsed Communist regime. It features the writer himself as the protagonist of a story woven from his principal fiction, most prominently *The Castle.* As in that novel, "the castle" is presented as the unapproachable seat of an anonymous power. But here it is the Hradzhin in Prague, ruling not just a village but the city, towering over the roofs, mysteriously lit, looming at a distance from the worm's eye view of the dark streets. A small group of anarchists vainly attempts

to enlist "Kafka" for their struggle against "the castle." Only when "the castle" sends a killer after him does he decide to confront it. Through a subterranean passageway he sneaks into the building and penetrates into the command center, an operating room for the forced medical transformation of captives into murderous agents. He carries in his briefcase a time bomb that will destroy the operating machinery in a fiery explosion.

The story line seems to be modeled on the James Bond films produced during the years 1962–89—the years between the building and the demolition of the Berlin Wall—that met worldwide success.[1] Based on a series of novels by Ian Fleming, they show how a British secret agent, code-named 007, thwarts the plans of SPECTRE (the Special Executive for Counterintelligence, Terrorism, Revenge and Extortion) to dominate the world. Bond, like Soderbergh's "Kafka," sneaks into the adversary's technical command centers to jumble their elaborate machinery until the whole site explodes in accelerating chain reactions. The well-known opening in every James Bond film, a circular view of the agent who swings around to shoot, has been adapted for the *Kafka* poster. It is in turn adapted from the episode "Going after the Red Beast" in Sergei Eisenstein's *Strike* (1923), during which a Tsarist police agent stalks a pair of conspiring workers. A close-up of the agent's eye blends into a projection of the agent's view. As if through a lens, the scene appears curved, distorted, and upside down. The workers notice the agent, point their fingers at him, shake him off, then trap and confront him, and finally throw him on the pavement. This was Eisenstein's adaptation of Dziga Vertov's "Cine-Eye" metaphor, which he converted into his more aggressive metaphor of the "Cine-Fist" (see p. 64). The episode from *Strike* turns the act of seeing into a struggle in which the target discovers and defeats the observer. The Bond film trailer dynamizes even more the violent confrontation through the mechanized gaze. A circular camera diaphragm, moving over the length and width of the screen, is trained on the briskly walking agent in the distance; suddenly the agent swings around at a right angle to fire his pistol out of the picture; the diaphragm fills with red blood, wobbles and sinks, revealing itself as the eye of the dying enemy agent, the outwitted observer. On the *Kafka* poster, the relationship between the figure and the viewer is reversed. The small gray figure of "Kafka" appears running at full speed across the enemy agent's huge, corporeal, colorful eye peering from the background. The eye is an enlarged projection of the agent's gaze through a microscope. The agent is looking the wrong way, through the

objective rather than the eyepiece. Hence his eye becomes visible, but he cannot see, thus losing "Kafka's" trail.

The difference between the Bond opening sequence and the poster of Soderbergh's film is significant. "Kafka" is shown not in pursuit but on the run. Even with his bomb he cannot ruin the castle. He escapes through the tunnel back into the city, where the castle's reign of terror persists. He resigns himself to prevailing conditions and keeps writing. The contrast between the lead actors embodies this reversal from a dare-devil success story to a glum tale of retreat. Sean Connery and Roger Moore, the most prominent of altogether five actors who played the self-assured agent "on Her Majesty's Secret Service," basking in their sexual irresistibility and never short of a snappy retort, are the opposite of Jeremy Irons, the shy, nervous, stammering observer, recoiling from women and reluctantly prompted to speak and to act by his growing indignation. Irons plays "Kafka" as a hesitant, awkward clerk who only becomes deliberate, circumspect, and agile when his investigations expose him, too, as a target for murder attempts. Then he leaps athletically across a windowsill, blocks an elevator door with his umbrella, climbs a crumbling hill slope, splashes an ink blot from his fountain pen to mark the castle's labyrinthine corridors, and balances on the iron frame of the observation cupola as on a circus tightrope, leaving his pursuer behind to crash through the glass.

While Soderbergh in 1990 was working in Prague on his film about a writer's resignation vis-à-vis the powers that be, another writer had just moved into the Hradzhin, the traditional residence of the Czechoslovakian presidents. "Havel to the castle!" posters in the streets of Prague had proclaimed the year before, when the Communist government fell. On 25 November, Václav Havel, the poet of absurdist theater, speaking at a mass rally of half a million demonstrators, had denounced that government as "a neo-Stalinist team." On 29 December, Parliament elected him president. It is his "castle" Soderbergh chose as the seat of evil power. Political reality and artistic fiction seemed at odds. While one Prague writer, having led a peaceful revolution to success, officiated at the Hradzhin as a popular head of state, the film showed another one operating as a bomb carrier in the same building, unable to shake oppression. The contrast was all the more poignant since Havel has named Kafka as one of his literary models.[2] Just when Havel had turned his well-reflected, well-publicized posture as an artist and intellectual— "the power of the powerless"—into a public platform for political change, Soderbergh confronted that model with the age-old question of

whether a writer can affect political conditions he critically describes and used the film template of the Cold War agent to arrive at an answer in the negative.

"Kafka's" investigations and escapes are staged in the glaring black-and-white prospects of the old city of Prague, which Soderbergh has stylized into the kind of nightmarish scene one often finds in popular picture books about the writer. Only when "Kafka" enters the castle does the film turn into color. The city to which he returns stays a misty gray. This haunted cityscape is ultimately derived from a tradition of early German silent films that starts with Paul Wegener's *The Golem* (1920), which is actually set in Prague, Robert Wiene's *The Cabinet of Doctor Caligari* (1919), and Friedrich Wilhelm Murnau's *Nosferatu, a Symphony of Terror* (1922). Soderbergh invokes that tradition by naming the evil physician working in the castle on the operative programming of agents Doctor Murnau. But it is Wiene's *Caligari* that prefigures most closely the scenario of a power-crazed psychiatrist working to terrorize the inhabitants of an uncanny cityscape by means of a hypnotized medium who murders according to his bidding. When the mysterious death of a friend, the anarchist Eduard Raban, alerts "Kafka" to unraveling the doctor's scheme, he reenacts the role of the young Francis in *Caligari*. No doubt Soderbergh was aware of the ideological importance Siegfried Kracauer gave to the figure of a determined investigator tracking down mysterious crime in *From Caligari to Hitler* (1947).[3] Kracauer interprets Francis's efforts to expose Dr. Caligari's hypnotic manipulations as a metaphor for a revolutionary challenge to political oppression. Apparently diverging from the script, Wiene had encased the story line within a framing scenario that eventually reveals it to be merely Francis's hallucination. Francis is an inmate of a mental hospital, and his doctor, who resembles Caligari, claims to know how to cure him. Kracauer reproached Wiene for having turned the action into a proto-fascist cowering before a criminal authority.

The James Bond films ultimately descend from the same tradition of films about fearless individuals exposing evil power. The British secret agent pursues a worldwide criminal organization, operating between the two blocs of the Cold War, that threatens to appropriate the technology of nuclear warfare for its own designs of global blackmail. It sometimes takes the collaboration of the intelligence organizations of East and West to save the world from a nonpolitical variant of their own strategies. The geopolitical status quo of state-sanctioned, globally controlled rearmament appears preferable to the possibility that nuclear

weapons might be misappropriated from their purpose of securing peace. Unlike Francis and other courageous investigators of early German silent films, James Bond acts on no humanitarian conviction. Extreme danger, with the luminous readout rapidly approaching zero, leaves no time for minding moral principles. The British agent's "license to kill" officially exempts him from legality. And in the pursuit of his mission he suspends conventional sexual morality as well. Bond's calculated sexual utilization of women for the purpose of gaining access to the criminal power center transfigures male prostitution into promiscuity of the highest taste. Ever new women, most of them prominent mannequins of the time, appear in each film before the identical hero, a professional actor. He acts decisively; they quickly change their posture from display to self-abandon and love, service and sacrifice. High-class ski resorts, casinos, and beaches of the Western world are apt backdrops for this hedonistic strategy. For the mass public, the luxurious lifestyle of the capitalist upper class seems to have yielded a more compelling justification of the nuclear defense effort than the political freedom of democracy.

In his film Soderbergh has severed the James Bond scenario from the geopolitical topicality of the Cold War. Surely versed in the history and literature of film, he has reconnected it to the severely moralistic case of conscience that Kracauer and later film historians writing in his wake have brought against the scenario of Wiene's *Caligari*. While 007 plots his attacks and trails his adversaries, "Kafka" is drawn into his case, acting on his own, neither on behalf of any organization, nor in pursuit of any political mission. Despite his resolve to clear up the disappearance of his anarchist friend, he rejects the efforts of the latter's fellow-conspirators to draw him into their struggle against the castle. Only when the castle starts going after him does he investigate the threat. Inside the castle, the bomb in his briefcase goes off by accident. Returning from his foray he submits to the corrupt police. When he resumes his writing behind his office desk, he coughs up blood as if his adventure had left him deathly sick. Soderbergh thus outlines a pessimistic picture of literary activity under oppressive conditions.

Politics

The conflict of anarchism and literature played out in *Kafka* facilitates the inconclusive ending of the film, since by definition anarchism is not obliged to propose political alternatives to the power it opposes. The

conflict is abstract enough to keep the story line detached from the historical situation in the city of Prague at the time the film was made, the collapse of an oppressive government with the leading participation of a writer. Had the film been really topical, communism rather than anarchism would have been the touchstone for evaluating the political significance of the seeming submission to authority in Kafka's work. Soderbergh, however, has narrowed "Kafka's" case down to the moral question of how one should behave toward an atrocious superior force that is beyond comprehension and hence impervious to counteraction. He has placed the writer in the milieu that can be least expected to yield an answer, that of the Bohème, where since the nineteenth century literature and anarchism have traditionally encountered one another. At a bar table the conspirators call "Kafka" to account. They hold their meetings among the presses of a print shop. Raban, the small-time clerk, is their point man. In separate compartments of his briefcase, Erich Mühsam's 1913 Munich journal *Revolution* and a home-made time bomb, with an alarm clock as detonator, lie next to one another. It is this briefcase "Kafka" happens to have on him when he slips into the castle. Yet he has declined to write for the journal and has not set the timer of the bomb when it goes off.

In his 1958 biography of Kafka's youth, Klaus Wagenbach attempted to trace Kafka's anarchist connections for the first time. He thought he had the evidence to prove that since 1909 Kafka attended meetings of the anarchists in Prague, took part in their rallies of protest or commemoration, and read the writings of their authorities: Bakunin, Belinsky, Herzen, and Kropotkin.[4] More recently, however, doubts have been cast on the credibility of Wagenbach's two main sources, memoirs by the Czech anarchist Michael Mares and the writer Gustav Janouch, both written and published after the Second World War. Moreover, it has been pointed out that Kafka's diaries, which are particularly detailed for those years, record no anarchist ties.[5] Finally, it has been argued that Kafka's literary works betray no anarchist ideas.[6]

Whatever Kafka may have known or thought about anarchism, did he believe in a workable relationship between literature and left-wing opposition? This is the political question denied in Soderbergh's film. Such a question can be raised only from an anarchist, never from a socialist perspective. Communist Kafka critics of the years 1950–70 always took for granted the political significance of culture and hence the relevance of literature to cultural policy. Accordingly, they were less interested in Kafka's political convictions and activities than in the intrin-

sic socialist significance of his writings, independent of his own conception of the relationship between literature and politics. Disregarding the issue of the writer's conscience, they embarked on a sustained debate about the implied social critique and potential political judgment to be read from Kafka's work, with a view of its limited appropriation for a culture of socialism. Wagenbach had already pondered Kafka's relationship to socialism. He assumed that Kafka's socialist classmate Rudolf Illowý took the writer to meetings of a group of Marxist students and revolutionary Russian émigrés.[7] Merely intent on strengthening his case for Kafka's left-wing leanings, however, Wagenbach made no categorical distinctions between anarchism and socialism. Because of this undifferentiated left-radical viewpoint, he has left pending the question of how literature and political practice relate in Kafka's life and work.

If Eastern European representatives of a socialist literature policy ventured to salvage the work of Kafka, a "bourgeois" writer, from the "decadence" verdict it had incurred from orthodox Communists critics such as Ernst Bloch or György Lukács, it was merely as a poignant expression of a crisis of capitalist society, diagnosed according to a Marxist scheme. Such a social pathology did not require the author to recognize the political causes of what he was describing. Even so, Kafka was taken to task for being caught up in his "bourgeois" class consciousness rather than siding with the "proletariat," and for not envisioning a political solution to the social crisis, a required task of literature according to socialist doctrine. The debate came to a head in the international socialist Kafka conference at Liblice, Czechoslovakia, in 1963. Kafka's most outspoken advocate at the conference was Eduard Goldstücker, a former Czechoslovak ambassador to Israel, who, after having served as a key witness at the show trial against former Party Secretary Rudolf Slánský in November 1952, had himself been condemned to a prison term in the following year and after his release had become a professor of German literature at the University of Prague. Although Kafka was unable to shed his class identity, Goldstücker argued, his "better ego, his heart" was with the workers, so much so that in his writings he sympathized with the proletariat to the point of advocating political struggle.[8] The October Revolution of 1917 had reinforced these sympathies, but Kafka could still not bring himself to take a political stand, one of the reasons, in Goldstücker's opinion, why he left his most important literary works unfinished and judged them to be failures.

No matter how literary scholars and critics in the Soviet Union, Czechoslovakia, and the German Democratic Republic adjudicated the

political questions of class consciousness, realism, partisanship, and historical perspective in Kafka's work, they always argued, expressly or by implication, against the overwhelming popularity that it had gained in capitalist culture, with its proliferating Kafka scholarship and criticism, its Kafka imitators, plays, operas and films. Here socialist critics found Kafka's decadence confirmed. And they charged Kafka himself with the fatalistic sentimentality, the moral subordination, and the apolitical introspection prevailing in Western interpretations of his work, interpretations that validated acquiescence to a universal state of crisis by burying its political causes under a literary mystification and a metaphysics of irreversibility. Socialist government and party agencies in charge of literature sought to forestall such an unwelcome popularity by a guided, selective publication of Kafka's texts just shy of outright censorship. To make a case against this literature policy, Kafka's rare defenders in the socialist camp felt obliged to interpret his work as an inherently Marxist critique of capitalist alienation or even to place the author near socialist opposition movements of his time. This ideologically polarized debate drew Kafka posthumously into a field of conflict determined by the Cold War.

If Soderbergh has moved beyond the Cold War alternative of Kafka interpretation, it is not by reassessing the political significance of Kafka's literary practice, either by engagement or expression, but merely by making literature appear categorically incompatible with any political thought and action. He has attempted to clear up the conflation of literature and politics to which Kafka's work was subject in the age of confrontation between capitalism and socialism by making the conflation itself into the theme of a film story. However, the film turned out to be yet another melodramatic display of "Kafkaesque" conditions.

Office Work

Kafka's commentators have schematized the incompatibility Kafka experienced between his calling as a writer and his job as a lawyer in the Workers' Accident Insurance Institute for the Kingdom of Bohemia in Prague according to modern stereotypes about the strain between art and life, imagination and experience, the former being superior to the latter. They did recognize that Kafka's social views, to the extent that he expressed them in his fiction, were bound to be informed by a professional activity of such unequivocal social relevancy as was his work for the state regulation of workers' insurance. But they valued Kafka's work

as a lawyer merely as a source for his literary renderings of legality and bureaucracy, imbuing his fiction with experiential authenticity but not with reflections of social critique. They hardly ever perceived Kafka's professional activity itself as a realm on which he might have brought his thinking to bear, although his superiors praised him in their job evaluations precisely for the thoughtful fulfillment of his growing responsibilities.[9]

Soderbergh restates conventional notions about Kafka's two-track work as toiling at a mindless job removed from the profundity of writing, in terms of the separation between life and art. His "Kafka," a subordinate clerk, fulfills assigned tasks without gauging their implications. He occupies one of countless desks in a large office. A grotesque supervisor brandishing a watch and a notebook monitors his punctuality. A pompous chief clerk curtly calls him to report, gives him inscrutable instructions, admonishes him for his reserved behavior, and even frowns at his literary ambitions. "Kafka" deprecates his writing before the chief clerk as a pastime that will not affect his job performance, just as he shields it as a self-fulfilling pursuit from the anarchists who want him to write for their cause. But the symmetrical detachment "Kafka" tries to maintain from both power and rebellion does not keep him out of the field of political conflict defining his existence. Unbeknownst to him, the chief clerk is the anarchists' adversary because the insurance agency is an outpost of the castle. What its files record as workplace accidents are in fact murders or abductions. Dr. Murnau, the district medical examiner, whom the records also list as dead, was kidnapped to the castle, where he now works on the medical transmutation of kidnapped workers into agents. Victim and perpetrator at once, he embodies the calculated connivance between risk and insurance, casualty and crime. As soon as the interconnected authorities of the castle, the insurance agency, and the police begin to realize that "Kafka" is about to unravel these ties, they put their killers on his trail. But now the awkward little clerk turns into the agile investigator who nimbly shakes off his pursuers and penetrates the power center—Kafka 007.

Hartmut Binder has questioned the widely held view "that the insurance employee Kafka was a small, insignificant cogwheel of a giant administrative apparatus and represented his resulting anxieties in *The Trial* and *The Castle,* where the principal figures see themselves confronted by impenetrable official hierarchies annihilating them eventually."[10] The fact is that Kafka was himself a high official, and, since 14 February 1922, a leading official of the Workers' Accident Insurance In-

stitute. He was responsible for, among other things, the assessment of workplace safety, which served as a basis for grouping factories into varying risk categories entailing different premiums. He supervised textile, machine, glass, and wood industries in four districts of northern Bohemia and controlled their operational safety on regular inspection trips.[11] He also worked on the formulation and enforcement of safety norms in factories with drilling, boring and milling machines, and in quarries where dynamite was used, drawing on medical statistics about workers' deaths and injuries caused by mechanized blades and dynamite.

Thus, at the highest administrative echelons of a semipublic, government-sanctioned institution implementing social policy, Kafka's job was to regulate the social conduct of employers vis-à-vis the working class. In the complete edition of Kafka's *Official Writings* (1986), editor Klaus Hermsdorf documents this activity and comments at length on its development. Employers under Kafka's supervision tenaciously resisted the enactment of Austrian social policy laws, adapted from Bismarck's legislation in Germany. They contested their risk classifications, disregarded safety norms, tried to thwart plant inspections, and evaded premium payments. The department headed by Kafka was pitted against these employers, no matter how nonpartisan the agency's social policy was mandated to be. Though the department never dealt with policy questions concerning compensation or support payments for workers or their survivors, it de facto represented their side in a class conflict with the employers.

Class Conflict

In Soderbergh's film, social conflict transpires only in the actions and gestures of bureaucrats, terrorists, killers, and police officers, but it remains unclear what the conflict is about. The workers' vital interests are hidden in the file stacks of the record office "Kafka" tends without seeing through the purposes and results of his paperwork. This is why his job is in fact as insignificant as he makes his writing out to be when he justifies it to his superior. Soderbergh construes both in a contradictory symmetry, a fictitious counterpoint of disoriented endeavors, futile alternatives of social oppression and artistic freedom, all of them subject to easy judgment. If both the purpose of Kafka's office work and the subject matter of his fiction are left out of consideration, their relationship cannot be mediated.

Before Kafka's official writings became generally known, political

assessments of his fiction were limited to the question of the extent to which its themes addressed antagonistic class relations of "bourgeois" society in generalized, metaphorical terms. But these writings allow some of the literary themes to be traced back to the issues that preoccupied Kafka as an insurance lawyer, suggesting that the two modes of writing were in some ways related. In 1961, Hermsdorf had implacably taken Kafka to task for "decadently" mystifying social reality.[12] In 1984, in his edition of the official writings, he differentiated his assessment of their relationship to Kafka's fiction, without, however, conceding to Kafka any deliberate reflections of his own about the relationship.[13] That Kafka should have occupied a leading post in an enterprise such as the Workers' Accident Insurance Institute was reason enough for Hermsdorf to account for the unenlightened, or even misguided, political understanding of social subject matter he continued to diagnose in Kafka's fiction. Only a conflict-conscious parti-pris for the workers' plight would have satisfied his Communist viewpoint. But the purpose of the agency excluded such a parti-pris, as long as Kafka's service there was loyal rather than subversive.

Any integral understanding of Kafka's official and literary writings depends on the question of how much Kafka, in the course of his career as an insurance official in charge of policy, remained confident that the legally sanctioned equalization of workers' and employers' interests could be socially enforced:

> And just as every particular question of social insurance irresistibly draws us to the common center of all these questions, where they all find their satisfactory solution, this one as well. Only the largest-possible generalization of insurance can meet the lawgiver's intentions (to make the benefits of insurance accessible to possibly all social strata of the working population) as well as the interests of those directly concerned: the workers, the entrepreneurs, and the Institute.[14]

Thus reads the confident conclusion of Kafka's first long report, written in 1908, just after Kafka had joined the agency as a twenty-five-year-old auxiliary employee, barely a year out of law school. He submitted a stylishly honed, wide-ranging analysis of the functional logic underlying the insurance process that defines "the law" in its pristine form as fitting the reality of social life. During the subsequent fourteen years of his career at the insurance agency, Kafka was apparently hard put to hold onto this initial assumption of a just risk distribution between capital and labor. The administratively calibrated adjudication process was turning before his eyes into a class conflict in which the letter of the law had to be accommodated to political controversies and pragmatic compro-

mises. Kafka's career advancement to ever higher levels of professional management in the agency occurred in the years of economic crisis before the First World War and then of a state-controlled war economy with its prerevolutionary strikes and labor disputes. His official writings show his increasing preoccupation with the crisis management whereby the agency attempted to counter the employers' growing obstruction of and open opposition to the government's social policy. Kafka tried to cope with this situation within the given legal and institutional parameters rather than dealing with worker's representatives from opposition trade unions or political parties. He was under no illusions about the limits of his efforts as a bureaucrat to do right by the workers' interests, no matter how much he may have sympathized with them.[15]

Did Kafka's own political thinking veer to the left of those institutional limits? As long as his left-wing political ties outside the office remain doubtful, that question can only be pondered through his fiction, particularly since he hardly ever touched on politics in his diaries and correspondence. Was Hermsdorf right when he concluded that Kafka's "poetic work differs from the insurance writings by abandoning itself 'artlessly' to life in its crude confusion—uncertain, questioning, meek, and without hope?"[16] Does that work betray "an irony of Kafka that just the man who was convinced of nothing so much as of the invalidity of each and every guarantee should have been an insurance official," as Bertolt Brecht put it to Walter Benjamin in 1934?[17] If Kafka in the pursuit of his two writing jobs really arrived at such a conviction, the irony would not be historically contingent, that is, unintentional on Kafka's part, as Brecht may have surmised, but would be the deliberate literary expression into which Kafka cast his professional experience of the social conflicts of his time.

A recurrent theme of Kafka's fiction is the unbridgeable distance separating his middle-class heroes, and the writer himself, from working-class people.

> Here there are many who are waiting. An immeasurable crowd fading away in the dark. What does the crowd want? Apparently there are certain demands it makes. I will listen to the demands and then answer. But I won't go out onto the balcony; I couldn't, even if I wanted to. In wintertime they lock the balcony door and the key is unavailable. But I won't even step to the window. I want to see nobody, I don't want to let myself be confused by any sight, at the writing desk, that's where my place is, head in hands, that is my posture.[18]

Such an uncompromising reflection on the class limitation of literature preempts the retrospective judgments of Kafka's socialist critics who ei-

ther reproach or excuse him for his entanglement in "bourgeois" forms of imagination. The ensuing distorted form of social experience has determined the political irony of his fiction.

In *The Missing Person* (1912), the adolescent Karl Rossmann is banished from his lower-middle-class home in Europe and later from his affluent new home in the United States and is forced to get back on his feet through simple labor. Because of his unbending conviction that willingness to work under any condition will lead to success,[19] he remains a misfit in the company of the proletarians whose fate he shares, vainly fraternizing with the stoker on the ship,[20] vainly trying to escape the company of the two tramps in search of employment who manage to become his masters.[21] He frowns upon strikes and labor disputes.[22] Yet instead of rising through hard work, he inexorably sinks, from aspiring manager to lift boy, from room servant to brothel attendant, ending up as an extra in a sham "nature theater" where the unemployed can make a show of their desired occupations to each other without pay.[23] In *The Trial* (1914), the bank manager Josef K., along with other members of the "higher classes,"[24] is summoned to court, but when he arrives at the designated location, he finds himself in a "political precinct meeting"[25]—originally Kafka had written "Socialist precinct meeting"[26]—taking place in a working-class neighborhood.[27] It is this meeting that turns out to sit in judgment over him, but he understands nothing about its procedure, nor what kind of case is being brought against him. Taking recourse in the legal system, the bank manager never again finds a venue for his case and eventually loses it. In *The Castle* (1922), finally, the land surveyor K. wages a "struggle" for employment with a landholding authority under mistaken assumptions about the conditions of his employment and labor relations prevailing in the countryside. Upon arrival in the village he encounters, in his appointment letter from the castle, what he takes to be an erroneous downgrading of his specialized professional qualification to "the worker's existence . . . , in all terrible seriousness, without any outlook elsewhere."[28] He decides to go along with the downgrading for now and to rectify it after assuming his job. However, to the feudal order of the country estate and the subordinate administrative village council,[29] K.'s urban mentality, obsessed as it is with workers' rights, labor disputes, and procedure, proves tragicomically inadequate. To secure his job, the land surveyor is prepared to put up with any social degradation, all the while remonstrating about his rights. In the end, like Karl Rossmann in *The Missing Person,* he is given a make-believe post in which neither work nor wages are of any account.[30]

In the years 1917–22, when revolutions or attempted revolutions of socialist workers' movements in Eastern and Central Europe were being quelled, Kafka wrote a few grotesque parables about the failure of individuals to come to terms with the class conflict. A fierce manifesto demands that the "unpropertied workers' force" organize itself, in the way of Cistercian lay brethren, as an unworldly order, complete with sexual abstinence and unquestioning obedience.[31] A miners' delegate delivers to the coal mine's "management chanceries" a petition for improvements of the pit lamps, which is sarcastically granted twice over to ridicule its unacceptability.[32] A mass meeting at the bank of a thundering river proceeds with so much sweeping unanimity that no one can understand a word or even think.[33] An "imperial colonel" is able to control a little mountain town with a handful of soldiers because he affects a look of human frailty, putting anyone with rebellious sentiments to shame.[34] A clerk who possesses "five children's rifles" pens a call for revolution to his fellow-dwellers in a workers' tenement, so desperately determined to go it alone that his proclamation already presupposes not being heeded by anyone and ends in a self-denial.[35]

The common point of all these stories is how mass movements of social oppression and social upheaval prompt nothing but tragicomic self-deceptions in the minds of the affected individuals. "It is in my nature that I can only assume a mandate nobody has given me. In this contradiction, always only in a contradiction, can I live."[36] That Kafka should have published none of these texts is significant, since in the stories and prose pieces printed during his lifetime he hardly ever touches on revolutionary themes. Although socialist critics could have read most of them after their posthumous publication, in their rush to generalized judgments about the presentation of social conflict in Kafka's literary work, they paid attention neither to the social structure of Kafka's narrative plots nor to the impact of his professional experience upon his literary imagination. As soon as plots and experience are related to one another, the criticisms of Kafka's supposed indifference to social policy become moot. Kafka has anticipated the political self-critique of literature, played out by Soderbergh's "Kafka," to the point of its nonpublication.

Woman's Sacrifice

The name of *Kafka*'s heroine, Gabriela Rossmann, recalls that of Karl Rossmann, the male hero in *The Missing Person,* a young immigrant whose eagerness to comply with the work ethic of high capitalism leads

to his downfall. Gabriela, "Kafka's" colleague in the office of the Workers' Accident Insurance Institute, however, is an anarchist leader who attempts to recruit "Kafka" to work with her group. "Kafka" encounters her in the castle, strapped to one of the medical machines Dr. Murnau uses to transform kidnapped victims into agents. She resists the treatment until it kills her. Upon "Kafka's" return to the city, police call him to identify her body in the morgue, where he confirms the inspector's suicide verdict despite his knowledge to the contrary. After this posthumous betrayal of the defeated revolutionary, he resumes his writing.

In most James Bond films, the main female character starts out beholden to the leader of the worldwide crime racket and is then seduced by 007 into betraying her master. The scenario recalls Kafka's novels *The Trial* and *The Castle,* in which K., the hero, attempts to enlist the help of women with sexual ties to officials of the court or castle in his efforts to confront the elusive authorities. To him, these women have superior social standing because they are desired by officials. By engaging them in sexual relations, the bank manager and the land surveyor vainly hope to use them as pawns or mediators.

> Women have great power. If I could move some women I know to jointly work for me, I should be able to advance. Particularly with this court made up almost wholly of woman chasers.[37]

This futile strategy of Josef K. in *The Trial* reads like the formula of James Bond's triumphs. Agent 007 knows how to avail himself of the assistance and sacrifice to be obtained from beautiful women. In *Live and Let Die* (1973), for example, he plays the initiation rite of the tarot game. The heroine, Solitaire, is the head gangster's virgin companion. As a tarot master, she can guide his plans by reading him the future from the cards as long as she remains chaste. But as a woman, she is susceptible to seduction. Her double nature is mirrored in two discrepant cards of the tarot hand, the "High Priestess" and the "Lovers." The first identifies her as "wife to the prince no longer of this world, the spiritual bridge into the secret church"; the other makes her succumb to 007 as soon as he deals it in a rigged string of repetitions.[38] As a consequence Solitaire forfeits her second sight. In retribution, the head gangster offers her up for sacrifice in a Voodoo ritual choreographed as a sex act. Tied between two trees, the woman stares in spellbound rapture at a male dancer lurching toward her under the beat of the drums, and brandishing a poisonous snake with darting tongue ever closer to her face. At the last moment, Bond leaps forward from behind the trees to blast the ceremony apart and cut her loose.

Soderbergh cannot have failed to make the comparison between representations of woman as a medium of power in Kafka's fiction and in the James Bond films. His own first film, *Sex, Lies and Videotapes* (1990), is a serious comedy about deliverance from sexual power. It shows how the social maladjustment of a man who can only gain satisfaction viewing self-made videos of masturbating women is cured by a woman who in return is helped to overcome her own sexual oppression by her unfaithful husband. The story unfolds as a reciprocal power exchange between two men and two women in which the two women, an unwitting tandem, punish the sexual predator and deliver the sexual victim.

In *Kafka* the heroine has shed the nexus of sexuality and power altogether. The castle officials appear just as lustful as in Kafka's novel. The twin assistants pride themselves of having watched Gabriela Rossmann undress. Burgel, the office supervisor of the insurance agency, who locks himself in a public toilet to study a sheaf of nude photographs, makes a crude pass at her. But unlike Kafka, Soderbergh shows no woman attracted by castle officials. Gabriela rejects Burgel's advances with a harsh insult, recalling Amalia's rebuff of Secretary Sortini in *The Castle*.[39] But while in the novel the woman is socially ostracized for her refusal and fruitlessly spends her years trying to make amends, in the film her open defiance expresses and betrays her subversive intent. The castle's retaliation is all the more decisive and severe: abduction, torture, and death. Soderbergh assigns to a woman the tragic role that Kafka reserves for men: to perish in the struggle against power.

In a further reversal of the stereotype Kafka's novels and the James Bond films have in common, Soderbergh's woman enlists the hero for her purpose, and she does so through provocative reasoning rather than seduction. The cool, guarded smile of Theresa Russell (who plays Gabriela Rossmann), as she draws the shy Jeremy Irons out of his office for a lunch appointment, contains a trace of sexual attraction, but it is tactically calculated and in any case finds no response. Once they talk seriously, Gabriela Rossmann and "Kafka" reassure one another that no erotic engagement is on their minds. As the film proceeds, the activist woman's moral standing gains over that of the introspective writer—to her peril.

Soderbergh's casting of a woman into an alternative position vis-à-vis the threat of power, perhaps superior to but also more risky than the man's, recalls not just Kafka's novels but also his lived obsession with sexual relations as the touchstone for success or failure of finding a social

footing. "I am expected to cross over, for the sake of an uncanny magic, of a hocus-pocus, of a philosopher's stone, of an alchemy, for the sake of a ring of luck."[40] This array of magical recantations was Kafka's way of explaining to Milena Jesenská his reluctance to sleep with her, despite his efforts to draw her into an existential community of love. Perhaps Gabriela Rossmann, the terrorist office clerk, embodies the alternative between Jesenská and Felice Bauer, the two women with whom Kafka maintained successive unhappy love relationships. The latter was a senior office clerk from an upper-middle-class family, the former a left-radical writer from a bohemian milieu. With Felice Bauer, Kafka sought a stabilizing middle-class marriage, with Milena Jesenská an intellectually fulfilling free love. Both relationships, drawn out over long correspondences and short encounters, have informed Kafka's literary portrayals of the sexual machinations whereby the bank manager in *The Trial* and the land surveyor in *The Castle* attempt to clear their lives with the authorities representing the social order to them. Benjamin misjudged this metaphysical as well as social validation of women in Kafka's work when he summarily characterized all of them as "whorish" beings in his Kafka essay of 1934.[41] The Marxist tradition on which he relied at that time could not furnish him a more adequate understanding of sexual ties than the cliché of commodity relations. Nor have Communist Kafka critics writing after the Second World War recognized the sexual conflict that pervades Kafka's work as a fundamental category of how he represented the social process, just as thoroughly as does the class conflict. These critics' schematic alternative between capitalist alienation and socialist emancipation did not accommodate the issue of sexual justice.

This is why Soderbergh, as long as he wished to validate sexual difference politically, could feature a woman as the protagonist of resistance against social oppression only in anarchist, not in socialist, terms. Gabriela Rossmann, who shows off her erotic superiority as inaccessibility in her dealings with Burgel and "Kafka," fails in her nonerotic, political resolve. Her defeat throws her back onto her sexuality. The medical manipulation to which she is subjected in the castle transforms the torture and execution machine described in Kafka's *In the Penal Colony* into a sexual allegory. Strapped to a reclining seat, her body is infused through transparent tubes with colored liquids as a medical assistant attempts to talk her into submission. The analogy to the animation of the pseudo-revolutionary female robot in Fritz Lang's *Metropolis* (1926) is unmistakable. Here a reclining woman's face is transferred to

the metal sculpture through an array of electrical and chemical conduits. Gabriela's programmed reactions, oscillating between convulsion and atony, make the operation appear a rape, her accidental death on the machine a sexual murder. The procedure is intended to reverse her emancipation from erotic resistance to political resolve. Its technical failure to recondition the woman back into sexual submission makes her a martyr.

This is the opposite of Kafka's own essentially sexual designation of women's social power, as he envisioned it on the unchanged terms of the society in which he lived. Whether Soderbergh's desexualization of the female corresponds to similarly unchanged terms in today's society is another question. Ideologically, in any case, it recalls the current elimination of sexual difference by the progressive incorporation of women into the capitalist work force of shrinking real wages and rising cost of living. Where everyone has to work, erotic appeal gives way to professional postures. Gabriela Rossmann, with her sexual restraint and combative resolve, is a subversive role model of those female police officers, jet fighter pilots, and astronauts who have become leading ideological figures of women's participation in capitalist working society. Their aggressive stylization in public imagery compensates for their continuing inequality when it comes to economic opportunity, sexual self-determination, and political power. Soderbergh presents the defeat of the ideal. Rossmann's murder, following that of her anarchist fried Raban, confirms the equality of victims.

"Modernity"

Like the sexualized operating chair on which Gabriela Rossmann is killed in Soderbergh's film, the castle's principal machine for the psychosurgical conditioning of men into blindly obedient murderers is a cross between the execution machine from *In the Penal Colony* and the animation machine from *Metropolis,* only more grandiose. In the center of a large domed hall, one of the kidnapped workers is spread-eagled on a circular frame, recalling the medical microcosm images of the Renaissance. A rectangular hole has been sawed into his skullcap, baring his bloody, throbbing brain. It is positioned below a microscope which projects a magnified view of the brain section into the glass cupola above, where it can be studied at ease from an observation seat below the timbers. It is in front of this machine that "Kafka" and Dr. Murnau wage a debate about the word "modernity." "Why do you involve yourself with revolutionary anarchists?" the doctor says to the writer. "Your work has

been an inspiration to me. You despise the modern, but you are at the very forefront of what is modern. . . . Unlike you . . . , I have chosen to embrace it." "Kafka" replies: "I've tried to write nightmares, and you've built one." In an earlier scene, a sculptor compliments "Kafka" for his story *In the Penal Colony,* recalling the description of the execution machine with a sadistic literary gusto. "It's new! I need to find a clever device to make my work more noticeable." Now the castle confronts the writer with the unbearable reality of his imagination.

At the end of the altercation Dr. Murnau reaches out to place his hand paternally on "Kafka's" head, as if to impress on him their mutual understanding. Here Soderbergh is quoting the last scene from Wiene's *The Cabinet of Dr. Caligari,* in which the chief doctor of the mental hospital tries with the same gesture to calm Francis, who crouches before him in a straitjacket, declaring that now he knows how Francis can be cured. This conclusion of the controversial "frame story" prompted Kracauer to denounce Wiene's film as proto-fascist because to him it visualized the quelling of reason in its quest for justice.[42] A final agreement between "Kafka" and Dr. Murnau on such terms would close the vicious circle of "modernity" that joins art and power in a common delusion of renewal. "Kafka" already cowers under Dr. Murnau's outstretched hand with the same frightened glance as Francis, but before the hand comes down on his head, the time bomb in his briefcase detonates at the door. The shackles of the prisoner with the opened skullcap spring apart in a hail of sparks, the prisoner descends from the operating machine, locks Dr. Murnau in an iron grip, hooks him onto the moving paternoster lift for the transport of files, and the doctor is carried up and away, crashing through the glass cupola on whose iron frame "Kafka" has now climbed, deftly keeping his balance, to escape from the castle.

"Kafka's" interrelated dialogues with the doctor and the sculptor address the ambivalence of the word "modernity" in the subversive posture of social dissent habitually struck in modern art. Capitalism's implacable drive for innovation underlies its profit-maximizing self-development to the point of oppressive terror as well as the expressive art forms of its nonconformist culture. Whoever operates within this culture is subject to the ensuing contradictions, first and foremost the successes of an art of social critique in the society criticized, but without the critique being heeded. As early as 1951, Günther Anders has judged the posthumous appreciation of Kafka's work from this viewpoint:

> Today, "precision" has . . . a meaning that cuts two ways: it denotes both the way the dangerous world functions and the salvation from

this dangerous world. It is homoeopathic, as it were: one expects a cure from the poison taken as an antidote to itself.

With Kafka, it is no different. With him, too, precision is not only inscribed on the "trial" to which one is subjected by the world, on the functioning of a superior force, but at the same time on the attitude he demands of a human being or of himself.[43]

Forty years later Soderbergh has literally illustrated Anders's "homoeopathy" of modernity with Dr. Murnau's medical machine.

The final argument "Kafka" advances in the debate invokes the masses who have no share in "modern" culture. "And what will you say when the great faceless mass comes calling [to confront you]?" "Kafka" asks Dr. Murnau in front of his machine. "A crowd is easier to control than an individual," answers the doctor. The masses will not rebel against modernity because they can be manipulated by modern psychotechnology. The upper-middle-class educational privilege restricting access to modern culture and its social critique delegitimizes its claims of speaking to the problems of society as a whole.

Most socialist literary critics have raised the issue of class limitations against Kafka's work, while his scattered socialist defenders have insisted on its supposedly class-transcending message. At the Kafka conference of 1963 at Liblice, Roger Garaudy, then still a Communist, reclaimed him for a socialist critique of capitalism according to the humanist ideals of the Popular Front: "Kafka is no desperate man, Kafka is a witness. I repeat—he is no revolutionary. He is someone who calls to responsibility."[44] Whose responsibility, to whom, for what? In 1990, Soderbergh presented the alternative between testimony and revolution as altogether intractable and hence futile. The ambivalent term "modernity" provides a familiar cliché for the anticipated resignation. "Kafka" claims the sole responsibility of literature to itself and to its author, first against Gabriela Rossmann and her anarchistic comrades and then against his chief clerk in the insurance agency, first as a refusal and then as a retreat. But a political responsibility of literature was not among the contradictory issues of his existence as a writer that Kafka pondered throughout his life. The various figures in Soderbergh's film who hold him responsible for this are merely arguing a posthumous case that has dragged on through half a century, prompted by the ideological overdetermination of culture in the geopolitical confrontation between capitalism and socialism since the Second World War. The more apologetically socialist commentators made Kafka into an unwitting Marxist critic of capitalist injustice, the more melodramatically did their Western counterparts el-

evate him into a prophet of fascism. Since capitalist literary culture was not bound by a cultural policy, the changing ideological agendas confronting each other in the Kafka debate remained largely hidden behind claims to an authentic understanding. But the determination to make Kafka's work into a short-circuited social or political allegory was similar. At the end of the Cold War Soderbergh one more time put Kafka's work up for discussion on those ideological terms. However, since the socialist alternative was now withdrawn from the equation, he overtaxed the term "modernity" with a depoliticized self-contradiction that offers no way out.

Conformity

When "Kafka," on his return from the castle, is shown Gabriela Rossmann's corpse in the morgue and confirms the police inspector's suicide verdict, although he can make out the wounds of her torture, the writer betrays the political martyr and professes his own adaptation to the criminal status quo. "You are very helpful, Kafka," the inspector commends him. "Kafka" then sits down to write his "Letter to Father," the well-known reckoning with the patriarchal oppression of his family, which nevertheless ends on a note of hope for small mutual adjustments in private life even though the causes of estrangement cannot be undone.[45] The letter's last sentences resound aloud from behind the writer's closed lips, as the blood-spitting cough begins to shake him. The film ends here. Betrayal of resistance, cooperation with the authorities, reconciliation with the tyrannical father—these are the stages of a rampant insight that literature can only be pursued by suspending one's political principles, one's moral sense.

When Orson Welles in 1962 turned *The Trial* into a film, he rejected such a conclusion. He replaced Josef K.'s abject self-abandonment to his execution by a last act of defiance. In the novel two executioners in top hat and cutaway drag the bank manager to a quarry at the outskirts of the city. He sits still on the ground, leaning against a broken stone, waiting for the executioners to stab him because he lacks the strength to take the knife out of their hands and kill himself. Ashamed of this half-hearted submission, he likens himself to a dog being put down.[46] In Welles's film, by contrast, Josef K. scornfully rejects the mute suggestions of two agents in fedoras and trench coats to do the job for them, loudly daring them to commit the execution. The agents, losing their nerve and retreating from the quarry, have to finish off their victim by throwing a

hand grenade into the pit. As they take cover behind a ridge, the explosion mushrooms into an atomic cloud.

The victim's refusal to commit his own murder in Welles's version of *The Trial* touches on the most sensitive point of the moral debate about Kafka which Anders in 1951 launched with the publication in West Germany of his essay *Kafka: Pro and Con*. Anders had first formulated his critique as early as 1934, shortly after his emigration, in a lecture at the Institut d'Études Germaniques in Paris. Hannah Arendt and Walter Benjamin were in attendance. Anders guessed they were the only listeners who knew anything of Kafka.[47] In fact, Kafka was of crucial importance for their own work. The encounter of the three friends at the lecture, "at the height of anti-fascist excitement,"[48] was to shape the understanding of Kafka after the Second World War, since Anders's two listeners in turn wrote fundamental essays about conformity versus resistance in Kafka's work—Benjamin in the same year, Arendt as late as 1943–44. The ethical and political assessment of the individual's chances of survival under oppressive injustice that both authors derived from their reading of Kafka were no less far-reaching than those of the speaker. Anders coined, in the final version of his essay at any rate, the most trenchant phrases for the common judgment Soderbergh reiterates in his final scenes. He called Kafka's fiction a "pre-fascist literary document," a "plea for blind obedience and sacrifice of intellect,"[49] and the author "a moralist of *Gleichschaltung*,"[50] the National Socialist term for the totalitarian coordination of society. Anders made it clear, however, that his indictment was aimed not so much at Kafka himself than at his later "theological"—and, after the Second World War, existentialist—interpreters. It was they who transfigured the despondency in Kafka's fiction into a metaphysical acceptance of fate, a perennial or "modern" human condition, oblivious to the inescapable need for moral self-assertion in the face of fascist injustice.

When Benjamin listened to Anders's lecture in 1934, he may have been preparing the essay about Kafka which the *Jüdische Rundschau* in Berlin had commissioned him to write on the tenth anniversary of Kafka's death.[51] Of the essay's four sections, the first and the third were published in December 1934, both titled with the names of figures that do not occur in Kafka's work: "Potemkin" and "The Little Hunchback." The first of these figures, the Russian prince Potemkin, personifies an aboriginal power beyond any comprehension, let alone influence, on the part of its subjects, a power that Benjamin calls *Vorwelt*, the "prehistoric world." In the second, unpublished section of the essay, Benjamin

CHAPTER FIVE

discerns a way of dealing with such a power in Kafka's fragment about the silence of the Sirens[52] whose deadly spell the wily Ulysses escapes by pretending not to notice it. The title figure of the third section is a figure from a German folk-song, one of nature's miscreations. He asks the listeners to include him in their Christian prayers. Benjamin relates the hunchback to certain abnormal hybrids in Kafka's stories who request admission to the human community, such as Odradek, the live twine spool. He concludes that the underlying misfit motif is "grounded in German just as in Jewish folklore."[53]

This conclusion of Benjamin's essay was consistent with the presentation of Kafka as a German author of Jewish descent current in Jewish community journals still allowed to be published in the early years of the National Socialist regime.[54] Benjamin's extrapolations from Kafka's stories to literary matches more familiar to German readers give his essay the topicality he had demanded in his essay "About the Present Social Position of the French Writer," written at about the same time.[55] Under the conditions of publication in the oppressed Jewish community of National Socialist Berlin, such a topicality could only be subversive. The essay's metaphysically exalted language gives all the more urgency to the idea of evading brutal power by ostensible compliance. Benjamin was implicitly contradicting Brecht's sharp verdict that Kafka promoted "Jewish fascism"[56] and expressed "a desire for the 'Leader'. . . who holds the petty bourgeois . . . responsible for all of his misfortune."[57] His own notions about taking an "inner" distance from power were more dialectical, which is not to say more realistic, than Brecht's. Perhaps readers of the *Jüdische Rundschau* in Berlin were able to discern in Benjamin's Kafka exegesis a model for their own illusory hopes to survive by adapting to their progressive outlawing by the National Socialist regime. Theodor W. Adorno wrote his "Notes about Kafka" (1953) from the historical experience that such a "reconciliation of myth by a sort of mimicry," as he called it,[58] had not worked. The metaphysical allegories of monopoly capitalism and fascism he discerned in Kafka's fiction were nothing but a "mute battle-cry against myth,"[59] the hermetic anti-fascist message of modern art.

In the first volume of *The Aesthetics of Resistance* (1975), Peter Weiss evokes an activist alternative that is just as illusory. Here a Communist worker in Berlin, sometime in 1936, reads Kafka's *The Castle* as a "proletarians' novel"[60] from which he can learn about imperialist oppression of the working class, along with "Neukranz's little insurrection manual, from the series of the Red Novels, priced at one Mark."[61] The comple-

mentary study of high literature and subversive party agitation impresses upon him the necessity of a class-transcending popular front culture for the anti-fascist struggle.

When Hannah Arendt published her two essays on Kafka ten years after Anders's lecture,[62] she did not leave it at Anders's moral alternative between conformity and self-assertion, nor at Benjamin's metaphysical polarity between "prehistoric" power and the cunning of the weak. She forthrightly related the submissive behavior Kafka seems to endorse in some of his fiction to the failure of Jews in European upper-middle-class society of the nineteenth and early twentieth centuries to achieve political emancipation, and to their illusory cultural assimilation in the guise of "pariahs." She made the land surveyor K. in *The Castle* into a hero of the unrelenting clamor for civil rights. In the first essay, "The Jew as Pariah: A Hidden Tradition," she still understood him to personify "the pariah as a figure of Jewish folklore,"[63] but in the second essay, "Franz Kafka," she transfigured him into the "sublime image of man as a model of good will"[64] according to the political ideal of the Bill of Rights. In Arendt's reading, the land surveyor overcomes the predicament of his namesake, the bank manager in *The Trial,* who is being broken "to adapt himself to existing conditions," until he lets himself be led away to "an execution to which, although it is without reason, K. submits without a struggle."[65] Later, in her book *Eichmann in Jerusalem* (1962), Arendt launched a similarly uncompromising political critique of conformity against the cooperation of Jewish community leaders and organizations all over Europe in the enactment of the organized mass extermination of Jews by the German government. Perhaps the Jewish officials' hopes of saving at least a few of their community members from death by implementing their deadly oppression[66] reminded her of Benjamin's interpretation of Kafka's parable of Ulysses on the escape. As an American citizen, Arendt was able to draw more deliberate consequences from her emigration than Benjamin in his endangered Paris refuge. The political morality she found in Kafka's last novel was founded on the constitutional order of her new home country.

No matter how differently these five authors tried to solve the problem of conformity in Kafka's writing, none of them took Kafka's own representation of society into account. Anders, Benjamin, and Arendt ignored it altogether—Anders, because he was demanding an anti-fascist ethics of conscience; Benjamin, because he was projecting an anthropological metaphysics of survival; and Arendt, because she was insisting on political equality over social accommodation. Weiss mis-

took the villagers in *The Castle* for workers to revalidate modern literature for the anti-fascist struggle of the Popular Front, and Adorno mistook the workers in *The Trial* for petty bourgeois,[67] proto-fascist persecutors of the social dissent he found embodied in modern art. Because of their ideologically overdetermined readings, all missed Kafka's literary class analysis.

Forty-five years after Arendt interpreted Kafka's land surveyor as a model of the struggle for civil rights, President Havel, Kafka's self-described literary follower, prevailed with his own deliberate notions of civil rights over an oppressive Communist regime. His decade-long resistance against Communism belies "Kafka's" retreat and resignation in Soderbergh's film. When Havel, serving a political prison term between 1979 and 1982, read Max Brod's Kafka biography,[68] he concurred with Brod's characterization of Kafka as a man who tried to live his life according to principles of humanism, ethics, even religion.[69] Benjamin, intent on transfiguring hopelessness and failure into metaphysical absolutes of Kafka's work, had contemptuously dismissed that characterization.[70] Yet Havel, a political activist-writer who had lived up to his device of a "power of the powerless"—a moral alternative to Adorno's "mute battle-cry against myth"[71]—could afford to reclaim it. In a series of tightly censored prison letters to his wife he ascribed his fundamentally idealistic views about the individual's moral responsibility to his upper-middle-class family background. The ensuing social degradation he incurred from the Communist regime[72] reversed the unilateral scheme of class divisions guiding orthodox Marxist Kafka criticism where oppression only strikes the working class. Because his class origin entailed the necessity to confront political injustice, Havel was able to embrace Kafka's middle-class background with no ideological apologies. Still, such idealistic views have not helped him to a differentiated assessment of political realities after the demise of Communism as a government system. Havel's world-historical predictions about a threat to mankind posed by nonpolitical apparatuses of technological world dominion[73] recall James Bond scenarios.

Terror

Soderbergh's "Kafka" moves in a nightmarish scenery of terror recalling early German horror films whose current ideological perception has been largely shaped by Kracauer's *From Caligari to Hitler*. The scenery provides a melodramatic backdrop for the metaphysical criminalization

of Kafka's world rampant in capitalist culture. If this culture transfigures Kafka into a prophet of Auschwitz, it substitutes the interpretation of a Jewish author according to the avant-garde stereotype of historical foresight for a historical awareness about the political complicity of the majority of the German people with the criminal phase of German history between 1933 and 1945. Kafka scholarship of recent years, which has dwelt on Kafka's autobiographical fantasy, artistic self-stylization, and linguistic irony, tends to clear him from such anachronistic projections.[74] The new diplomatic edition of his writings on the basis of his manuscripts, published between 1982 and 1995, has restored to the texts the spoken rhythm that made Kafka and his listeners laugh to tears when he was reading them aloud.[75] The growing discrepancy between Kafka's ideological demonization in the public sphere and his humanization in literary scholarship is an example of how aesthetic terror overtakes historical rationality in today's public culture, whose spectacles are politically disoriented and hence ideologically overcharged.

The pervasive but diffuse terror of Soderbergh's film has a historical topicality of its own. Although the end of the Cold War has done away with political equations between oppression and revolution according to theoretical formulas about the alternative between capitalism and socialism, a fundamental threat to the capitalist social order persists even without originating from any socialist alternative. Within democratic industrial societies, devaluation of labor has led to shrinking real wages, growing unemployment, illegal immigration, crime against property, drug abuse, and political extremism, all of which cannot be staved off in the long run by police control and criminal prosecution. In the countries that were called the Third World as long as the Soviet bloc was being counted as the Second, impoverished populations are struggling against their governments through armed terrorism or ethnic civil wars, provoking brutal countermeasures or corrupt acquiescence that diminish these governments' political legitimacy. Whenever those struggles are being displaced into the industrial states to draw public attention, both spheres of destabilization intersect, compounding the internal structural damage caused by capitalism with repercussions of its worldwide effects. Soderbergh's eerily illuminated castle looming over the dark city, where the threads of an all-pervading conspiracy between a government, an insurance agency, and the police force run together, recalls the functional interpenetration of politics, bureaucracy, corruption, and crime to be currently observed in many democratically constituted states. "Kafka's" timid showdown with criminal power,

modeled as it is on James Bond's struggle against SPECTRE operating over and above the Cold War power blocs, remains as inconsequential as the efforts of intrepid state attorneys or criminal investigators in Mexico, India, or Italy. "Why should today be different?" the chief clerk of the insurance agency asks "Kafka" on his return to the office after the bomb explosion in the castle. Audiences of the film will agree that there is no political change in sight.

The last James Bond film antedating Soderbergh's *Kafka, License to Kill,* was produced in 1989. No longer scripted after a novel by Ian Fleming, it could illustrate contemporary historical experiences more directly. In the preceding film of the series, *The Living Daylights* (1987), agent 007 still fights Soviet occupation troops on the side of the Mujahideen in the Afghanistan conflict. The new film, like *Kafka,* deals with the nexus between government and crime. James Bond no longer combats nuclear disaster, only the spread of the drug trade. His opponent is a South American drug producer with a small republic at his disposal, complete with banks and army, like Manuel Noriega, the ruler of Panama, whom the United States removed from power with a brief regional war the year the film was shown. Heroin and gasoline, not nuclear materials, are being fused in the technical center of power. The *New Official James Bond Movie Book* (1989) points out that this "story about drugs and power . . . could almost have been plucked straight from today's newspaper headlines."[76] It seemed as if the recurrent theme of the James Bond series, the struggle against the threat to world order by organized crime, could now be pursued in ever more realistic terms, with ever less political fantasy. The political scene of a secure, undivided capitalist world no longer seemed to require utopian Cold War projections. Had this political assurance lasted, Bond films would have remained depoliticized, no more than ordinary crime stories with government and corporate participation, played out on a global scale.

However, such a development has not occurred. Instead, the next film of the series, *Goldeneye* (1996), has returned with a vengeance to the scenery if not the politics of capitalist-communist confrontation. A Soviet spaceship, marked "CCCP" in giant red letters, is circling the globe and threatening to knock out the computerized communications systems of capitalism. A former Soviet general, whom the accustomed introductory sequence shows in a last match with 007 before the collapse of the Soviet Union, is in charge of the technology, newly dressed in a post-Soviet Russian uniform. The scores of ordinary Russian soldiers mowed down by Bond's machine gun look the same before and after. It

makes no difference that the direction of the enterprise now lies in the hands of a criminal with no political credentials. Russia remains the site of confrontation. In the opening credit sequence, giant mockups of Soviet monuments loom as remnants from the past, partly ruined, to be sure, but still to be undone. That task falls to a ballet of seductive women. First they are precariously dancing on the cutting edge of a sickle, barely avoiding the hammer crashing down. Then in a close-up a pistol emerges from a woman's open lips, blowing two Soviet flags away. Finally, dancing women use huge hammers of their own to demolish Stalin's sculpted head. Communism's monuments are not ruins, as in Bilal's "Epitaph (1990)" (see p. 117), but menacing revenants.

The motif of Eisenstein's cine-fist, which has been adapted from the introductory sequence of the Bond films in the *Kafka* poster, has been fundamentally changed in *Goldeneye.* Its theme is no longer a deadly confrontation between walking agent and enemy observer. Instead, the explosion of the Soviet space control station, Bond's last successful mission against the USSR, contracts and congeals into a mechanical diaphragm of shiny gold, whose spiral form swirls to reveal the inside view of a gun barrel. The image symbolizes the title *Goldeneye,* the code-name for the imaginary computer-disabling satellite developed in the former Soviet Union. The golden spiral expands again to release another explosion in reverse. No human subject intervenes. The confrontation of power blocs continues over not political alignments but technological development. Ideologically, however, communism is still being pictured as a threat.

Compared to *Goldeneye,* Soderbergh's transfer of the James Bond scenario onto the enigmatic environment of Kafka's stories in Kafka's Prague looks as antiquated as the anarchism of the turn of the century may look compared to contemporary politics after the confrontation with communism. What is missing from Kafka's fiction is Soderbergh's key motif: the exploding bomb. Today Soderbergh's masked anarchist serving a detonating meal to a pair of rich gluttons in a small restaurant returns on the grandest scale. When I began to write this essay, Palestinian immigrants from the state of New Jersey on 26 February 1993 detonated a car bomb in the parking garage of the World Trade Center in Manhattan. Three weeks later, on 19 March 1993, Indian Muslims blew up twelve high-rise buildings in Bombay in a synchronized sequence of two-and-a-half hours that started with the stock exchange. The lack of apparent political purpose in actions such as these fits a time without a clear-cut ideology allowing for easy distinctions between revolutions

and terrorism. When on 15 April 1995, the Murrah Federal Building in Oklahoma City was destroyed by a car bomb, killing 153 victims, the American government and public had arrived at a state of consciousness where a full-scale anarchist assault could be instantly and fully absorbed into the ideology of a caring and commemorating society. A highly publicized rescue action drawing on teams of experts flown in from across the country and a pompous memorial service with a keynote speech by the president projected a ready-made ethos of endurance uniting all segments of society. The quest for the political reasons prompting such a frontal assault on a center of government was adjourned for years of trial preparation. It fell to the defense team of the two men convicted of the crime to insist on such a political assessment. Whether the outcome will touch upon crucial questions facing capitalist society today, or fall back on a fatalistic acceptance of terrorism as a systemic risk beyond political reasoning, remains to be seen. During the seventies, fiercely determined groups such as the Weathermen in the United States or the "Red Army Faction" in West Germany acted on the premise of a worldwide political accord with liberation movements in Vietnam, Angola, Nicaragua, and elsewhere. Today's anonymous bomb throwers, acting with no recognizable strategy, contribute to the destabilization of capitalist democracies. The explosion of the time bomb in "Kafka's" briefcase, half planned, half accidental, and with no lasting impact, matches their political opacity. Opacity, however, is no objective condition, to be confirmed by "Kafka's" fatalism. It is a subjective condition, to be dissolved by Kafka's penetrating reason.

CONCLUSION

Projection

Dimming Icons

Walter Benjamin's dialectical speculations about the impossible rectification of historic injustice; Sergei Eisenstein's dynamic panorama of a military force as the people's harbinger of freedom; Picasso's visual outcry against women and children being caught up in a people's war—after over half a century of progressive abstraction from politics to ideology, from history to utopia, these images are dimming into irrelevancy before our own historic predicament. Their clear-cut antithetical schematism falls short of the seeming rise of a universal order of capitalism, whose devastating impact on masses of people the world over is manifest but cannot yet be met with any coherent political alternative. Their judgmental self-assurance was originally grounded in a sweeping alternative to capitalism, that of Marxism, with Communism as its extreme. In the course of time, their time-bound historic topicality has been lost and replaced by the timeless ideological sentimentality of left-wing culture. They can be contemplated in the recollection of a lost resolve to sustain a principled dissidence, even after having disavowed the doctrine that gave faith to the resolve. However, once confronted with the double question of historical significance and political practicality, the obsolescence of these images becomes ineluctable. Christin's and Bilal's picture story about Communist neurosis and crime and Soderbergh's short-circuited fusion of Kafka's biography and fiction into a

nightmare of oppression are their negatives. The diagnostic critique of the revolutionary ideal remains caught up in the nonpolitical resignation of the psychoanalytic father complex.

The years 1989–91, when I began to study my five themes in the public culture, were the time when the "collapse of Communism" was prematurely recorded as a definite world-historical historic event, spelling the end of any conceivable politics of the Left. In a mirror reverse of that assumption, the ascendancy of capitalism was taken for final and therefore justified. The political victory of one economic system over the other was transfigured into proof of its essential superiority as a social way of life. At that time I wrote the first, tentative versions of the texts from which this book has been developed. Today, in 1998, the self-serving certainty about the triumph of capitalism over socialism is gone. The ideological polarization underlying the belief in the finality of the decision was itself conditioned by schematic thinking in mutually hostile absolutes. My historical critique of the Icons of the Left stays clear of current commonplace acknowledgments of socialism's errors and capitalism's foresight. It is intended to participate in ongoing efforts everywhere to update the socialist challenge to the political order of capitalism, efforts that require us to shed the cultural and existential self-deceptions weighing on the tradition of the Left.

Political Base

The foremost development in the current economy of capitalism is the global cheapening of labor, with the attendant resurgence of an as yet unclarified antagonism between thriving and impoverished segments of the working population. The class division between those who can sell their work and those who can't, which is now being added to the class division between those who own capital and those who don't, eludes political articulation in terms of traditional Marxist class analysis. The attendant categorical realignment in the functional relationship between economic and political systems entails a reconfiguration of socialism, capitalism, and democracy.

What is up for a revision is the identification of Communist political oppression with state socialism on the one hand and of democratic freedom and market capitalism on the other. While in China a repressive Communist government is guiding the dynamic development of a capitalist economy, the democratic governments of the traditional capitalist industrial states are being put ever harder to keep their societies intact.

In Eastern Europe, including Russia, new parties of the Left are p democratic politics. Here and in Western Europe, socialist parti/ been elected to lead the government. Everywhere political grou the Left, large and small, are at work gauging the necessary balance ν͜ tween adaptation or resistance to the global workings of the capitalist economy. This drawn-out process is no longer compromised by the faulty paradigm of a socialist state and its party leading compliant masses. Socialism is recovering the political mode of democracy it largely lost after the Bolshevik revolution.

Artistic culture touches upon only a small part of the conceptual premises or substantive issues in politics, economics, and society being rethought in the current political modernization of the Left. But here, too, the most urgent revision consists in making historical experience of both past and present prevail over theoretical obduracy. Marx' and Engels's claims that the theory of socialism would follow from historical experience were predicated on taking their convergence for granted and made historical inquiry into an argument for the theory. Today, by contrast, the Marxist tradition is faced with an explosion of historical experience, and the historical past now includes its own. It has to come to terms with historical experience because its own historic refutation is at stake. Can the Icons of the Left be taken for refuted because the ideological projections attached to them do not jibe with their historical significance and are not confirmed by our political experience? It is Communist soldiers deployed for the oppression of civilians who have taken the faith out of Eisenstein's dynamic montages, it is partisans trapping soldiers in modern people's wars who make Picasso's black-and-white verdict subject to revision, even before the visual inadequacy of both works to present revolutions and wars becomes apparent. A writer's efforts to brood upon the world's salvation when politics has failed appears as a vacuous literary posture even before Benjamin's adaptations of Klee's *Angelus Novus* to pose as an "Angel of History" prove to be expeditious adjustments for the purpose of validating political disorientation. The history of literature confirms that Kafka was interrelating his professional and literary practice with clear-headed sobriety, even before the triumph of Havel's "power of the powerless" politically refuted Soderbergh's film about "Kafka's" caving in before oppression. Perhaps the comic strip acquires an unexpected poignancy as a satirical medium of contemporary mass art, because it is unbridled by aesthetic pretensions and dependent on a public acceptance without the benefit of institutional support. It has enabled Christin and Bilal to straightfor-

wardly caricature Marxist claims of changing the world by the imposition of a doctrine, without offering a political morality, let alone an ideological alternative, of their own.

In My Place

I am under no illusions about the political impact of what I am writing, here or elsewhere. On this point I am at variance with the tradition of the Left in the sphere of current culture, and of academic culture in particular. Here, the habitual Marxist claims for an interdependence of theory and practice, despite the lack of a political base, have congealed both theory and practice. The representatives of that tradition are operating all the more high-handedly, be it in their world-historical judgments, their moral demands, or the apocalyptic styling of their own frustrations. The filtering of Marxism into Critical Theory with its attendant academic installation has made a commonplace out of the interpretation of historical reality through a template of its normative redress. In the process, the categorical distinction between history and politics has been lost. Today, cultural critique is being formulated as a self-serving alternative to the course of history, even though no connection with the Marxist claim to practice is apparent anymore. Its claims are absolute, hence hypothetical, oblivious to the political conditions that would permit their achievement. And when cultural critique despairs of its claims, which it does more often than not, it turns resentfully ominous. Without a political perspective, a critical thinking that wishes to both diagnose and rectify the world-at-large cannot be carried to any conclusion. The Icons of the Left make up for the missing perspective, like stage prospects painted on flat cloth. They obstruct the view of history and offer aesthetic utopias as surrogates for politics. Their historical understanding is being sacrificed in the process. In the examples discussed in this book I have attempted to restore such a historical understanding. A historicization of these images and texts entails their release from the posthumous ideological appropriation that has obscured their past political significance. The historical critique of a past artistic culture dispenses it from confirming our own aspirations. Niethammer and Herz, for all their pertinent critique of Benjamin and Eisenstein, were not prepared to take this step toward a historical distance of no return. Grass, in his zeal to vindicate *Guernica* against its propagandistic use by the Bundeswehr and to hold on to his own pacifist understanding of the picture, was not interested in what it stood for during its time. In order to hold

onto the topicality in their subjects, all three authors replaced the ideological origins in Soviet or Popular Front politics with abstract utopias of a better history, a more humane revolution, a more peaceful world. I feel no need to anchor political projections in historic paradigms, nor, conversely, to justify political positions of the past to make them topical. Therefore the resolve of past artists and intellectuals to attach themselves to Communism, to uphold its ideals, needs no belated justification. A contemporary politics of the Left, on the other hand, needs a contemporary artistic culture.

Notes

Introduction

 1. Bertolt Brecht, *Werke: Gedichte* (Frankfurt and Vienna, 1991), p. 348.

Chapter One

 1. Lutz Niethammer, *Posthistoire: Ist die Geschichte zu Ende?* (Reinbek, 1989), p. 120.

 2. Wissenschaftszentrum Nordrhein-Westfalen, Kulturwissenschaftliches Institut: *Das Gründungsjahr. Bericht 1990* (Essen, 1991), pp. 84–85.

 3. Ibid., pp. 48ff.

 4. Ibid., p. 18.

 5. Following Niethammer: Ralf Konersmann, *Erstarrte Unruhe: Walter Benjamins Begriff der Geschichte* (Frankfurt, 1991), pp. 123–24

 6. Niethammer, *Posthistoire,* p. 132.

 7. *Das Gründungsjahr,* p. 19.

 8. Ibid., p. 16.

 9. O. K. Werckmeister, "Walter Benjamins Passagenwerk als Modell für eine kunstgeschichtliche Synthese," in Andreas Berndt et al., eds., *Frankfurter Schule und Kunstgeschichte* (Berlin, 1992), pp. 165–82.

 10. Niethammer, *Posthistoire,* p. 128.

 11. Cf. Terry Eagleton, *Walter Benjamin, or Towards a Revolutionary Criticism* (London, 1981), pp. 183–84, the author's poem "Homage to Walter Benjamin."

 12. Bernd Witte, *Walter Benjamin* (Reinbek, 1985), p. 135.

 13. Rolf Wiggershaus, *Die Frankfurter Schule: Geschichte, theoretische Entwicklung, politische Bedeutung* (Munich, 1986), p. 348.

 14. O. K. Werckmeister, "Walter Benjamin, Paul Klee und der Engel der Geschichte," *Neue Rundschau,* 87 (1976), pp. 16–40; reprinted with revisions in

idem, *Versuche über Paul Klee* (Frankfurt, 1981), pp. 98–123; English version: "Walter Benjamin, Paul Klee, and the 'Angel of History,'" *Oppositions* 24 (1982): 103–25.

15. Walter Benjamin, *Gesammelte Schriften,* ed. Rolf Tiedemann and Hermann Schweppenhäuser (Frankfurt am Main, 1974–89), VI, pp. 520–23. Hereafter cited as GS.

16. To Gretel Adorno, April 1940, GS I.3, pp. 1226–27.

17. Gershom Scholem, "Walter Benjamin und sein Engel," in Siegfried Unseld, ed., *Zur Aktualität Walter Benjamins* (Frankfurt, 1972), p. 120.

18. Ibid., p. 131.

19. GS, VI, pp. 522–23.

20. Gershom Scholem, ed., *Walter Benjamin, Gershom Scholem, Briefwechsel 1933–1940* (Frankfurt, 1980), pp. 96–97, 101–2 (Benjamin's letters of 1 and 10–12 September 1933); Jürgen Ebach, "Agesilaus Santander und Benedix Schönfliess," in Norbert Bolz and Richard Faber, eds., *Antike und Moderne: Zu Walter Benjamins 'Passagen'* (Würzburg, 1986), p. 150, with references.

21. Benjamin to Scholem, 1 September and 10–12 September 1933, Scholem, *Benjamin,* pp. 96–97, 101–2, with commentary by Scholem; Rolf Tiedemann, in GS VI, pp. 809ff.

22. Scholem, "Walter Benjamin und sein Engel," p. 122.

23. R. H. Charles, ed., *The Apocrypha and Pseudepigrapha of the Old Testament in English,* II, *Pseudepigrapha* (Oxford, 1913; reprint 1969), pp. 191ff.

24. H. Odeberg, *3 Enoch, or The Hebrew Book of Enoch* (Cambridge, 1928; reprinted with new introduction by J. C. Greenfield, New York, 1973), p. 127.

25. Theodor Klauser, ed., *Reallexikon für Antike und Christentum,* V (Stuttgart, 1950), col. 87, s.v. "Engel."

26. Werner Fuld, "Agesilaus Santander oder Benedix Schönflies: Die geheimen Namen Walter Benjamins," *Neue Rundschau,* 89 (1978), pp. 253–63.

27. Gershom Scholem, "Ahnen und Verwandte Walter Benjamins," in idem, *Walter Benjamin und sein Engel: vierzehn Aufsätze und kleine Beiträge* (Frankfurt, 1983), pp. 129, 131.

28. Ebach, "Agesilaus Santander und Benedix Schönfliess," p. 150.

29. See Benjamin's letters to Scholem of 31 July and 1 September 1933, Scholem, *Benjamin,* pp. 91–92, 94–95.

30. Plutarch, *Vies,* VIII (Paris, 1973), ed. Robert Flacelière and Emile Chambry, pp. 97ff.

31. Ibid., 27, pp. 128ff. Cf. Markwart Michler, "Die Krankheit des Agesilaos in Megara," *Sudhoffs Archiv für Geschichte der Medizin,* 47 (1963), pp. 179–83.

32. Scholem, "Walter Benjamin und sein Engel," pp. 92–93; Scholem, *Benjamin,* p. 96, note 1.

33. Scholem, *Benjamin,* p. 92.

34. Cf. "Verzeichnis der gelesenen Schriften," GS VII.1, p. 466, no. 1239 <1> ("Blaise Cendrars: Moravagine [Paris, 1926].") Benjamin does not note the German translation which he asks Gretel Adorno, in a letter of 30 April 1933 (GS II.3, p. 1511) to retrieve from his apartment in Berlin.

35. "Zum gegenwärtigen gesellschaftlichen Standort des französischen

Schriftstellers," *Zeitschrift für Sozialforschung,* 3 (1934), no. 1, pp. 54–78; GS II.2, pp. 776–803; cf. Rolf Tiedemann's editorial comments, GS II.3, pp. 1508ff.

36. GS II.2, p. 799. My translation renders the German translation which Benjamin quotes in his essay (cf. letter of 30 April 1933 to Gretel Adorno in Berlin, where he asks her to search in his apartment for "ein oder zwei Überset-zungen von Cendrars, die zu haben mir wichtig wäre," GS, II.3, p. 1511), and hence differs from the English translation of the original by A. Brown (London, 1968), pp. 83, 89–90. Original: Blaise Cendrars, *Oeuvres complètes,* II (Paris, 1987), pp. 299–300.

37. Cendrars, *Oeuvres complètes,* II, pp. 253, 261–62, 324.

38. GS II.1, pp. 213–19, 960–63.

39. GS II.2, p. 1026.

40. "Karl Kraus" (1931), GS II.1, p. 367.

41. GS II.3, p. 1112.

42. GS II.1, p. 215.

43. GS II.1, p. 195.

44. GS II.1, pp. 216–17.

45. Cendrars, *Oeuvres complètes,* II, p. 322.

46. "Zur Lage der russischen Filmkunst," GS II.2, p. 747; "Erwiderung an Oscar A. H. Schmitz," GS II.2, pp. 753ff.

47. GS II.2, p. 802.

48. Cendrars, *Oeuvres complètes,* II, pp. 293–94.

49. GS II.1, pp. 299–300.

50. GS II.2, p. 802.

51. GS IV.1, p. 83.

52. Cf. Susan Buck-Morss, *The Dialectics of Seeing: Walter Benjamin and the Arcades Project* (Cambridge, Mass., 1989), pp. 21 (about the author herself in 1968), 32.

53. Cendrars, *Oeuvres complètes,* II, p. 304.

54. Ibid., p. 305.

55. André Breton, *Oeuvres complètes,* ed. Marguerite Bonnet, I (Paris, 1988), p. 822. Breton's emphasis.

56. Tiedemann, in GS II.3, p. 1515; cf. Chryssoula Kambas, *Walter Benjamin im Exil: Zum Verhältnis von Literaturpolitik und Ästhetik* (Tübingen, 1983), p. 19.

57. Kambas, *Walter Benjamin im Exil.*

58. GS II.3, p. 1317.

59. Cf. Horkheimer's letter to Benjamin of 16 March 1937, GS II.3, p. 1331.

60. "Carl Gustav Jochmann, Die Rückschritte der Poesie," GS II.2, pp. 572–98.

61. Benjamin to Horkheimer, 22 February 1940, GS I.3, p. 1226.

62. Ibid., pp. 1129–30; Benjamin to Adorno, 7 May 1940, GS I.3, p. 1135.

63. Benjamin to Horkheimer, 30 November 1939, GS I.3, p. 1127.

64. Kambas, *Walter Benjamin im Exil,* p. 221.

65. "Eduard Fuchs, der Sammler und der Historiker" (1937), GS II.2, pp. 467, 468, 477.

66. Ibid., p. 477.

67. Horkheimer to Benjamin, 16 March 1937, GS II.3, p. 1332.

68. Jürgen Schiewe, *Sprache und Öffentlichkeit: Carl Gustav Jochmann und die politische Sprachkritik der Spätaufklärung* (Berlin, 1989), p. 154, 156.

69. GS II.2, pp. 577–78.

70. Carl Gustav Jochmann, *Die Rückschritte der Poesie,* ed. Ulrich Kronauer (Hamburg, 1982), p. 42.

71. Cf. Krista R. Geffrath, "Der historische Materialist als dialektischer Historiker," in Peter Bulthaup, ed., *Materialien zu Benjamins Thesen "Über den Begriff der Geschichte"* (Frankfurt, 1975), p. 230, note 27.

72. To Margarete Steffin, 29 March 1937 (GS II.3, p. 1393); similarly in a letter to Stephan Lackner, 16 March 1937 (quoted by Schiewe, *Sprache und Öffentlichkeit,* p. 59, note 114).

73. Jochmann, *Die Rückschritte der Poesie,* p. 18.

74. GS II.2, p. 582.

75. The following paragraph is adapted, with crucial corrections, from O. K. Werckmeister, *Versuche über Paul Klee* (Frankfurt, 1981), pp. 110ff.

76. GS I.3, p. 1245.

77. GS I.3, p. 1237.

78. GS I.3, p. 1250.

79. Cendrars, *Oeuvres complètes,* II, p. 417.

80. Blaise Cendrars, *Le Fin du Monde filmée par l'Ange N. D.* (Paris 1919); reprinted in Cendrars, *Oeuvres complètes,* II.

81. Dieter Kimpel and Robert Suckale, *Die gotische Architektur in Frankreich 1130–1270* (Munich, 1985), pp. 344ff., figs. 344–46.

82. The following paragraph is adapted with changes from Werckmeister *Versuche,* pp. 113–14.

83. "Das Paris des Second Empire bei Baudelaire" (1937–38), GS I.2, p. 588.

84. Cendrars, *Oeuvres complètes,* II, p. 49.

85. Robert Musil, "Vortrag in Paris. Vor dem Internationalem Schriftsteller-Kongress für die Verteidigung der Kultur, Juli 1935, korrigierte Reinschrift," *Gesammelte Werke,* II, *Prosa und Stücke etc.* (Hamburg, 1978), p. 1261.

86. Witte, *Walter Benjamin,* p. 135.

87. GS I.3, p. 1241.

88. GS I.3, p. 1242.

89. Rolf Tiedemann, "Historischer Materialismus oder politischer Messianismus? Politische Gehalte in der Geschichtsphilosophie Walter Benjamins," in Peter Bulthaup, ed., *Materialien zu Benjamins Thesen "Über den Begriff der Geschichte"* p. 88; cf. the note N 8,1 for the Arcades Project, GS V.1, p. 589.

90. GS V, p. 459.

91. Paul Klee, *Schriften,* ed. Christian Geelhaar (Cologne, 1976), p. 107.

92. GS II.1, p. 216.

93. Kambas, *Walter Benjamin im Exil,* pp. 222–23.

94. GS I.2, p. 702.

95. GS IV.1, p. 109.

96. Cf. Kathrin Hoffmann-Curtius, " 'Wenn Blicke töten könnten.' Oder:

Der Künstler als Lustmörder," in Sigrid Schade et al., eds., *Blick-Wechsel: Konstruktionen von Männlichkeit und Weiblichkeit in Kunst und Kunstgeschichte* (Berlin, 1989), pp. 369–93.

97. "Der Sürrealismus," GS II.1, p. 300.

98. Walter Benjamin, *Reflections: Essays, Aphorisms, Autobiographical Writings,* ed. P. Demetz (New York, 1978), editor's introduction, p. xli; Eagleton, *Walter Benjamin,* p. 31.

99. Scholem, "Walter Benjamin und sein Engel," p. 133.

100. Charles Baudelaire, "Le Revenant," *Oeuvres Complètes,* ed. Claude Pichon, I (Paris, 1975), p. 64.

101. Baudelaire, "Das Gespenst," *Blumen des Bösen,* tr. Stefan George, *Werke* II (Munich and Düsseldorf, 1958), p. 280.

102. Baudelaire, *Oeuvres Complètes,* I, p. 111.

103. GS I.3, p. 1147.

104. "Das Paris des Second Empire," p. 524.

105. GS I.2, p. 525.

106. GS V.1, p. 169.

107. GS I.2, p. 528.

108. "Über einige Motive bei Baudelaire," GS I.2, p. 652. Benjamin quotes the French original, *Journaux intimes: Fusées,* in *Oeuvres complètes* I, p. 667.

Chapter Two

1. Rudolf Herz, "Schauplatz," in Diethard Kerbs, ed., *Bilder für Timm: Eine Festgabe für Timm Starl zu seinem 50. Geburtstag am 13. 9. 1989* (Marburg, 1989), pp. 8–9.

2. Sergei M. Eisenstein, *Schriften,* ed. Hans-Joachim Schlegel, vol. II: *Panzerkreuzer Potemkin* (Munich, 1973).

3. Eisenstein, "Das Organische und das Pathos in der Komposition des Filmes 'Panzerkreuzer Potemkin'" (1939), *Schriften,* II, p. 182.

4. Werner Sudendorf, *Sergej M. Eisenstein: Materialien zu Leben und Werk* (Munich, 1976), p. 63.

5. Viktor Schklowski, *Eisenstein: Romanbiographie* (Berlin, 1986), p. 182.

6. Eisenstein, "Das Organische und das Pathos," *Schriften,* II, p. XXX.

7. "Marx on Ideology and Art," *New Literary History,* 4 (1973), pp. 500–519; German version: "Ideologie und Kunst bei Marx," *Neue Rundschau,* 84 (1973), pp. 604–27, reprinted in O. K. Werckmeister, *Ideologie und Kunst bei Marx und andere Essays* (Frankfurt, 1974), pp. 7–35.

8. Rudolf Herz, *Schauplatz,* with text by O. K. Werckmeister (Munich, 1991).

9. Rudolf Herz, "Rote Fahnen: Ein Gespräch mit Heinz Schütz," *Kunstforum,* 102 (1989), pp. 150–57.

10. *1. Internationale Foto-Triennale Esslingen 1989* (Stuttgart, 1989).

11. *Rudolf Herz,* Catalog (Munich, 1988).

12. Letter of 10 August 1991.

13. "Von der Leinwand ins Leben: Zum zehnjährigen Jubiläum des 'Panzerkreuzer Potemkin'" (1935), *Schriften,* II, p. 199.

14. V. Nevsky, *Vosstanie Na Bronenostse 'Knyaz Potemkin Tavrichesky'*, *Vospominaniya, Materialy, Dokumenty* (Moscow and Leningrad, 1924).

15. Constantine Feldmann, *The Revolt of the "Potemkin"* (London, 1908).

16. Ibid., pp. 18–19.

17. John Bushnell, *Mutiny Amid Repression: Russian Soldiers in the Revolution of 1905–1906* (Bloomington, 1985).

18. F. Slang (i.e., F. Hampel), *Panzerkreuzer Potemkin: Der Matrosenaufstand von Odessa 1905. Nach authentischen Dokumenten mit 5 Originalphotographien und 10 Filmbildern* (Berlin, 1926), p. 3.

19. MEGA 21, pp. 350–51.

20. Jacob W. Kipp, "Lenin and Clausewitz: The Militarization of Marxism, 1915–1921," in Willard C. Frank, Jr., and Philip S. Gillette, eds., *Soviet Military Doctrine from Lenin to Gorbachev, 1915–1991* (Westport, 1992), pp. 64–83.

21. Sergei Eisenstein, "Montage 1937," *Selected Works*, ed. Michael Glenny and Richard Taylor, vol. II: *Towards a Theory of Montage* (London, 1991), p. 50.

22. Robert Weinberg, *The Revolution of 1905 in Odessa: Blood on the Steps* (Bloomington, 1993).

23. David Bordwell, *The Cinema of Eisenstein* (Cambridge, Mass., 1993), p. 73.

24. Denise J. Youngblood, *Movies for the Masses: Popular Cinema and Soviet Society in the 1920s* (Cambridge, 1992), p. 155.

25. Stephen P. Hill, "The Strange Case of the Vanishing Epigraphs," in Herbert Marshall, ed., *The Battleship Potemkin: The Greatest Film Ever Made* (New York, 1978), pp. 74–86.

26. Leon Trotsky, *1905* (New York, 1971), pp. 197–98.

27. "Constanza: Wohin die Fahrt des 'Panzerkreuzer Potemkin' geht" (1926), *Schriften,* II pp. 128–31; *Selected Works,* I, *1922–34,* ed. Richard Taylor, (London, 1988), pp. 67–70.

28. "Was Eisenstein zum 'Panzerkreuzer Potemkin' sagte," *Vetchernaya Moskva,* 1 February 1926, quoted in *Schriften,* II, p. 121.

29. Mark von Hagen, *Soldiers in the Proletarian Dictatorship: The Red Army and the Soviet Socialist State, 1917–1930* (Ithaca and London, 1990), p. 247.

30. Ibid., p. 6.

31. Ivan Anisimov, "The Films of Eisenstein," *International Literature* (Moscow), no. 3 (1931), pp. 495–97.

32. Helmut Kresse, "Russenfilme," in Klaus Kändler, Helga Karolewski, and Ilse Siebert, eds., *Berliner Begegnungen* (Berlin, 1987), pp. 164–81; Bruce Murray, "The Film Program of the IAH, the Birth of Prometheus, and *Battleship Potemkin,*" *Film and the German Left in the Weimar Republic: From Caligari to Kuhle Wampe* (Austin, 1990), pp. 119–21; Kristin Thompson, "Eisenstein's Early Films Abroad," in Richard Taylor and Ian Christie, eds., *Inside the Film Factory: New Approaches to Russian and Soviet Cinema* (London, 1991), pp. 53–63.

33. Eisenstein, *Schriften,* II, p. 155.

34. "Die Aufhebung des Verbotes. Berlin, den 10. April 1926. Protokoll der Film-Oberprüfstelle," Gertraude Kühn, et al., eds., *Film und revolutionäre Arbeiterbewegung in Deutschland 1918–1932,* I (Berlin, 1975), p. 328.

35. "Mit 'Potemkin' auf der Spree," *Die Rote Fahne,* 29 June 1926,

pp. 350–51, reprinted in Hermann Herlinghaus, ed., *Sergei Eisenstein, Künstler der Revolution: Materialien der Berliner Eisenstein-Konferenz* (Berlin, GDR, 1960), pp. 299–301.

36. "Bericht des Veterans der deutschen Arbeiterbewegung Fritz Urbanke über die Aufführung des 'Panzerkreuzers Potemkin' 1926 in Johanngeorgenstadt (26. September 1957)," in Herlinghaus, *Sergei Eisenstein*, pp. 303–4.

37. Sudendorf, *Sergej M. Eisenstein*, p. 68.

38. Lion Feuchtwanger, *Panzerkreuzer Potemkin: Erzählungen* (Frankfurt, 1985), pp. 170–75, incorporated into his novel *Erfolg* (Berlin, 1930), II, pp. 15–21.

39. Walter Benjamin, "Erwiderung an Oscar A. H. Schmitz," *Gesammelte Schriften*, II.2, p. 755 (*Die literarische Welt*, 11. 3. 1927).

40. Cf. Eisenstein, "Von der Leinwand ins Leben: Zum zehnjährigen Jubiläum des 'Panzerkreuzer Potemkin'" (1935), *Schriften*, II, pp. 198–99; cf. D. J. Wenden, "Battleship Potemkin—Film and Reality," one of "Selected papers from a conference sponsored by Zentrum für Interdisziplinäre Forschung, University of Bielefeld held in 1979," in K. R. M. Short, ed., *Feature Films as History* (Knoxville, 1981), p. 58.

41. *Schriften*, II, p. 123.

42. Bertolt Brecht, "Keinen Gedanken verschwendet an das Unänderbare," in Bertolt Brecht, *Werke: Große kommentierte Berliner und Frankfurter Ausgabe*, ed. Werner Hecht et al., XIV, *Gedichte 1926–1933* (Berlin and Weimar, 1992), pp. 154ff.

43. Michael MccGwire, *Perestroika and Soviet National Security* (Washington, D.C., 1991), p. 52.

44. Marshall, *The Battleship Potemkin*, p. 375.

45. Wenden, "Battleship Potemkin—Film and Reality," p. 60.

46. Federico Fellini and Tonino Guerra, *E la nave va: Soggetto e sceneggiatura*, transcribed by Gianfranco Angelucci (Milan, 1983), pp. 133ff.

47. Federico Fellini, *Intervista sul Cinema*, ed. Giovanni Graziani (Rome, 1983), p. 62.

48. Peter E. Bondanella, *The Cinema of Federico Fellini* (Princeton, 1992), p. 223.

49. Fellini and Guerra, *E la nave va*, p. 139.

50. André Breton, *Oeuvres complètes*, I, p. 822. Breton's emphasis.

51. Walter Benjamin, "Exposé of the Arcades Project," *Gesammelte Schriften*, V. 1, p. 54.

52. Raymond Williams, "The Politics of the Avant-Garde," in Edward Timms and Peter Collier, eds., *Visions and Blueprints: Avant-Garde Culture and Radical Politics in Early Twentieth-Century Europe* (Manchester, 1988), p. 1.

53. Fellini, *Intervista*, p. 142.

54. Raymond J. Swider, *Soviet Military Reform in the Twentieth Century* (Westport, 1992), pp. 23–74; Jacob W. Kipp, "Soviet Military Doctrine and the Origins of Operational Art, 1917–1936," in Frank and Gillette, *Soviet Military Doctrine*, pp. 85–131.

55. MccGwire, *Perestroika*, pp. 20ff.

56. David M. Glantz, "Developing Offensive Success: The Soviet Con-

duct of Operational Maneuver," in Frank and Gillette, *Soviet Military Doctrine,* pp. 133–73.

57. MccGwire, *Perestroika,* p. 296.

58. Ibid., p. 296.

59. Oksana Bulgakova, ed., *Herausforderung Eisenstein* (Berlin, 1989).

60. Ibid., p. 3.

61. *Bilder im Vorbeifahren,* Catalog (Munich, 1985).

62. David C. Turnley et al., *Beijing Spring* (New York, 1989).

63. *The City in Crisis: A Report by the Special Advisor to the Board of Police Commissioners on the Civil Disorder in Los Angeles, October 21, 1992* (Los Angeles, CA: Special Advisor Study; Washington, D.C.: Police Foundation, 1992), I, p. 153.

64. Turnley, *Beijing Spring,* p. 38.

65. Staff of the Los Angeles Times, *Understanding the Riots: Los Angeles Before and After the Rodney King Case* (Los Angeles, 1992), p. 72.

66. Turnley, *Beijing Spring,* p. 36.

67. *Understanding the Riots,* p. 85.

68. Slang, *Panzerkreuzer Potemkin,* p. 64.

69. Timothy Brook, *Quelling the People: The Military Suppression of the Beijing Democracy Movement* (New York and Oxford, 1992), p. 63.

70. *The City in Crisis,* I, p. 153.

71. Brook, *Quelling the People,* p. 80.

72. "Uprising and Repression in L.A.: An Interview with Mike Davis by the Covert Action Information Bulletin," in Robert Gooding-Williams, ed., *Reading Rodney King, Reading Urban Uprising* (New York, 1993), p. 149.

73. Eisenstein, *Selected Writings,* I, p. 64 (1925).

74. Bordwell, *Cinema of Eisenstein,* p. 116.

Chapter Three

1. Thanks to the Federal Defense Ministry for making the series and other relevant materials available to me.

2. Klaus Herding, "Picasso an die Front! Die Bundeswehr wirbt mit dem Kriegs-Bild 'Guernica' potentielle Mörder an," *Konkret,* 1990, no. 11, p. 35.

3. Günter Grass, "Das geschändete Bild: Wie die Bundeswehr in einer Anzeigenserie Picassos 'Guernica' missbraucht—und wie dieser Missbrauch uns zeigt, dass wir von einer 'Ehrenwerten Gesellschaft' regiert werden, die verbrecherischen Waffenhandel billigt und die Vergangenheit umlügt," *Die Zeit,* 46, no. 13 (22 March 1991), pp. 63–64; English version: "Guernica Revisited: Germany's leading novelist saved his objections to what he saw as the Bundeswehr's abuse of the famous Picasso painting until he could voice them in his speech to the German president," *Guardian,* 23 May 1991.

4. "Was den Meister so erzürnt: Streit um eine Anzeige," *Die Zeit,* 46, no. 17 (19 April 1991), p. 20.

5. Josefina Alix Trueba, *Pabellón español, Exposición Internacional de París, 1937* (Madrid, 1987).

6. Alix Trueba, *Pabellón español,* p. 39.

7. Michael Alpert, *El ejército republicano en la guerra civil* (Barcelona, 1983), p. 71.

8. Ellen C. Oppler, ed., *Picasso's Guernica,* Norton Critical Studies in Art History (New York, 1987), p. 163.

9. Alix Trueba, *Pabellón español,* pp. 78, 229.

10. Aeschylus, *Agamemnon,* v. 1383–84.

11. John Tisa, ed., *The Palette and the Flame: Posters from the Spanish Civil War* (New York, 1979), p. 60.

12. O. K. Werckmeister, "Lucas, Morris," *Citadel Culture* (Chicago, 1991), pp. 142–61.

13. J. Larrea, *Guernica, Pablo Picasso* (New York, 1947), p. 38.

14. Arthur Rimbaud, *Une saison en enfer, Oeuvre-Vie,* ed. Alain Borer (Paris, 1991), p. 452.

15. Ibid.

16. André Breton, *Oeuvres complètes,* ed. Marguerite Bonnet, II (Paris, 1992), p. 459.

17. *Leon Trotsky on Literature and Art,* ed. Paul N. Siegel (New York, 1970), p. 112.

18. *Focus on Minotaure: The Animal-Headed Review,* Catalog (Geneva, 1987).

19. Robert Melville, "Picasso in the Light of Chirico—Mutations of the Bullfight," *View,* 1, no. 1 (February–March 1942), p. 2; reprinted in Gert Schiff, ed., *Picasso in Perspective* (Englewood Cliffs, N.J., 1976), p. 92.

20. "Le problème de la femme est, au monde, tout ce qu'il a de merveilleux et de trouble. Et cela dans la mesure même où nous y ramène la foi qu'un homme non corrompu doit être capable de mettre, non seulement dans la Révolution, *mais encore dans l'amour.* . . . Celui-ci, qui se dit révolutionnaire, voudrait pourtant nous persuader de l'impossibilité de l'amour en régime bourgeois, tel autre prétend se devoir à une cause plus jalouse que l'amour même: à la vérité presque aucun n'ose affronter, les yeux ouverts, le grand jour de l'amour en quoi se confondent . . . les obsédantes idées de salut et de perdition de l'esprit." (*Oeuvres complètes,* I, pp. 822–23; Breton's emphasis).

21. C. Zervos, "Histoire d'un tableau de Picasso," *Cahiers d'Art,* 12, nos. 4–5 (1937), pp. 105–11.

22. P. Eluard, "Paroles peintes: A Pablo Picasso," *Cahiers d'Art,* 12, nos. 4–5 (1937), p. 123.

23. Alix Trueba, *Pabellón español,* p. 135.

24. Der Bundesminister der Verteidigung—Parlamentarischer Staatssekretär [Dr. Alfred Hennig]: Fragestunde des Deutschen Bundestages am 25. April 1991; hier: 2 Fragen des MdB Horst Peter (Kassel).

25. Catherine B. Freedberg, *The Spanish Pavilion at the Paris World Fair* (New York and London, 1986), p. 656.

26. Larrea, *Guernica,* p. 27.

27. Herikberto, "The Creator," *Heavy Metal,* XI, no. 111 (1987), pp. 60–64.

28. Rudolf Arnheim, *Picasso's Guernica: The Genesis of a Painting* (Berkeley and Los Angeles, 1962; new ed., 1973), pp. 20ff.

29. Peter Weiss, *Die Ästhetik des Widerstands,* I–III (Frankfurt, 1975–81).

30. Anthony Blunt, "Art in Paris," *The Spectator,* 159 (7 August 1937), p. 241.

31. Anthony Blunt, "Picasso Unfrocked," *The Spectator,* 159 (8 October 1937), p. 584.

32. Herbert Read, Reply to Blunt's "Picasso Unfrocked," *The Spectator,* 159 (15 October 1937), p. 636.

33. Anthony Blunt, *Picasso's Guernica* (New York and Toronto, 1969), p. 57.

34. Ibid., p. 8.

35. Karl Marx, *Werke,* ed. Hans-Joachim Lieber, VI, *Ökonomische Schriften,* III (Darmstadt, 1975), pp. 831–33; cf. Werckmeister, "Marx on Ideology and Art," pp. 500–519.

36. Weiss, *Die Ästhetik,* I, p. 340.

37. Ibid.

38. *Akzeptanz und Sympathie: Eine Imagekampagne für die Bundeswehr* (Düsseldorf, 1989). Thanks to McCann-Erickson Scope for letting me study this document.

39. Personal communication from Dr. Karl-Heinz Hilzheimer, the director of the Krakow-McCann ad agency directly responsible for the campaign.

40. *Öffentlichkeitsarbeit: Argumente zur Sicherheitspolitik.* Argumentionen zur Sicherheitspolitik und Berufsperspektive in der Bundeswehr. Der Bundesminister der Verteidigung, Informations- und Pressestab, Referat Öffentlichkeitsarbeit, p. 4.

41. *Newsweek,* 18 July 1988, p. 24.

42. P. Eluard, "Paroles peintes: A Pablo Picasso," p. 123.

43. Blunt, "Picasso Unfrocked," p. 584.

44. *The Times* (London), 21 November 1979, p. 5.

45. *Art contra la guerra: Entorn del pavelló espanyol a l'exposició internacional de París de 1937,* Catalog (Barcelona, 1986); Alix Trueba, *Pabellón español.*

Chapter Four

1. Günter Schabowski, "Selbstblendung: Über den Realitätsverlust der Funktionärselite," *Kursbuch* (1993), no. 1, pp. 111–24.

2. Ibid., p. 112.

3. Ibid., p. 116.

4. As he related it to me in our conversations.

5. Similarly, Günter Schabowski, *Abschied von der Utopie: Die DDR—das deutsche Fiasko des Marxismus,* Beiträge zur Wirtschafts- und Sozialgeschichte 60 (Stuttgart, 1994), p. 34.

6. George Schopflin, *Politics in Eastern Europe, 1945–1992* (Oxford, UK, and Cambridge, Mass., 1993), p. 74.

7. Günter Schabowski, *Das Politbüro: Ende eines Mythos* (Reinbek, 1990), p. 59.

8. Schabowski, *Der Absturz* (Berlin, 1991), p. 192.

9. Schabowski, *Das Politbüro,* pp. 51, 60ff.

10. Enki Bilal, *Partie de Chasse,* scenario Pierre Christin, Collection Legendes d'aujourd'hui (Paris: Dargaud, 1983).

11. "Bilal," *Citadel Culture,* pp. 47–93.

12. *Partie de Chasse, suivi de Epitaphe* (Paris, 1990).

13. O. K. Werckmeister, "Ein Comic über die Umkehrbarkeit der Geschichte: Zur Neuausgabe von Christins und Bilals *Treibjagd,"* in Joachim Kaps, ed., *Comic Almanach 1992* (Wimmelbach, 1992), pp. 27–34.

14. Schabowski, *Das Politbüro,* p. 59.

15. Enki Bilal, *La Femme Piège* (Paris, 1986).

16. Wilhelm Reich, "Psychoanalysis in the Soviet Union" (1929), in idem, *Sex-Pol: Essays 1929–1934,* ed. Lee Baxandall (New York, 1972), pp. 75–88.

17. Graeme Gill, *The Origins of the Stalinist Political System* (New York, 1990), pp. 324–25.

18. Herbert Marcuse, *Eros and Civilization* (1955; New York, 1961), pp. 50ff.

19. W. Jurinetz, "Psychoanalyse und Marxismus," in S. Bernfeld, et al., *Psychoanalyse und Marxismus,* ed. Jörg Sandkühler (Frankfurt, 1970), p. 77.

20. Raymond A. Bauer, *The New Man in Soviet Psychology* (Cambridge, 1952), p. 124.

21. David Joravsky, *Russian Psychology: A Critical History* (Oxford and New York, 1989), pp. 235ff.

22. Alex Kozulin, *Psychology in Utopia: Toward a Social History of Soviet Psychology* (Cambridge, Mass., 1984), pp. 16–17.

23. Joravsky, *Russian Psychology,* p. 236.

24. Bauer, *New Man,* p. 99.

25. Schabowski, *Der Absturz,* p. 217.

26. Enki Bilal, *La foire aux immortels* (Paris, 1980), pp. 35, 42, 57.

27. Interview with Bilal on the occasion of the appearance of *La femme piège, Bande dessinée,* 1986, pp. 7–8.

28. Rudolf Herz, *Lenins Lager: Entwurf für eine Skulptur in Dresden* (Berlin, 1992).

29. Bilal, *Catalogue Un sur un,* (Paris, 1991) p. 12.

30. Louis Althusser, *The Future Lasts a Long Time and The Facts,* ed. Olivier Corpet and Yann Moulier Boutang, trans. Richard Veasey (London, 1993).

31. Althusser, *The Future,* p. 227.

32. Ibid., p. 364.

33. Ibid., p. 203.

34. Ibid., p. 226.

35. Schabowski, *Der Absturz.*

36. Althusser, *The Future,* p. 223.

37. Pierre Gassier and Juliet Wilson, *The Life and Complete Work of Francisco Goya* (New York, 1971), p. 125.

38. Schabowski, "Selbstblendung," p. 122.

Chapter Five

1. Cf. Nick James, Review of *Kafka, Sight and Sound,* 4 (1994), no. 3, pp. 42–43.

2. Havel, *Briefe an Olga: Identität und Existenz: Betrachtungen aus dem Gefängnis* (Reinbek, 1984) pp. 37, 228, 230; idem, *Disturbing the Peace: A Conversation with Karel Hvizdala* (New York, 1990), p. 6.

3. Siegfried Kracauer, *From Caligari to Hitler: A Psychological History of the German Film* (London, 1947), pp. 67ff.

4. Klaus Wagenbach, *Franz Kafka: Eine Biographie seiner Jugend 1883–1912* (Berne, 1958), pp. 162–63.

5. Hartmut Binder, *Kafka: Ein Leben in Prag* (Munich, 1982), pp. 115–16; Ernst Pawel, *The Nightmare of Reason: A Life of Franz Kafka* (New York, 1984), pp. 151–52.

6. Paul Reimann et al., eds., *Franz Kafka aus Prager Sicht* (Prague, 1966), pp. 40–41.

7. Wagenbach, *Kafka,* pp. 162, 164.

8. E. Goldstücker, "Über Franz Kafka aus der Prager Perspektive 1963," in Reimann et al., *Kafka,* p. 40.

9. Franz Kafka, *Briefe an Ottla und die Familie,* ed. Hartmut Binder and Klaus Wagenbach (Frankfurt am Main, 1974), p. 178, note to letter no. 50; Franz Kafka, *Amtliche Schriften,* with an essay by Klaus Hermsdorf (Berlin, 1984), p. 24.

10. Binder, *Kafka,* p. 111; cf. Pawel, *The Nightmare of Reason,* p. 189.

11. Wagenbach, *Kafka,* p. 125.

12. Klaus Hermsdorf, *Kafka: Weltbild und Roman* (Berlin, 1961; 3d ed., 1978).

13. Franz Kafka, *Amtliche Schriften.*

14. "Umfang der Versicherungspflicht der Baugewerbe und der baulichen Nebengewerbe" (1908), p. 120.

15. Speech on the appointment of Dr. Marschner, Spring 1909, *Nachgelassene Schriften und Fragmente,* I–II, ed. Malcolm Pasley (1992), I, p. 179, in *Gesammelte Werke in Einzelbänden in der Fassung der Handschrift* (Frankfurt am Main, 1983–1994).

16. Hermsdorf, in Franz Kafka, *Amtliche Schriften,* p. 44.

17. Benjamin, *Gesammelte Schriften,* ed. Rolf Tiedemann and Hermann Schweppenhäuser (Frankfurt am Main, 1974–89), II.3, p. 1255.

18. *Nachgelassene Schriften und Fragmente,* II, p. 16, not dated.

19. *Der Verschollene,* ed. Jost Schillemeit (1983), pp. 184, 352ff., in *Gesammelte Werke.*

20. Ibid., p. 50.

21. Ibid., pp. 148–49, 163–64.

22. Ibid., pp. 75, 100–101, 147.

23. Ibid., pp. 387–88.

24. *Der Proceß,* ed. Malcolm Pasley (1990), p. 93, cf. p. 94, in *Gesammelte Werke.*

25. Ibid., p. 58, cf. p. 71.

26. Ibid., Apparatband, p. 184.

27. Ibid., pp. 53, 57.

28. *Das Schloß,* ed. Malcolm Pasley (1984), pp. 42–43, cf. p. 58, in *Gesammelte Werke.*

29. Ibid., pp. 107ff.

30. Ibid., pp. 494–95.

31. *Nachgelassene Schriften und Fragmente,* II, pp. 105ff., end of January to beginning of May 1918.

32. Ibid., I, pp. 408ff., August-September 1917.

33. Ibid., II, p. 223, August to end of 1920.

34. Ibid., II, pp. 278–79, August to end of 1920.

35. Ibid., I, pp. 329–30, January-February 1917.

36. Ibid., II, p. 320, August to end of 1920.

37. *Der Proceß,* pp. 289–90.

38. Sally Hibbin, *The New Official James Bond Movie Book* (New York, 1987; rev. ed., 1989), p. 65.

39. *Das Schloß,* p. 302.

40. Franz Kafka, *Briefe an Milena: Erweiterte und neugeordnete Ausgabe,* ed. Jürgen Born and Michael Müller (New York and Frankfurt, 1983), pp. 202–3.

41. GS II.2, p. 413.

42. Kracauer, *From Caligari to Hitler,* pp. 67ff.

43. Günter Anders, *Mensch ohne Welt: Schriften zur Kunst und Literatur* (Munich, 1984), p. 104, first published as *Kafka, pro und contra. Die Prozeß-Unterlagen;* my own translation from the German. The English version in Günther Anders, *Franz Kafka,* translated by A. Steer and A. K. Thorlby (London, 1965), p. 78, departs from the original.

44. Roger Garaudy, "Kafka, die moderne Kunst und wir," in Reimann et al., *Kafka,* p. 205.

45. *Nachgelassene Schriften und Fragmente,* II, pp. 216–17.

46. *Der Proceß,* p. 312.

47. Anders 1984, p. xxxiv.

48. Ibid., p. xxxii.

49. Ibid., p. 68.

50. Ibid., p. 63.

51. Rolf Tiedemann, in GS II.3, pp. 1160–61.

52. *Nachgelassene Schriften und Fragmente,* II, pp. 40ff.

53. GS II.2, p. 432.

54. Jürgen Born et al., eds., *Franz Kafka: Kritik und Rezeption 1924–1938* (Frankfurt, 1983), pp. 339ff.

55. "Zum gegenwärtigen gesellschaftlichen Standort des französischen Schriftstellers" (1934), GS II.2, pp. 776–803.

56. GS II.3, p. 1165.

57. GS II.3, p. 1253.

58. Theodor W. Adorno, "Aufzeichnungen zu Kafka," *Gesammelte Schriften,* X, part 1 (Frankfurt, 1977), p. 285.

59. Ibid., p. 278.

60. Weiss, *Die Ästhetik,* I, p. 179.

61. Ibid., p. 180.

62. Hannah Arendt, "The Jew as Pariah: A Hidden Tradition," *Jewish Social Studies,* 2 (1944), pp. 199–222; idem, "Franz Kafka," *Partisan Review,* 11 (1944), pp. 412–22; German version in Arendt, *Sechs Essays* (Heidelberg, 1948), pp. 81–111, 128–49.

63. Arendt, *Sechs Essays,* p. 83.

64. Arendt, "Franz Kafka," p. 422.

65. Ibid., p. 413.

66. Hannah Arendt, *Eichmann in Jerusalem: A Report on the Banality of Evil* (rev. ed., New York, 1983).

67. Adorno, *Gesammelte Schriften,* X, part 1, pp. 272–73.

68. Havel, *Briefe an Olga,* p. 75.

69. Max Brod, *Franz Kafka: A Biography* (1937; New York, 1947).

70. GS, III, pp. 526–29; *Briefe,* II, pp. 748. 758ff., to Gerhard Scholem, 14 April and 12 June 1938.

71. See note 59.

72. Havel, *Briefe an Olga,* pp. 125–26, 129; idem, *Disturbing the Peace,* p. 6.

73. Havel, *Disturbing the Peace,* p. 10, 166.

74. Mark Anderson, *Kafka's Clothes: Ornament and Aestheticism in the Habsburg Fin de Siècle* (New York, 1992); Pavel Petr, *Kafkas Spiele: Selbststilisierung und literarische Komik* (Heidelberg, 1992).

75. Max Brod, *Franz Kafka,* pp. 156–57; cf. Petr, *Kafkas Spiele,* pp. 80ff.

76. Hibbin, *James Bond Movie Book,* p. 129.

Previously Published Versions

"Walter Benjamin's 'Angel of History,' or the Transformation of the Revolutionary into the Historian," *Critical Inquiry,* 22 (1996), pp. 239–267.

"Kafka 007," *Critical Inquiry,* 21 (1995), pp. 468–495.

The other chapters are developed in part from the following shorter texts:

"Stichworte zur gegenwärtigen Perspektive marxistischer Kunstgeschichte," *Kritische Berichte,* 18 (1990), no. 3, pp. 79–84; revised English version: "A Working Perspective for Marxist Art History Today," *Oxford Art Journal,* 14 (1991), no. 2, pp. 83–88.

"Text zum *Schauplatz,*" in Rudolf Herz, *Schauplatz,* Munich, 1991, pp. 6–15.

"Picassos Guernica," in Monika Wagner, ed., *Moderne Kunst: Das Funkkolleg zum Verständnis der Gegenwartskunst,* II, Reinbek, 1991, pp. 491–510.

"Ein Comic über die Umkehrbarkeit der Geschichte: Zur Neuausgabe von Christins und Bilals *Treibjagd,*" in Joachim Kaps, ed., *Comic Almanach 1992,* Wimmelbach, 1992, pp. 27–34.

Index

Kafka, 139, 144–47; on Klee, 2, 11, 14–15, 19, 26, 30–31; on Kraus, 14, 19–20, 26, 30; literary politics of, 13, 22–24, 34, 56–57, 111; Moscow trip of, 19; names of, 17; on New Man, 30–31, 113; on surrealism, 21–22; on terror, 24, 56–57; women's relationships with, 16, 21; works: "About the Present Social Position of the French Writer," 18–19, 20–22, 25, 30, 145; "Experience and Poverty," 19–20, 22, 26, 30; *One-Way Street,* 21, 31; "On Some Motifs in Baudelaire," 14; *Theses on the Concept of History,* 12–13, 23–24, 31–32, 34; "The Work of Art in the Age of Its Mechanical Reproducibility," 23. *See also* "Agesilaus Santander" (Benjamin); Angel of History (Benjamin)

Berlin (Germany), *Battleship Potemkin* screened in, 50

Berlin Wall, representation of, 68

Bilal, Enki: psychoanalysis and, 107, 113–15, 119–21; publications by, 99–100; on tableaus, 116–17. *See also The Hunting Party* (Christin and Bilal)

Binder, Hartmut, 131–32

Blanqui, Auguste, 33

blast, Benjamin's use of term, 31

Blaupott ten Cate, Toet, 16, 21

Bloch, Ernst, 129

Blunt, Sir Anthony, 79–82, 92

Bohème, literature and anarchism in, 128

Bolshevik Revolution, harbingers of, 20

Bolshevism: industrialization under, 20, 48, 101, 111–13; psychoanalytic caricature of, 119–21; socialization in, 106; structure of, 108; visual alienation of, 59

Bolshoi Theater (Moscow), 38

Bombay (India), bombing in, 150–51

bombings: of civilians, 68, 71, 72, 74; reasons for, 150–51

boys, names of, 17

Brecht, Bertolt, 1, 4, 52, 134, 145

Breton, André: Benjamin on, 19, 31–32; historical context of, 4; on historical topicality, 75; on politics and art, 74;

works: Second Manifesto of Surrealism, 19, 21, 22, 56, 75, 107

Brezhnev, Leonid, 52

Brod, Max, 147

Bulgakova, Oksana, 58

bullfight, Picasso's imagery of, 75, 80–81

Bundeswehr (Federal army): advertisements by, 67–69, 73, 77–79, 93, 95, 156; media strategy of, 84–87

Bund Proletarischer und Revolutionärer Schriftsteller, 23

Bunte (newspaper), 67

Bush, George, 62–63

The Cabinet of Doctor Caligari (Wiene), 126, 127, 141

Cahiers d'Art (journal), 76, 83

Cambodia, massacres in, 80

capitalism: basis for critique of, 3; impact of, 148–49, 153; labor's devaluation in, 148, 154–56; Marxist critique as sideshow of, 7; oppression vs. expression in, 141–42; productivity under, 87–88; "triumph" of, 154. *See also* capitalist societies; Marxist cultural critique

capitalist societies: Cold War and, 58–59; Communist neurosis in, 117–20; Communist parties in, 52–54; crisis in, 5–7; government and crime in, 149; Kafka's popularity in, 130, 142–43; Left's political dysfunctionality in, 59, 92–93; Left's retrenchment in, 80–81; military's role in, 79; nuclear defense justified in, 127; revision of critical culture of, 1–2; revolutionary changes possible in, 52–54; threats to, 148–51

The Castle (Kafka): class in, 135; critique of, 131–32, 146–47; power of castle in, 123–24; as proletarians' novel, 145–46; sexual relations in, 137, 138, 139

Castro, Fidel, 53–54

cats, folk dancers as, 54

Cendrars, Blaise: *The End of the World,* 28–29; *Moravagine,* 18–22, 28, 31

censorship, of *Battleship Potemkin,* 49–51

Chernenko, Konstantin, 59

Chevchenko, Gen. Vasily Aleksandrovich: as assassin, 102, 113,

International Association of Revolutionary Writers (Moscow), 22
International Brigades (Spanish Civil War), 79, 80, 83, 92
International Conference on the Contemporary Concept of Socialism, 58
International Writers Congress for the Defense of Culture (1935), 23, 29, 74
In the Penal Colony (Kafka), 139–41
Iranian Airbus plane, destruction of, 88, 91
Iran-Iraq war, *Vincennes* in, 88–91
Iraq, weapons for, 69
Irons, Jeremy, 125, 138
Isar River, 41

Jacob (biblical), 18
Janouch, Gustav, 128
Jesenká, Milena, 139
"The Jew as Pariah" (Arendt), 146
Jewish culture: Kafka and, 145, 146, 148; traditions in, 16–17
Jiang Zemin, 98–99
Jochmann, Carl Gustav, 24–27
Johanngeorgenstadt (Germany), *Battleship Potemkin* screened in, 50
journalism, as religious metaphor, 14
Jüdische Rundschau (journal), 144–45

Kafka, Franz: Benjamin on, 139, 144–47; as bourgeois, 129–30, 134; characterization of, 147; class conflict and, 132–36, 142–43, 147; conformity and, 143–47; films and, 123–27; Jewish culture and, 145, 146, 148; on Klee, 34–35; literature and political practice for, 123–24, 128–30, 134, 137; love relationships of, 139; occupations of, 130–32, 155–56; official writings of, 132–36; popularity of, in capitalist culture, 130, 142–43; rehabilitation of, 110, 129, 142–43; terror and, 147–51; woman's sacrifice and, 136–40, 143. *See also Kafka* (Soderbergh)
Kafka: Pro and Con (Anders), 144–45
Kafkaesque, use of term, 123
Kafka (Soderbergh): bomb as key in, 150–51; conformity in, 143–47; historical topicality in, 148–49; literature incompatible with politics in,

130; machinery in, 139–41; "modernity" in, 140–43; moralistic conscience in, 127; as negative of icons, 153–54; occupations depicted in, 131; plot of, 123–25; politics in, 127–30; poster for, 124–25, 150; site for, 125–26, 148–49; social conflict in, 132; terror in, 147–51; woman's sacrifice in, 136–40, 143
Kambas, Chryssoula, 22, 31
Khmer Rouge, massacres by, 80
Klee, Paul: artistic radicalism of, 19–20; Benjamin on, 2, 11, 14–15, 19, 26, 30–31; on destruction, 30; as harbinger of industrialization, 20; Kafka on, 34–35. *See also Angelus Novus* (Klee)
Kohl, Helmut, 85
Kracauer, Siegfried, 126, 127, 141, 147
Kraus, Karl, 14, 19–20, 26, 30
Kronstadt, sailors' revolt at, 101
Krupp Cultural Foundation, 39, 59
Kulturgesellschaft: dissent in, 14; use of term, 11
Kunstforum [Art Forum], concept of, 37, 42

labor. *See* workers
Lacis, Asja, 16, 19, 21
Lake Aral, 111–12, 117
Lang, Fritz, 139–40
Left: on Benjamin's communism, 13; disenchantment of, 54; *Guernica* reinterpreted by, 79–84; life, politics, and art aligned for, 12; on military's role, 79; pacifism of, 73; political culture absent for, 3; psychoanalysis considered by, 107–8; response to *Battleship Potemkin*, 51–52; sentimentality of culture of, 153–54; in seventies and eighties, 5–7; updated challenge of, 154–56. *See also* anarchism; Communism; Marxist cultural critique; socialism
legality: film's suspension of, 127; insurance and, 133–34; Kafka's rendering of, 131
Lenin, V. I.: broken statue of, 111, 117; leadership principle of, 102–3; portrait of, 60; on spectators, 64; on worldwide revolution, 44, 47–48

Picasso, Pablo: characterization of, 81–82; Communist critique of, 80–81; context of, 92–93; imagery of, 75–76; as militiaman, 73–74; on resistance vs. disaster, 71; warrior recast by, 72–73. *See also Guernica* (Picasso)

"Pictures in Passing" (competition), 59–60

Plutarch, 17

poetry, critique of, 25

Poland, Communist government collapse in, 99

police, in Los Angeles riots, 62, 64

political culture: absence of change in, 148–49; arts in, 3, 34, 74–77, 80–81

political partisanship. *See* partisans

politics: conservative shift in, 5–6; cultural critique and, 156–57; culture removed from, 11; vs. historiography, 30; ideology vs. action in, 92–93; Left vs. Right, 92–93; literature's relation to, 13, 22–24, 34, 56–57, 111, 127–30, 142–47; parody of, 54; radicalization of, 21–22, 31–32, 56; rejected in aesthetics, 59–61, 64, 68; soldiers vs. civilians and, 61–64, 98–99. *See also* cultural politics

Popular Front: congress associated with, 23, 29, 74; intellectuals in, 22–23, 74; pacifism of, 71, 77–78; Picasso in, 80

postmodernism: Marxism's place in, 6; reflexivity of, 42. *See also* avant-garde; modern art

Potemkin (battleship): Cendrars on, 20; Eisenstein on, 42–43, 45–46; history of, 43–44; soldier/civilian confrontation and, 62–64. *See also Battleship Potemkin* (Eisenstein)

Potemkin (Russian prince), 144

power: conformity vs. resistance to, 143–47; of electronic imagery, 89–91; justification for communist, 97–99; shifting center of, 149; structure of, 108–9; use of coercive, 102; woman as medium of, 137–40

Prague (Czechoslovakia/Czech Republic), castle in, 123–24, 125–26, 128

Pravda (newspaper), 59–60

proletariat: composition of, 44–46; Kafka

and, 129; novel for, 145–46; revolutionary consciousness of, 48–49. *See also* civilians; masses; workers

propaganda: art as, 58–59, 69–71; preconditions for, 78; reduction in, 67–68; soldiers and civilians depicted in, 72–73; war theme in, 70–71

protest movements (U.S.), *Guernica* embraced by, 94

psychoanalysis: Althusser's use of, 117–19; Bolshevism caricature through, 119–21; film's use of, 126; as nemesis of Communism, 107–10, 112–16; suppression of, 106–7, 112, 113–15. *See also* neuroses; psychology

Psychoanalysis and Dialectical Materialism (Tretyakova), 105–7

psychogram, of ideal Communist, 113–14

psychology (Soviet): analysis vs. adjustment in, 114–15; on social attitudes, 106. *See also* neuroses; psychoanalysis

public culture, revolution vs. peace in, 57–61

Pygmalion myth, 76

Raban, Eduard, 126, 128

racial difference, soldiers vs. civilians, 63

radar, interpretation of, 88–91

radicalization, of love and politics, 21–22, 31–32, 56

Raft of the Medusa (Géricault), 82

Ramstein Field, airshow at, 89–91

Raumer, Friedrich von, 28

Read, Herbert, 80–81

reading, sexual metaphor for, 31–32

reason, absent in Communism, 120–21

Red Army Faction, 151

Red Front (Berlin group), 50

red star, symbolism of, 111–12

redundancy, military ad campaign and, 84–86

The Red Wedge (Herz), 42

Reich, Wilhelm, 106

Renau, Josip, 76

resistance: aesthetics of, 79–80, 82–84, 145–47; ambivalence about means of, 80–81; vs. conformity, 143–47; vs. disaster, 71